PAINTING STORIES

Visit my webpage: hellebundgaard.com

Painting Stories

Lives and Legacies from an Indian Crafts Village

HELLE BUNDGAARD

UNIVERSITY OF TORONTO PRESS
Toronto Buffalo London

© University of Toronto Press 2022
Toronto Buffalo London
utorontopress.com
Printed in the U.S.A.

ISBN 978-1-4875-2732-7 (cloth) ISBN 978-1-4875-2735-8 (EPUB)
ISBN 978-1-4875-2733-4 (paper) ISBN 978-1-4875-2734-1 (PDF)

Library and Archives Canada Cataloguing in Publication

Title: Painting stories : lives and legacies from an Indian crafts village / Helle Bundgaard.
Names: Bundgaard, Helle, author.
Identifiers: Canadiana (print) 20210315059 | Canadiana (ebook) 20210315180 | ISBN 9781487527327 (hardcover) | ISBN 9781487527334 (softcover) | ISBN 9781487527358 (EPUB) | ISBN 9781487527341 (PDF)
Subjects: LCSH: Artisans – India – Raghurajpur – Biography. | LCSH: Patas (Art) – India – Raghurajpur. | LCSH: Folk art – India – Raghurajpur. | LCSH: Raghurajpur (India) – Biography. | LCSH: Raghurajpur (India) – Social conditions. | LCGFT: Biographies.
Classification: LCC NK1048.R325 B86 2022 | DDC 745.092/254133 – dc23

We welcome comments and suggestions regarding any aspect of our publications – please feel free to contact us at news@utorontopress.com or visit us at utorontopress.com.

Every effort has been made to contact copyright holders; in the event of an error or omission, please notify the publisher.

University of Toronto Press acknowledges the financial assistance to its publishing program of the Canada Council for the Arts and the Ontario Arts Council, an agency of the Government of Ontario.

Canada Council Conseil des Arts
for the Arts du Canada

ONTARIO ARTS COUNCIL
CONSEIL DES ARTS DE L'ONTARIO
an Ontario government agency
un organisme du gouvernement de l'Ontario

Funded by the Financé par le
Government gouvernement
of Canada du Canada

Canada

For Aliya, Mathai, and Behnan, with love

Contents

Contents

Introduction

I arrived by bus from Puri, then a lazy provincial town on the east coast
of India. It was winter, 1988. The last leg of the excursion was a nar-
row dirt road along the curving banks of the river Bhargavi. From a
cycle-rickshaw, I watched men heaving nets from wooden fishing boats,
women washing clothes, and colorful garments of intricate designs dry-
ing on the riverbanks. Shortly before the hamlet a signboard welcomed
visitors to Raghurajpur. After passing that threshold, craft makers soon
began to approach, hoping to sell their goods.

A line of temples and wells connected the entrance, where I had
arrived, to the river at the other end of the hamlet. Along each side of
the temples ran a path and a seemingly endless line of thatched row-
houses – one after the other, some houses so narrow that you could
literally reach across from one wall to the next without any effort. Men
and women worked on their verandas surrounded by displays of their
crafts. Some were painting masks or wooden figurines of Hindu deities;
others were incising palm leaves with iron styluses; and still others were
carving stones into gods or sculpting masks, animals, and birds from
papier-mâché. The villagers were craft makers; painting and sculpting
was what they did and have always done for a living – or so it seemed.

Everywhere I turned, I saw figures of Hindu deities, colorful wall
paintings of dancing girls, and illustrations of scenes from the great
epic *Ramayana* or the life of *Krishna*.[1] I was swept off my feet that after-
noon and made up my mind: This hamlet, this community, was where

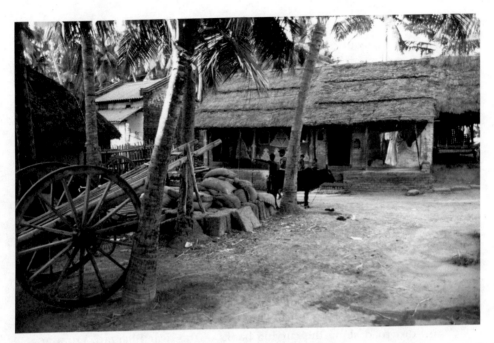

A glimpse of Raghurajpur, 1988

I wanted to carry out my first fieldwork. I returned that afternoon to
Puri with a plan and a painting. Little did I know then that this was the
beginning of a lifelong engagement with the painters.

Almost thirty years and many visits after my first fieldwork, I returned to
Odisha to collaborate with the painters and make sense of our lives and
legacies through story writing. On that visit, a painter named Niranjan,
from the neighboring hamlet of Danda Sahi, invited me over. His wife
served tea, and for a brief moment we chatted, catching up on news. That
was when Niranjan suddenly changed his posture, sat up straight, pulled
back his shoulders, and asked: "So what do we get out of your work?"

His question made me wince. I am not sure what I had expected, but
not this; no one in the hamlets had ever asked me this before. I have
known Niranjan since he was a small boy and used to spend hours with
his father in the early 1990s. Apart from some entertainment and an oc-
casional lift to one of the Brahmin villages in which he served as temple

artisan, what had the old man gotten out of the time he spent with me? Niranjan had a point. The painters have never benefited financially from my engagement. Yes, I have always lent a sympathetic ear. I have given photographs and hosted feasts. But my work has done little to ease the hard realities of life among the Indian craft makers.

Niranjan sat quietly waiting for an answer to his question. What could I say? I acknowledged his point. If nothing else, I suggested, the stories themselves might be meaningful to the painters. Niranjan had not heard the stories and was not convinced. In this regard, he differed from the painters with whom I shared the first early drafts. One afternoon, sitting on the roof of the painter Tophan's house near Puri Beach, my research assistant, Prasanta, helped me in accurately translating the story "A Ladies'. Bicycle," in which Tophan is a primary character. As Tophan sat attentively listening, reawakened memories danced across his face. He smiled to himself, laughed, and slapped his knees.

"It's just how it was! How can you remember everything so well? I want a copy of the book."

"Of course, you will have a copy. But be warned: it might take many years before it is published."

"I do not care if I am dead when your book is published, as long as my children get a chance to read it. I want them to know about my youth ..."

Perhaps writing for the future will allow me to give something back.

The stories in this book can be read in a number of ways. You can jump straight to the stories and see what you can gain from them in themselves. Or you can continue reading this introduction to get an impression of Raghurajpur, to learn about what the "stories" here entail, and how they have taken form. If you are interested in the history of the cloth paintings (*patta chitras*) that have attracted outsiders to the hamlet, I suggest reading "Painting Matters" – either before or after the stories. To get a broader sense of the setting in which the stories take place, you should read "A Heritage Village." And if you wish to know about my own background and research partners, this information is available in "Fieldwork and Personal Locations." You will find these three sections in "Voyages through Time" at the end of the book.

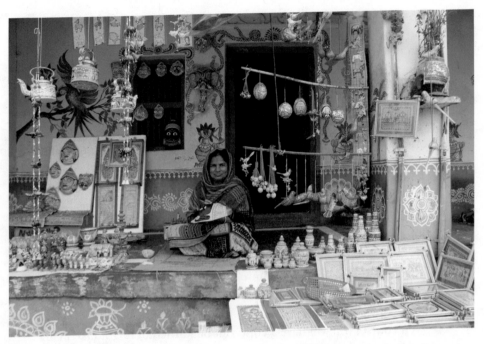

Sarojini Moharana working in front of her house, 2020

Like Niranjan, my scholarly colleagues might ask, "So, what do we get out of your work?" To anthropologists and South Asia specialists, I would say that the personal stories offer a window into larger national, colonial, and historical processes, which are played out in the stories without driving them. They do this through ethnography that can be seen and felt and thus invites lay readers in, too. To scholars of traditional art, I would reply that the stories show how crafts are neither "pure" nor "economic." The two orientations are inherently intertwined, and the balance is varied in complex personal, cultural, and social contexts. For everyone else, read the stories for what they are: small snippets evocative of a time, a place, and a way of life.

A day's drive south from Kolkata, Raghurajpur beats to a rhythm similar to many Indian villages. Children mill about, trailed by their younger

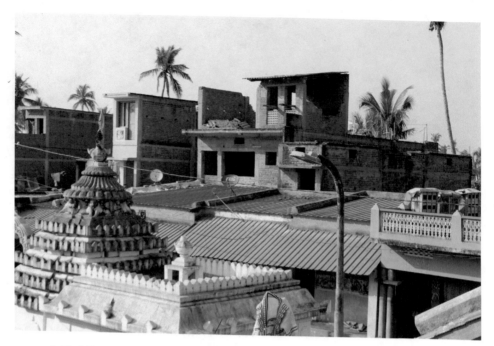

Added floors to narrow houses, 2019

siblings; men of all ages ride bicycles or motorbikes to the nearby town to buy groceries or to catch a bus to Puri; and, these days, even girls and young women cycle to visit friends and relatives in neighboring hamlets. While working on their crafts, villagers keep an eye out for customers, chat with passers-by, and remind the children of their presence. The few unfortunate people who live on their own have company from the time they open the front door in the morning and step out onto their veranda. In this respect, not much has changed over the last thirty years.

What has changed are the number of people engaged in craft production, the regularity of customers, the level of income and material wealth, the running water and electricity in each household, the size and colors of houses, and the roofs. Most have replaced thatch with sheets of corrugated iron, the relative cool characteristic of thatch apparently not making up for its disadvantages (the need for recurrent repair and uninvited dwellers).

Many have added an extra floor to their narrow, deep houses, which are popularly known as "trains" – the only way to get more living space

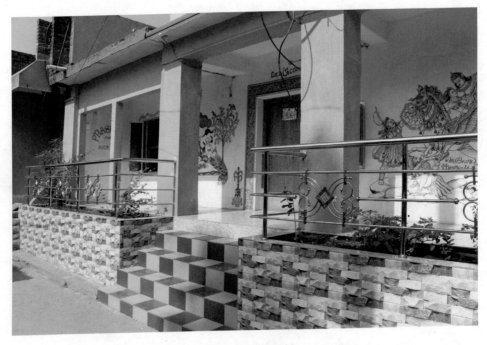

A recently renovated house in Raghurajpur, 2020

within the constricted hamlet setting. The local government has pro-
vided each family with a latrine and a shower – facilities that are in
place but are not connected to water. While many in the late-1980s had
only somewhere between two and seven years of education, the hamlet
now has more than a handful of university graduates, some of them
young women.

Dancing girls, deities, and stories from mythology still decorate the
walls of houses. A few are still made with earthen colors, but most
shine in brighter shades. The most striking difference, however, is the
change in communication. For the younger generation, it is incon-
ceivable that their parents grew up without access to a telephone or
the internet. They make use of social media, some more efficiently
than others, and use their proficiency to help their parents expand
their networks.

It is not easy to make a living as a craft maker, but it is better than
nothing – and for a few it is even lucrative. In a country struggling with
massive underemployment, Odisha is no exception. Raghurajpur's

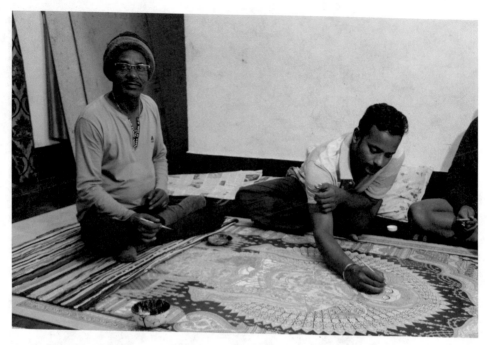

Ramesh Moharana and one of his sons working on *Hanuman*'s story, an order from a showroom in Raghurajpur, Puri, 2019

boundaries are slowly but surely extending, blending into neighboring hamlets as more producers and sellers of crafts are attracted by the continuous flow of visitors. An increasing number of showrooms on the way to the hamlet reflect the advantage of being the first stop when customers arrive.

Bent over a palm leaf while working on the floor of his unusually bright front room, an artisan named Siddhara shared his fatigue with me in 2019: "You know what the past was like, look at us now – we are like the Puri *pandits* [priests working for the *Jagannath* temple]. If everybody is businessmen, what will happen to us in the future? Raghurajpur will be nothing but a market." The same market has made it possible for his son to rebuild their house and install a double-pane sliding window, an addition that explains the amazing light. Listening to Siddhara, I was reminded of conversations I had in the late 1980s and early 1990s with painters who have passed, among them Siddhara's father-in-law, Jagannath. In 1991, he vividly described the drawback of living in a

A *jātri patti* made for pilgrims, 1991

well-known painter community: "As you know, our hamlet is famous.
Nowadays some of us have more money than previously, but we have
lost our peace. You can write that in your book."

The development would have been difficult to imagine in 1952,
when an American named Halina Zealey first came to Odisha because
of her husband's work. A chance meeting with a painter led Halina to
Raghurajpur, where only a few remaining artisans still made paintings
for pilgrims (*jātri pattis*) on recycled newspaper.[2] Even if she found the
quality of the work uneven, she was fascinated with the paintings and
kept returning to the village, paying generously to motivate what she
considered good-quality work.

Halina's encouragement has secured her a place in history as the savior of Odishi painting. Today, she is part of hamlet mythology. Some of the young painters claim that an increasing number of households can make a living as craft makers as a direct consequence of my work. As I passed through the hamlet one afternoon in 2016, I overheard an elderly man say to a youth, "Even if we wash her feet and then drink the water, we will still fall short – we owe her." My engagement, it seems, is also becoming part of local mythology. Is it our common foreign status, I wonder, which bestows on Halina Zealey's and my own involvement an importance in the revival of *patta chitra* that is undeserved? I do not know. What I do know is that myths are not fixed in place; they change over time. On my way out of the hamlet during a recent visit, a young woman I had never met before called to me from the veranda of her in-laws' house. "Are you Helli Zealey?" she asked. "I have heard so much about you." Halina and Helli are gradually merging into one.

Apart from intermediaries, Halina Zealey was one of the first of a long list of people who became involved with the villagers and their production of crafts. Outsiders have come and gone, serving different ends and interests, whether their own or the villagers'. Some of them play a role in *Painting Stories*. The web spun is centered on the hamlet but reaches far and wide, connecting the hamlet to other parts of the world.

Contemplating the changes, I have one remorse: the cutting down of the magnificent banyan tree that used to shelter the village-goddess and provide shade for the old men playing the traditional card game *ganjapā* to make way for a bright new temple. The goddess no longer has to make do with a small black stone at the foot of the banyan but now resides in a shiny statue, from where she offers *darshan* to those in need.

Today when I visit Raghurajpur, I am no longer able to see the hamlet as I once did. It is not only because things have changed. The main reason for my altered perception is that formal aesthetic experience has given way to intimate knowledge of the social life of the people and the crafts they produce. Where I once saw craft makers immersed in colorful production, today I see people who struggle to make a decent life for themselves and their families, some as producers, others as traders, but all in relentless competition driven by a merciless market.

STORY MATTERS

Based on my work with painters stretching over a period of more than thirty years, the stories in this book are a mix of life histories, reflections, and events that have shaped the lives of the painters as well as mine. Some of the stories have their basis in my own experiences with artisans over the years, while others are creative re-narrations of painters' own accounts of their lives. My choice of narrative form is guided by the specific ethnographic material and implicitly draws on pragmatist and phenomenologist traditions that perceive experience as grounded in the actual events of everyday life.

I have largely ordered the stories with an emphasis on chronology. However, story, content, and theme play a role too. Within the stories, I flash back and forth in time. Two of the interconnected stories that follow the lives of three main protagonists take place in the 1970s and break markedly from the overall chronology.

Like my previous writing,[3] the stories reflect events that have actually taken place, but I have changed certain facts to ensure anonymity. I have also included details that traditional ethnographic scholarship commonly forgoes out of commitment to scientific truth. These glimpses into the minds and internal monologues of others, however, are far from free invention. They are based on painters' narratives. I have taken this liberty because the stories, when presented this way, to my mind come closer to a truthful representation of painters' experiences. Of course, I will never know precisely what thoughts have tracked through someone else's head, but my rendering of events is a possible interpretation of a human experience.

In their unity, the stories paint a larger picture of life among craft makers in an Indian hamlet and of what painting means to them. Earning a livelihood – whether it stems from painting *patta chitras*, papier-mâché masks, figurines, or some combination of these crafts – is key. As the stories will show, however, there are other important reasons why the villagers paint. Religion, family, gender, ambition, and passion all play a role. The book, among other things, reflects my wish to see beyond my previous concern with the social world of *patta chitras*, one craft of many, to consider what painting means to painters, women as well as men. In that way, *Painting Stories* is a continuation of my work as an academic but it is also a turn toward a different kind of writing.

The stories convey everyday activities in a painters' community; apprentices gradually learning the art of *patta chitra* painting, a painter sculpting a deity for a religious ceremony, the commotion arising when potential customers pay a visit, or the influence on painters' lives by external actors in the form of customers, government officials, or art specialists. Rather than the everyday humdrum, however, the stories are often centered on dramatic events that, as abnormal as they might appear, are nothing but the ups and downs of village life. Twists and turns govern the lives of villagers. Like anybody else, they are subject to contingencies outside their influence or, as the painters say, "Fate." People live and die, some before their time. Some do well for a while but then experience a dramatic turn of fortune while others, after years of misery, are lucky enough to experience a life of relative ease – but who knows for how long? The villagers do not sit by passively waiting for their life to improve. Based on culturally rooted decisions and their place in a rapidly changing world, villagers act with resilience and creativity. Their choices often have consequences that could not be foreseen. As different as our lives might be, this is one aspect of living we have in common.

Three of the stories in this book pay tribute to female papier-mâché mask makers, their resourcefulness and resilience. Life is precarious, as the villagers know all too well. When shattered, one must pick up the pieces and go on. There is no other way. Women are not alone in facing difficulties. Men, too, carry the weight of the world on their shoulders. Skill and enterprise are rarely sufficient on their own to make a successful *patta chitra* painter. Some are able to put Instagram and WhatsApp to good use, and on rare occasions a painter is fortunate enough to be noticed by someone who can recognize skill and is powerful enough to make a difference. Far too many, however, struggle to make a livelihood. Among those are gifted men who are unable to invest the time it takes to paint a *patta chitra*. They turn to other crafts commonly made by women, such as papier-mâché birds and masks. These they can churn out in large enough numbers to feed their families. But just like the intricate rice paste designs painted by women on walls and floors in preparations for festivals, these crafts have no prestige and little economic value.

The stories focus on individual experiences of specific events and are, in this sense, unique. But they are also situated in a cultural environment and are steeped in social relations. As such, *Painting Stories* is a window into a part of our world and reminds us of our shared humanity. I hope the suggestive but open-ended stories will carry resonance.

A Foreign Bird

"*Paradeshi chadhei*." The words passed through the packed bus running between the capital, Bhubaneswar, and Puri. I was fighting my way down the aisle, asking whoever was in my way to move a bit to let me pass. I had heard the phrase the first time a few months earlier, but recently it had become impossible to move among strangers without hearing them whisper "*paradeshi chadhei*." By then, I had picked up sufficient Odia to know that it meant "foreign bird." At first I found it annoying, but when I realized that not only men but also young women took me for a "foreign bird" curiosity got the better of me. *Paradeshi Chadhei* turned out to be an Ollywood movie, a craze at the time, and I made a mental note to see it in the not-too-distant future.

It was the second time I had come to Odisha to stay in Raghurajpur, this time for a period of eighteen months. My vocabulary had gradually increased, and after six months I was able to string together simple sentences, much to the delight of whoever overheard my language struggles. Humans are social beings, and unless you are determined to separate yourself from the group you are with, you will gradually fit in, picking up phrases and unconsciously toning down some behaviors while developing other traits. For an anthropologist, it is to be expected – part of the trade, really.

When I mentioned *Paradeshi Chadhei* in the hamlet, many had heard of the film but hardly anyone had seen it. I suggested we see it together, and at a time when sources of entertainment were rare, the idea was

positively received. Assisted by some of the young boys, I invited all the villagers for an open-air film night in the hamlet. Siva, the nephew of Jagannath, borrowed a bicycle to rent the movie and hire a television in the local town a couple of kilometers from the hamlet. The trip back from town was nerve wracking. Positioned on a small, wheeled plat-form, the television and a transformer bounced up and down, threaten-ing to fall off wherever the road was uneven. Being a dirt road in rural India in the early 1990s, that was just about all the time. Children from the neighboring hamlets accompanied us with shouts of excitement in much the same way they would welcome the annual traveling circus. At the entrance of the hamlet, some of the youngest inhabitants met us and took charge, leading the procession to the platform next to the banyan tree that then sheltered the village-goddess.

Today, it is unlikely that our initiative would have caused such ex-citement. Televisions are now common, and many young people have smartphones. However, in 1991 there were only three televisions in the hamlet and no telephones. During winter, when the sun sets a little after 6 o'clock and it is pitch-black by 6:30, evenings could feel long indeed. "Timepass" was always most welcome, whether it was the yearly thirty-day-long practice and performance of the grand epic *Ramayana* or a heated argument among the ever-competing painters. Open-air cinema was a novel, exciting experience.

That night, the villagers came in little groups and found a place to sit somewhere on the ground. Bollywood films usually last several hours, and this locally produced film was no exception. The plot was simple: When a young Odia man returns from his studies in the United States with a foreign bride, his family is mortified, fearing the worst. Surely, nothing good can come from this union. The behavior of the young woman, however, lays those fears to rest. She speaks Odia, wears bangles and anklets with a delicate grace, and decorates her forehead and the parting of her hair with vermilion red to indicate her married status. Gradually, she wins the family over, one after another. She is consider-ate, pressing the legs of her in-laws when they are tired, and respectful, touching the feet of her father-in-law. The ultimate compliance, how-ever, takes place when she prostrates herself in front of Lord *Jagannath*, the all-important Hindu god in Odisha; she is finally accepted.

During the film, young and old commented loudly on the scenes:
"That is a beautiful sari."

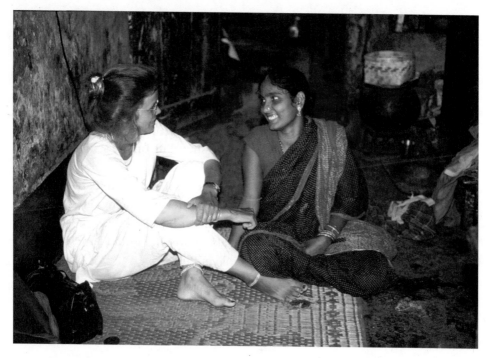

The author with Manju Mohapatra, 1991. Photo by Prasanta Mishra

"Oh see, she wears *sindura* [vermilion in her hair parting]."

"Tsk, that is how a daughter-in-law should behave."

A small boy cried excitedly: "Oh look, it is Helli *apā* [elder sister]," and soon several children were shouting: "Helli *apā* is in the movie, see, Helli *apā* is in the movie!"

I laughed but had to admit that the resemblance was striking; no wonder I was met by comments wherever I went. The children were hushed, and someone quietly explained that although the bride looked like Helli, she was someone else: "Helli is not a movie star; would she be here with us if she was?"

People came and went, only to turn up again a little later to keep track of the plot. In short, it was a success, stimulating reflection and, as it turned out, discussion. The next morning I dropped in to visit Manju, who lived a few houses down the lane from Jagannath's household, where I had stayed two years earlier. When, during my second stay, I decided to live outside the hamlet in Puri, it was always Manju

who was the first to offer a place to stay if it got too late to return home. Never mind that the family had only one bed. She shifted the children around, somehow made space for the five of us, and retired with her husband to the floor in the front room. Manju was good company, never hesitating to offer her opinion, whether I asked for it or not.

"She looked so nice in a sari, why don't you wear yours?"

"I feel more at ease wearing my *sālwar kameez* [loose trousers and long shirt]; you know how I roam around, traveling on the scooter …"

"You look nicer in a sari."

"That might be." I felt irritated, reminded of my unavoidable foreignness by the woman in the film. "No matter how many times she prostrates in front of *Jagannath*, she will never be allowed to enter the temple." In retrospect, I was speaking about myself. I would have loved to see the magnificent *Jagannath* temple in Puri.

"Of course not, she is foreign."

It was only in romantic melodramas that a change of clothing and appropriate behavior was sufficient to be fully accepted.

PASSING THROUGH

Young, inexperienced student, researcher, daughter, daughter-in-law, mother. A willing ear, a source of never-ending questions, the only woman to throw color participating in *Holi* games with young male villagers, the one who cried when her washing fell down in the mud during the monsoon, the one who knows everything about us. Villagers have experienced me in more roles than I care to remember. Over a span of thirty years, *Helli apā* has proved to be flexible enough for those who know me to accommodate them all, the suffix shifting depending on who addresses me – and when. Where children once addressed me as *apā* (elder sister), children and youths today who do not know me use *māusi* (mother's elder sister), reflecting relative age and serving as a not-so-subtle reminder that our lives are but a brief instant in the passage of time.

I know for sure that there is one role that villagers do not remember me in: that of customer and visitor passing through. To them, it was insignificant; after all, they saw, and continue to see, Indian and foreign visitors every day during the winter season. For me, however, it was an all-important event in my life, even if I did not know it at the time.

MOVING IN

I returned to the hamlet some weeks after my first brief visit in November 1988 to find a place to stay, accompanied by my co-researcher and translator, Seema. We planned to stay in the hamlet for three months and negotiated with the only person who could accommodate us. Jagannath Mohapatra lived in a thatched house with several rooms and an inner courtyard with a washroom and a water pump, an unusual luxury in the hamlet at the time. Behind the house were two latrines belonging to the household – the only ones in a hamlet of more than 500 people. He listened to our request and quickly made up his mind. We were welcome to stay. Although I did not realize it at the time, Jagannath *mausā* (mother's sister's husband), as I was to call him, could see an advantage in having us. Highly skilled, both as a painter and an opportunist, he had plans for me. We got a room at one end of the house, close to the studio where all his apprentices slept at night. At the time, there were eight apprentices living with him apart from his family, which consisted of his wife and his brother's family. Adding the two of us, it was a total of sixteen people. Now and then, one of *mausā*'s three married daughters paid a visit with her children in tow. To withdraw and be on my own was not an option, but what was the need? As Sobha, Jagannath's niece and the closest family member to me in age, told me, "No one wants to be left alone."

The learning curve was steep the first month of my stay. Learning about the world of paintings was one thing. I had more difficulties with the social norms of behavior, many of which were never explicitly described to me. After all, they are obvious – unless, of course, you happen to be an outsider. It was the women who took it upon themselves to work some sense into me. Sobha in particular took pains to guide me when I blundered, which, in the early days, was nearly all the time.

It was relatively cool when we first arrived, so I decided to wear my *sālwar kameez* two days at a stretch to save some washing. As it turned out, this was not a good idea. I had just come out from my bath, dressed and, I thought, ready for the day.

"You wore that yesterday."

"Yes, it was cool yesterday."

"It's dirty."

"It's not dirty, I did not sweat at all."

"You wore it yesterday. It's dirty."

"I see no dirt at all, do you?"

"You can't wear your clothes for two days without washing them. It is not done."

There was no way around it; I had to change, and the sooner the better if I did not want to be the laughingstock of the entire hamlet. People who owned only one set of clothing washed it in the river every morning and then got into their wet clothes. And here I was with two perfectly good sets of clothes, insisting on reusing my dirty garments. Twenty-three years old and behaving like a child. Some days later, the ever-observant Sobha asked me whether I had a bad stomach. Being Danish I felt deeply embarrassed by this reference to my bowel movements, which I (though apparently no one else) considered my private business.

"What is the matter with you?"

"What do you mean?"

"Ever since you came you have been going to the latrine all the time."

"What are you saying? I drink a lot of water, of course I have to go."

"Water does not make you go to the latrine. Is our food not good?"

"Of course water makes you go to the latrine."

"Number one perhaps, not number two."

Not number two … I was confused. How did she know what I did and did not do when using the latrine? It was simple really. If going for a pee, one brings a small pot of water, otherwise a bucketful is necessary. I had taken the bucket every time I went to the outhouse, causing my hosts to discuss among themselves what was wrong with me. There were other blunders too, such as when I unknowingly polluted food under preparation for the deities. But my hosts were patient, and I gradually learned to behave like a decent human being.

Although the women did their best to make me conform, decorating my feet with red *olatā* or offering me advice about clothing, nail polish, and jewelry, they nevertheless accepted that I moved around as I pleased, spoke to men and women alike, and dressed up or down as I saw fit, generally sticking to my *sālwar kameez* and only on rare occasions making use of my sari. My position was in stark contrast to the recently married young women whose every move in the hamlet was monitored by their mothers-in-law. The freedom I enjoyed in terms of movement

and choice of company or clothes was a consequence of my position as an outsider – a foreign bird.

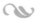

Work began early in the household. After their morning tea, the boys returned to the studio where they had slept, one after the other. Tophan, Jagannath's oldest apprentice, or Jagannath's nephew, Siva, set them to work. While the youngest ones began drawing outlines of fish or hens on their black boards, the older ones picked up where they had left off the day before. Among other things, the size of a painting gave a hint about the degree of skill of specific apprentices. The boys working on canvasses the size of a small paperback usually still had a lot to learn, particularly when it came to getting the pose or the proportions right. As they improved their skills, they advanced to larger canvasses, first assisting an older apprentice or their guru and then gradually getting more responsibility until one day they were allowed to paint larger paintings on their own ... or almost on their own. Frequently, their guru decided the composition, proportions, and pose, penciling a sketch on the canvas. Only apprentices in the final part of their apprenticeship made their own sketches and completed their paintings with the final black lines, which give the deities their characteristic black outline and are a clear indication of the skill of a painter.

The dry, cool days of winter were particularly well suited for preparing the canvas. On a regular basis, Jagannath's wife, Tikina, worked away on the floor of the central courtyard. It was a cumbersome task in which two, occasionally three or four, layers of cotton from thin-worn saris, *lungis*, and *dhotis* were smeared with glue made from tamarind paste, left to dry, and then smeared with a grayish mix of glue and chalk. When dry, Tikina placed the canvas in front of her to smoothen the surface with first one grinding stone, then another smoother one. Up and down the canvas, back and forth, Tikina repeated the task even when her strong arms got weary and her back gave her trouble.[4] She, for one, did not regret that hardly anyone used the traditional colors these days. Grinding colors from conch shell and stone used to be yet another task reserved for female *chitrakāras* (makers of pictures). When completely smooth and soft enough to be rolled up, Tikina passed the

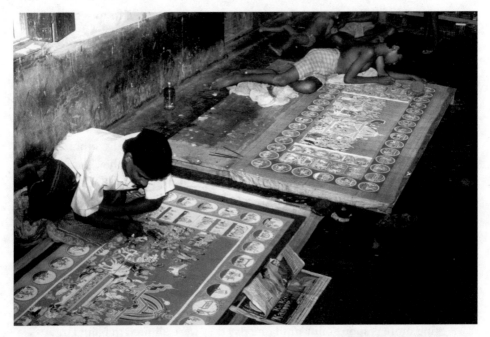

Apprentices working on *patta chitras* with a linear presentation of illustrations, 1992

canvas to her husband. He then trimmed the edges and cut the canvas into suitable sizes, ensuring that nothing was wasted.

During the early days of my stay, I found the paintings and their numerous illustrations overwhelming. The traditional iconic representation of the *Jagannath* temple was one thing, but even the contemporary popular cartoonlike format required knowledge of mythology. Well-known scenes from *Krishna lila* or *Ramayana*, such as *Krishna* stealing butter or *Rama* slaying a demon, surrounded a central motif. It took a while, including focused reading of *Ramayana* and selected *puranas* (Sanskrit texts) and careful guidance by Prasanta, my friend and research assistant, and Tophan, before I possessed the necessary visual skills to be able to decipher the paintings. It was my luck that they were both patient. With a smile that reached his eyes, Tophan explained what to look for – weapons, mounts, and colors indicating specific deities – enabling me to see, rather than look at, the paintings. Gradually, their assistance turned me into something akin to an expert, a skill that

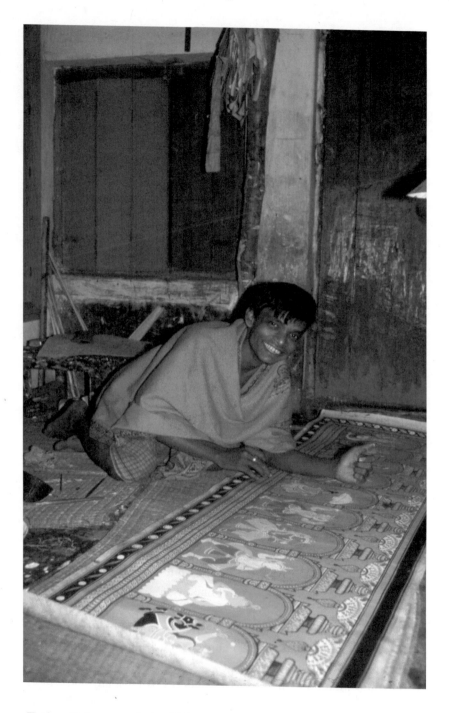

Tophan Moharana painting *Vishnu*'s ten avatars, 1988

proved handy when tourists came to the household. I was finally able
to make myself useful by explaining the various images. Tophan and
Prasanta, however, were not the only ones who took it upon themselves
to open my eyes.

Jagannath spent hours explaining motifs, mythology, and his par-
ticular role in the development of *patta chitra*. He was generous with
his time, not least when our conversation turned to mythology. To hear
Jagannath describe how the milkmaid Manika offered *Jagannath* and
his brother *Balabhadra dahi* (yoghurt) on their way to Kanchi was to be
transferred to another age and realm, one populated by former *rajahs*
interacting with deities and demons. Jagannath was a gifted storyteller.
He captivated both young and old with his dramatic stories and con-
crete details that anchored the adventures of deities and let them be
played out in the mind's eye. Light-skinned *Balabhadra* riding on his
black horse followed by his dark-skinned younger brother *Jagannath* on
his white horse. Their meeting with Manika, who balanced an earthen
pot of *dahi* on her head and graciously accepted *Balabhadra*'s ring in
lieu of money. The scene was still popular at the time and was one of
the few I recognized from the art historian Mildred Archers' remark-
ably varied collection of Indian popular prints at the India Office Li-
brary in London.

I had read what was available about Odishi paintings and crafts, and
Jagannath and I exchanged views of existing texts. One such text was
Puri Paintings. Jagannath kept a copy of the book together with a pre-
cious collection of sketches and texts in a cupboard he always made
sure to lock at night. One day, he brought out the book for us to see.

"This book tells you everything you need to know about *patta chitra*.
How Halina Zealey came and made us take up our tradition again."

"I know the book, I have read it."

"Look how thick this book is." Jagannath held up the book and indi-
cated the size of the book with two fingers.

"Yes, I see it."

"Jagannath Das paid many visits during a period of only six weeks to
write this book. But you live here and for much longer; imagine how
thick your book will be!"

That was what he wanted from me, a book. Not just any book, but a
book that would bolster his reputation as an awarded master of his craft,
a guru who had played a key role in the development of *patta chitra*. I

am not sure exactly how I responded at the time, but I remember feeling overwhelmed; after all, I was just a third-year bachelor student.

MOVING OUT

My first stay in the hamlet left a deep impression. It also engendered questions concerning the quality of painting, questions I had not explored before. I decided to pursue distinct notions of quality in *patta chitra* for my PhD and moved back to the hamlet in 1991, two and a half years after my first stay. I realized soon after my arrival, however, that asking questions about the evaluation of paintings did not make me any wiser about the painters' notions of quality. It was not that they were unwilling to talk – far from it – but their answers were vague, most commonly ending with a hesitant "this is our tradition." After a frustrating period, I decided to learn how to paint.[5] Although I never got very far as a painter myself – it takes six years to become an accomplished *patta chitra* painter – my efforts still paid off. Painters began to comment on my work and let me into their art world. I have always regretted that I do not have what painters refer to as "a good hand." Practice can make a difference; most people can learn the skill of traditional painting if they set their minds to it. However, they might never accomplish more than just that. Learning a skill is not the same as becoming a master. At the time, it was consoling that I was not alone. Not everybody in a painters' community has "good hands," and only a few are truly gifted.

Gifted or not, I watched them painting stories of *Vishnu*'s life in his forms as *Krishna* or *Rama* and key events that have shaped the avatars' existence. A story needs a beginning, and many painters began with the birth of their favorite deities in the top left corner and continued through the different life stages with more or less detail, all depending on the size of the painting and their or their customer's preferences. Some paintings, however, represented but a glimpse of the mythology. Although a single image can stand on its own, it is part of a larger context and acquires meaning through its connection to mythology.

When preparing for my second fieldwork, a member of the faculty strongly advised me to ensure independence by staying on my own, and being young and insecure I followed his advice. Instead of staying in my former well-run household, I rented an old broken house and

settled in. Though I realized little at the time, I must have added more than a few gray hairs to the elders of the hamlet. A young woman living on her own, what was I thinking? The reputation of the hamlet was at stake; I was their responsibility. Lingaraj's father, Mukunda, made sure I could bolt my door at night and stressed more than once that I must never go to sleep without making sure my door was securely locked. Mukunda also negotiated with my neighbor, and the two of them ran a cable between the terraced houses, providing me with a single source of light in the only room with a functioning roof. I stayed there for six weeks during the monsoon, experiencing the all-too-common colds and fevers of the season. After six weeks of ill health, moldy clothes, and feeling lonely, I had enough and moved out of the hamlet to stay in a household in Puri. It must have been a relief to see me go – a burden lifted from the shoulders of the old men. It turned out to be a good decision workwise as well. Free to involve myself with painters in Puri and Bhubaneswar, my network of craft makers developed rapidly, and my investment in a moped, a red Hero Puch, paid off. The expanded network provided a new perspective on life and craft production in the hamlet.

Moving out meant new practical arrangements involving families in the hamlet. I had a standing invitation to eat lunch in Lingaraj's home and often did so. During my first stay, twenty-eight-year-old Lingaraj was the first in the hamlet who decided to eat with me. When Mina, Lingaraj's young wife, brought two *thālis* for Prasanta and me, Lingaraj sat down next to me. That Lingaraj was the first to eat with me, and thus break with social norms regarding commensality, did not come as a surprise. He had spent time with different kinds of people during his years in the capital pursuing a course at the handicraft-training center and later when participating in exhibitions and fairs held across the country to trade in paintings.

"At the fairs, we all line up to get our food and then quickly find a seat somewhere to eat. Do I know who is who?"

"I guess not."

"Right. I don't. Do I ask?" Lingaraj asked rhetorically and answered himself before I had time to say anything. "No. One eats, that is how it is in the cities."

During the early weeks of my first stay in the hamlet, I had been pleased that so many villagers invited me to eat in their homes; I felt

they had been gradually accepting me. It took a while before I under-stood that the majority were happy to serve but would never eat with me. It was Jagannath, my host, who kindly explained to me that it was because of my caste. The majority of villagers feared the social sanc-tions that might follow if it became known that they had eaten with someone belonging to a community of Christians. I had not grown up with the social sanctions of caste – sanctions that continued more than thirty years after the caste system had been abolished. Still, I felt humil-iated when I realized that things were not what I thought them to be. Social exclusion hurts. To say that Lingaraj's act meant a lot to me at the time is an understatement.

Lingaraj was as quick to adjust, as he was smart when it came to his trade. During his years in the capital, he realized what it takes to become a truly good *patta chitra* painter. He also saw that even the best painters could never be certain to earn a decent living. Competition was stiff and, if not well connected, it was a continuous struggle to make a living, even for the best of painters. To be smart and willing to work and travel, however, is no guarantee for success, particularly not if one happens to be born in a community of traditional painters.

Lunch was one thing that needed planning because of my new living arrangement. Breaks during long working days also had to be decided. When staying in Jagannath's household, Seema and I would always go home to sit in the interior veranda for a little time in relative peace. This was different now that I did not live in the hamlet. Sula and her family, who lived across the lane from Jagannath, however, provided me with a safe haven. Making their living primarily from painting masks and the occasional ritual painting tasks for Brahmin patrons, they owned very little but always shared whatever they had with me, including their stories and hopes for the future. In the common courtyard where they and their neighbors were at work from morning until nightfall, I always felt welcome. And just like Manju, Sula did not hesitate to tell me what she thought.

"It's so hot; it feels like my head is boiling."

"This is our life, you know; when your work is done, you go home. Your country is cold right? But we have to stay on, as hot as it might be."

Sula was right, obviously. Who was I to complain? Nobody had asked me to come, and here I was, being peevish about the relentless heat while painters struggled to make ends meet.

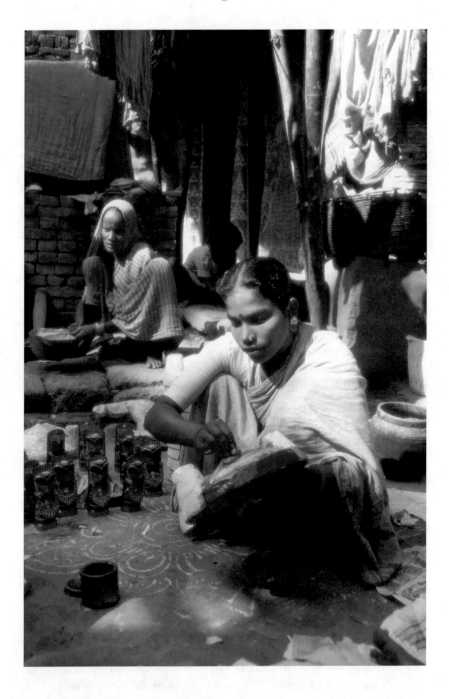

Sula Moharana painting a papier-mâché mask, 1991

"I am sorry Sula, what you say is true. I have no right to complain ..."
Tilting her head ever so slightly, Sula acknowledged my words while
continuing her work. Next to her lay a number of masks, some of which
were still not quite dry. It was the kind of work that goes unnoticed.
Women's work, unless a man has no alternative: day after day, one mask
after the other. Two stacks of masks, one placed on top of the other,
stood in the corner of the courtyard waiting to be painted. Another
stack of masks decorated with bright colors – red, yellow, blue, and
black – stood next to the passage. Tomorrow, perhaps, Sula's father
would wrap them in a piece of cloth, sling the bundle over his shoulder,
and walk along the river to the bus stand to reach the bazaar in front
of the temple in Puri.

While we sat there, a young woman, Mera, from a neighboring
house dropped in to chat with Sula and joined in her painting. I knew
her family had been negotiating her marriage for months. Whenever
Mera's father thought the parties had finally reached an agreement,
the groom's family added to the already long list of things they wanted
as part of the dowry. I was curious to know whether any progress had
been made, and before Mera even had time to sit, I blurted out, "Mera,
has your father returned from his talk with the family?" Hearing my
reference to her father's negotiations, Mera blushed but replied with a
barely audible no. I should have known better. I was probably not the
only one who wondered what news he might bring today, but I was for
sure the only one who was foolish enough to bring it up. First selfish,
then a cause of embarrassment. Just as well, I was with people I had
known a long time. Our conversation drifted back and forth, broken by
long passages of silence, a silence that felt comforting in the company
of people with whom I was at ease. Sula and her mother worked on
their masks, Mera kept them company, and I contributed to their small
talk the best I could, jotting down field notes in between.

SPECTATOR BIRD

Twenty-six years after my discussion with Manju about my choice of
dress, her daughter Lina gave us an opportunity to pick up on our
conversation from all those years earlier. I was surprised to hear Lina
mention the movie *Paradeshi Chadhei*. Given the number of films

released by the Indian film industry every year, I did not expect that the younger generation would remember or indeed know of this particular melodrama.

"Did you see the film, Lina?"

"Yes, of course, it is good. We should see it together."

"Helli has seen it already."

"Your mother is right. We saw it once in the hamlet many years ago."

"I know, I was there too. Don't you remember?"

Yes, she was right. She was but a little girl at the time and not old enough to understand the underlying message of the film. Now, however, a married woman with children of her own, it was different. Lina and Manju talked about the film. For a while, I just sat listening, but when Manju said to Lina that all daughters-in-law ought to see the film, I had to join in.

"Are you serious? Why should they see the film?"

"All daughters and daughters-in-law should learn from her; that is why the movie was made. Odisha daughters-in-law are not doing their 'service duty' for their in-laws, but a foreign girl comes and steals their hearts, showing them respect."

"But Manju, surely … just before, you said times are changing. You are changing too, maybe it's time to stop these …"

"Things must change. If our ways do not change, there will be trouble," she agreed. "But … *we* used to show respect. These days, however, we cannot chide our daughters-in-law if they don't show respect. They ought to obey their in-laws."

"If I bowed down to touch the feet of my father-in-law, he would be upset. He would not like it one bit."

"Helli, your family is of one kind. Here it is different. We are not city people."

We looked alike, the character in the film and I, both of western origin and with the same color of hair, even our bodily proportions were more or less alike. We shared one more aspect in our common role as foreign birds. Both of us had chosen to marry men from the subcontinent, though my husband hailed from Kerala, not Odisha. Apart from that, our lives could not have been more different. The character in the movie pleased her in-laws by choosing to conform and live as a traditional, obedient Indian daughter-in-law. My in-laws, on the other hand, never had much patience with conformity and have always encouraged

my work and a life of shifting engagements. What makes for a happier life? It all depends. The point, to my mind, however, is not who chose more wisely but that both of us had a choice.

Where "foreign bird" once, in a different stage of life, made me flinch, I find it today an apt metaphor for the life of a young anthropologist doing long-term fieldwork. Later in life, when fieldwork must be fit in the best one can between various other obligations, it appears less appropriate. At this stage of life I find myself in, to be an anthropologist is more to be an observer of life, a spectator bird that lands on a perch at regular intervals, stays just long enough to immerse, but always takes off in a continuous movement between immersion and reflection on experience, back and forth between places and lifeworlds, settling in and taking off just like migratory birds. Although the painters would never refer to me as a foreigner, I am not one of them and shall never be. I have a place in their world as Helli, that is all. But for that, I shall always be grateful.

The Sketchbook[6]

"It's all in Jagannath's book; just ask him, he knows everything."

As so often before, a painter referred me to my former host, Jagannath, and his book whenever my questions about the mythology of paintings went beyond basic knowledge. Everybody knew about *grantha*, "the big one," Jagannath's self-made collection of sketches of deities and texts describing their particular appearance. At its core, it might have only been a locally produced notebook, but nevertheless it was an awe-inspiring volume of a size that required careful handling, a privilege granted to only select members of Jagannath's household. Jagannath himself could not stand with *grantha* in his hands for long, even if he had wanted to. *Grantha* forced him to sit before he could start turning its pages, one thick off-white page at a time. Jagannath kept his precious book locked up in the studio with *Puri Paintings*, another valued book of his, and a stock of small paintings, the key safely secured in a knotted corner of his *gāmuchhā* (loincloth).

It was not only its owner who bestowed the book with value. Others held a reverence for *grantha*, although not necessarily of the same kind. After the death of Jagannath, rumors circulated about its possible whereabouts. My inquiries since then have generally been met with guesses. "His son-in-law perhaps, ask him," or, "Yes, his son in-law, it must be he who has it." The son-in-law, however, does not have the book. He last saw it with Jagannath's nephew, who is now dead. At the height of its time, *grantha* served many functions, the majority of which

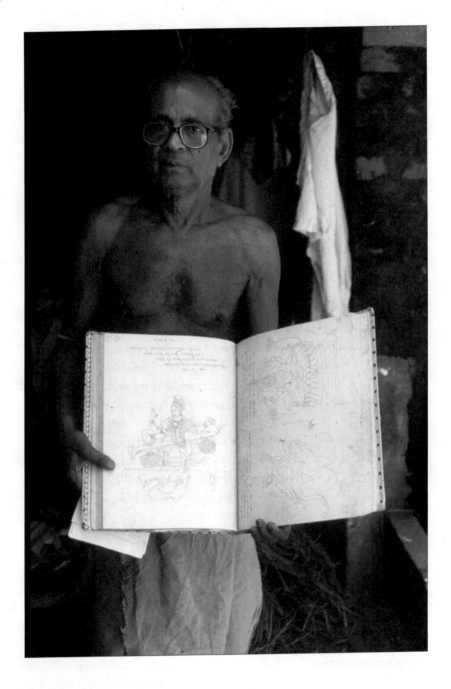

Jagannath Mohapatra with his sketchbook, 1991

revealed themselves in everyday use. The book's key purpose, however, was a well-kept secret.

The youngest apprentices sat bent over their work behind low-sloped desks when three visitors entered the studio one afternoon in 1989. Jagannath was instructing Tophan but quickly turned his attention to the guests. He had seen enough customers in his life to judge the potential scale of transaction they represented. These people, he saw at a glance, had come with a purpose. Jeans and silver glasses, a peacock green sari with gold borders, and tassar silk *kurtā pyjāmā*. Bengalis, well fed ... fat. Shielded behind his silver glasses, the young man assumed an air of indifference, but his parents conveyed a keen interest. The husband asked to see their stock, a request Jagannath followed up with a gesture to Tophan. His apprentice quickly untied some large rolls of paintings from their place under the ceiling, unfurled them carefully in front of the guests, and added to the display a stack of smaller works from their place in the cupboard.

The visitors hardly looked at the small paintings but showed interest in the large, expensive ones and a medium-sized painting of *Saraswati*, the goddess of learning and eloquence. Jagannath had been right. With some luck, money might change hands. Speaking to her husband in Bengali, the woman commented on the objects in *Saraswati*'s hands. Jagannath, who was listening attentively, understood enough to act on what he heard. He asked Tophan to find his glasses while he retrieved *grantha* from among the piles of paintings in the cupboard.

Without acknowledging Tophan, who handed Jagannath his black-framed glasses, Jagannath balanced the pair on his nose, forgetting to adjust for the broken arm of the frame in his fixation with the book. Sitting cross-legged on the woven floor mat, he leant forward, his crooked glasses balancing precariously on his nose, with the book reposed securely between his knobby knees and stomach.

When Jagannath opened *grantha*, the goddess *Durga* in her mighty form appeared on the double page, intricate weapons carefully depicted in her ten hands. He slowly turned a few pages until he found what he was looking for. "*Saraswati*," he said, pointing at the relevant

aspects of the sketch as he talked, "must be painted with her *veena* [a string instrument] and a book. That is our tradition."

Grantha always came in handy if customers questioned a particular form of a deity. Armed with the book and wearing his black-framed glasses, Jagannath spoke with authority, his shrunken body and worn-out *gāmuchhā* of no importance. The book, of course, did not work wonders on its own. Jagannath was a master of his craft with several accolades to his name. Both the awards and the book contributed to establish Jagannath as a man of renown.

"Look here," he continued, "we make paintings according to the *slokas* [Sanskrit verse]." The visitors acknowledged his words, glancing briefly at the sketch, but there was too much going on for them to read the accompanying *slokas* describing the deity. They had come to buy from a renowned painter and had no reason to doubt his knowledge of *slokas* or craftsmanship. The process of haggling could then begin.

"What is this? What does *Krishna* look like? How will anyone know it is *Krishna* if he does not carry his flute?"

Jagannath was scrutinizing a central motif from the *Krishna lila* made by two of his older apprentices. The apprentices listened quietly, looking with stern concentration at their work to avoid the judgmental gaze of their guru. A silly mistake, really. They had been working too long with their master to commit a mistake like this. However, they had been working quickly on a tight deadline. To add insult to injury, Jagannath asked one of the younger apprentices to get *grantha* from the cupboard and told the older pair to look carefully as he went through the different sketches of *Krishna*. "See, this is how you depict *Krishna*, always with something that tells us who he is, his flute, butter, or *gopis* ... Something must be there." The younger apprentices pricked up their ears but, wisely, did not look at the two their guru was chastising.

The sketchbook came in handy in 1992 when Jagannath secured a close relative a temporary job in one of the grand hotels at the beach. The young man, who had only recently acquainted himself with painting, was to perform as a supposedly skilled artisan in the lobby. Jagannath made a number of carbon copies of popular sketches found in

grantha while addressing his relative: "See, if you transpose these to the canvas, you will get the pose and proportions right." This particular way of using the book, however, was unusual. Normally no one was allowed to copy Jagannath's sketches.

Painters from the hamlet or the neighboring hamlets might pay Jagannath a visit to get advice on how best to depict one of the numerous forms of a deity. Although they knew the deities, they did not necessarily recall what specific item a deity should hold on any given occasion. As one of them told me, "the book has everything about the color necessary, the weapons needed for the hands and other things too. If a painting is done according to the *sloka* then it is thought to be worthy of god. Whatever we do, whether dresses, body color, or weapons, it should be right. The rule is that paintings should be made according to the *sloka*." Jagannath knew various forms of countless deities off the top of his head but sure took his own sweet time when answering. He would pull out *grantha*, sit down while the villager would stand next to him waiting, and begin looking for the relevant sketch. Having found the right image, he would pour over the text, recite the appearance of the deity in this particular form, explain what it meant in plain language, and round out his performance by carefully closing *grantha* and returning it to its place in the cupboard.

Grantha was, of course, brought out whenever government officials showed up in the studio, whether they came from one of the government institutions that develop or sell crafts. While they explained the purpose of their visit, Jagannath's niece served tea and *tiffin*, and, without fail, Jagannath would find a reason to draw out *grantha*. Always one to recognize an opportunity, he would begin to speak of his contribution to the revival of *patta chitra* painting and, no less important, his tireless effort to teach a new generation of painters and, thus, safeguard the tradition: "The hamlet would not be what it is if not for my effort. Like Durga, who was able to kill the demon drawing on the strength and weapons of the deities, I succeeded in making the hamlet famous only because I had the support and encouragement of the villagers. I tried to help the villagers as much as possible and later became famous at the national level." Nodding approvingly at first and later nodding off, the officials sat listening to Jagannath's elucidation of his merits. The book lay open, nested in its usual place, and that was sufficient to serve its purpose for this particular group of visitors.

A few visitors were genuinely interested in the actual content of the book – not least some of the researchers who came to inquire about the traditional craft. Personally, I spent hours in 1991 carefully scrutinizing the sketches, their proportions and forms. Jagannath enjoyed the opportunity to show his sketches of the most popular deities, whether from the *puranas* or the epics, the *Ramayana* and more rarely the *Mahabharata*. After all, the Sanskrit *slokas* that described the deities in different forms and accompanied his sketches testified to Jagannath's commitment to tradition. In *Puri Paintings,* Das indirectly refers to Jagannath's sketchbook in his discussion of existing notebooks. Given the common concern among art specialists with safeguarding the traditional characteristics of the craft, this interest is hardly surprising.[7]

The afternoon had begun like so many others. Apprentices were working on a large order, Jagannath was preparing a dish for lunch, and Prasanta and I were hanging around. Jagannath enjoyed cooking but only when he did not have more pressing responsibilities. This was a good opportunity to approach him to hear more about *grantha.* Three years had passed since I first became acquainted with the book in December 1988, and I still did not fully understand its secrets.

"*Mausā,* why did you decide to make *grantha?*"

Looking up from the pot he was stirring Jagannath hesitated: "It's a long story."

"Oh, how nice, I like stories."

"Yes, I have noticed that." Jagannath sat back on his haunches, leaving the simmering pot to its own. He was quiet for a while, perhaps wondering where to begin.

"In 1965 I was awarded the national award by the president Sarvepalli Radhakrishnan."

I wondered whether Jagannath had heard my question. What did the national award have to do with *grantha?* Often enough he had told me about this award, why mention it again?

"I became famous, but I felt ashamed."

"Ashamed?"

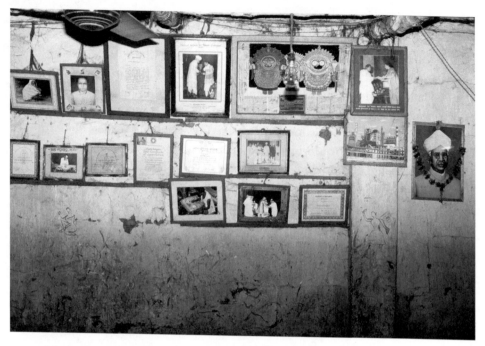

Display of awards and a picture in commemoration of President Dr. Sarvepalli
Radhakrishnan, 1991

"It was an honor … at least that is what people thought. But I was too
ashamed to feel honored."

I could not make heads or tails of this. Why would anyone receiving
a national award from the president of India feel ashamed? The cere-
mony was an official acknowledgment of Jagannath's skills. What more
could an artisan want? Jagannath continued his explanation.

"You remember what I told you about Halina Zealey?"

I had heard about Zealey's role in reviving *patta chitra* more than a
few times and braced myself for yet another account.

"Zealey preferred fine brushstrokes. She hardly looked at the *jātri
pattis* made for her benefit."

"The paintings made for pilgrims with broad, swift brushstrokes? I
rather like them."

"You might like them. She was not impressed. She wanted us to im-
prove our skills and paid more for finely executed paintings. She even
organized small competitions!"

"I know. You won one of them."

"I did, just before she left. Halina changed my fortune."

At the time, Jagannath was based in Cuttack where he worked as a mason and leader of religious plays, but he decided to take up the challenge and spend whatever time he had working on an entry. His efforts paid off. Jagannath surpassed the other competitors with his finely executed depiction of *Ganesh*, the elephant-headed god in his five-headed form, which today is part of the Zealey collection at the Museum of Mankind, London. He never returned to his masonry work in town, deciding to commit himself full time to painting.

As knowledge of his accomplishment spread, families began approaching him, offering their sons as potential apprentices. He accepted first one, then another, gradually transforming his home into a *guru kula āshrama*, thus ensuring a lasting influence on the craft of *patta chitra*.

When Jagannath received the national award in 1965, he became the first *patta chitra* painter to ever earn official recognition for his contributions to India's national heritage. Although he had already built himself a reputation at the time, this was different. He suddenly found himself the center of attention of government officials and specialists on arts and crafts. Listening to their questions and exchanges, Jagannath realized their profound interest in the connection between traditional crafts, myth, and ancient religious texts in Sanskrit. Like many other people of his particular community, Jagannath could paint the deities, and compared to them his knowledge of mythology was vast. But he did not know the old Sanskrit scriptures and could not read them. Could he live up to their expectations? The uncertainty left him deeply uneasy. Just imagine if they found out about his unfamiliarity with Sanskrit *slokas*! They might think him an imposter. Being a man of action, Jagannath decided to do something about his apparent lack of knowledge.

"Because I felt ashamed when receiving the award, I was obliged to collect various texts from many places. Just as astrologers look at almanacs to explain certain events to people, I have my book with *shastras*

[sacred writings of Hinduism]. There are many things in this world; I have collected a few of them. They are all in *grantha*."

"So this is the reason you decided to make *grantha*? To add to your knowledge of paintings?"

"Yes, when it is needed the book is brought out from the cupboard."

Grantha was out and Jagannath was about to return it to its place in the cupboard when I saw my chance to follow up on the curiosities of the book.

"*Mausā*, could we go through some of the sketches in *grantha* together?"

"What would you like to see?"

"Well, why not start with *Saraswatī*? She is my favorite."

Jagannath leafed his way to *Saraswati* and looked up: "What about it?"

"Read the text written next to the sketch."

Jagannath looked at me with an expression I could not decipher. He then began reading, stumbling through the text written in a random mix of Sanskrit and Odia. Searching for words with which he was familiar, Jagannath described the appearance of *Saraswati*, gradually relying more and more on his knowledge of mythology. As he let go of the written text, his posture changed, as did the way he looked at me. After Jagannath had finished telling me about *Saraswati*, we turned our attention to *Hanuman*, the monkey god and army commander devoted to lord *Rama*. The *sloka* next to *Hanuman* caused him even more difficulties when reading it aloud, not to mention when explaining the content of the text. Jagannath chose to disregard the text entirely, opting instead to speak of *Hanuman* from memory.

"*Mausā*, who wrote these texts?"

"A Brahmin from Janakadeipur village."

"*Mausā*, are some of these texts difficult to understand?"

"Yes, there are difficult *slokas*. One can only understand after thinking about it a lot. We who have experience must use our knowledge to make up for the fact that something is incomprehensible."

Incomprehensible indeed. A majority of the textual fragments in the *grantha* were incomprehensible, not only to villagers but also to the

owner of the book. The sketchbook was made to bolster his already con-
siderable knowledge of traditional painting and live up to the expec-
tations of art specialists whose interests and priorities have profound
effects on the lives of craft makers. What was it then, this sketchbook?
A bridge between the world of artisans and that of government officials
and art specialists? Or perhaps a caricature of the demands of distant
people with the power to change the fortunes of painters? We will never
know. One thing is certain, however: it was never Jagannath's intention
to use the textual fragments as texts to be read and understood. Care-
fully written next to his sketches, the *slokas* functioned as signifiers of
his depth of knowledge and thus contributed to secure his hard-earned
status as a master of his craft among fellow painters, tourists, art special-
ists, and researchers alike.

A Ladies' Bicycle[8]

It was bright red, the color of *sindura,* the vermilion powder used by married women along the parting of their hair. I brought the bicycle from the capital to the hamlet by train. Not that it was absolutely necessary. I could have taken a bus on my weekly visit to Puri, one of India's major pilgrimage centers. And when Seema, my research assistant, and I wanted to talk to painters living in one of the neighboring hamlets, we always walked.

I guess it was equal parts the promise of freedom and the need for exercise that, in December 1988, made me spend more than 1,100 rupees (then approximately $60) on the bicycle. The weekly 12-kilometer ride to Puri along the Dhaudia River certainly felt liberating after days of sitting, interrupted only by short walks between households and an occasional visit to a nearby hamlet. I found great joy riding around what was then a small town – on my own, with no one to tell me what to do and how.

The bicycle was a valuable asset, less expensive than a cow of course, but just like the few cows owned by farmers in the hamlet, the bicycle had to be dragged up several stairs to be kept safe behind bolted doors at night. Soon it became second nature to bring the bicycle onto the veranda and continue through the narrow passage leading to the courtyard and to the room that Jagannath had reserved for Seema and me. The room already contained a big wooden bed and a small desk, leaving little space for us, never mind a bicycle. So it was kept securely

locked just outside our room, on the interior veranda surrounding the courtyard.

The bicycle presented one of few opportunities to break with my usual social position as the ever-enduring "recipient." Not a day went by without someone tracking me down to ask for the key. Usually, it was one of the apprentices from our household, Tophan or Jagannath's nephew Siva, needing to make a run when colors were in short supply. Occasionally it was one of the other villagers in need of groceries or utensils available in the nearby small town. As the weeks went by, however, it was increasingly only Siva who asked to borrow the bicycle. He began wondering about my intentions and plans for the future, not only curious but also shrewdly hopeful.

"Who will have the cycle when you go back to America?"

"I will not go to America; you know that I am not American."

My answers were, at best, vague. I naively thought he might drop the issue even if I did not make it clear that he was not a likely candidate. Although I did not realize it at the time, Siva gradually laid claim to the bicycle. He was not the only one who would like to have the bicycle after my departure, but unlike the rest, his quest was explicit, gradually evolving into what appeared at the time to be an obsession. It was not as if he desperately needed a bicycle. More than I did, of course, but less than many other villagers. His household already had one bicycle, which really belonged to Jagannath. No one dared ask to borrow that bicycle, though Jagannath would often request a boy take it on an errand. It was a favor to be granted.

Had my bicycle been black, like the majority of bicycles at the time, it would have been no less desirable. Only a few men in the hamlet owned bicycles, and these were rarely left to rest. If not used by the owner, their male relatives, or friends for a visit to the local bazaar, their young sons would practice the art of cycling. A tiny body resting against the top tube, one arm reaching across to the handlebar, a leg stuck through the frame to reach the pedal, and a trail of children in close pursuit, the boys eager for a turn on the bicycle. Up the narrow lane running in front of the houses, around the banyan tree and the old men playing *ganjapā* in the shade, and back again through the hamlet and down toward the river.

The riverbank was our destination in the early afternoon just after lunch, when many villagers were having a rest. Otherwise a sanctuary

of peace, it became our playground, a place to practice cycling. Tophan, Seema, and I walked through the hamlet, Seema pulling the cycle along. Tophan did offer to take it, but Seema insisted, towing it herself to get familiar with the feel of the bike before actually trying to ride it. I imagine she thought holding the bicycle would give her a hint of confidence once riding. Our procession down toward the river was noticed by the villagers who had skipped their afternoon rest in order to work on their verandas, where they would carve or paint deities while chatting.

Seema responded coyly to the barrage of questions as we made our way through the hamlet.

"Where are you going?"

"To the river."

"At this time! What for and why are you not wearing a sari?"

"We are going cycling ... It is fun."

During the dry season, the riverbank is broad, offering an ideal space to practice for someone who has never tried cycling before. Tophan had chosen well when he decided to bring us here. While I wrote up my research notes in the shade of a mango tree, Seema began her cycling lessons. Tophan guided her with patience, just like he guided all new apprentices in our household.

"See what I do, first I put one foot on the right pedal then I put the other foot ... like this ... see it is not difficult, you can do it too." Passing the cycle to Seema, Tophan gave her an encouraging smile, "Now it is your turn." Seema tied up her *chunni* and tentatively placed herself in position, one foot on the right pedal, then the other.... She tried and failed, tried again and failed again, giggling all along.

Tophan often guided young apprentices in the workshop, sketching animals on a blackboard and letting the youths trace over the pictures, honing their painterly hands. With much the same care, Tophan briefly held the cycle steady, allowing Seema to position herself before he let go. Seema did her best to keep her balance, first precariously and then gradually with more confidence. "Helli see ... See! I am cycling." "Excellent!" I said, as she lost her balance and fell over on the firm sandy surface. Tophan quickly came to her rescue. Seema rearranged her clothes and soon she was back on the bicycle, as keen to learn as any apprentice I have seen. By the time we returned to the hamlet to

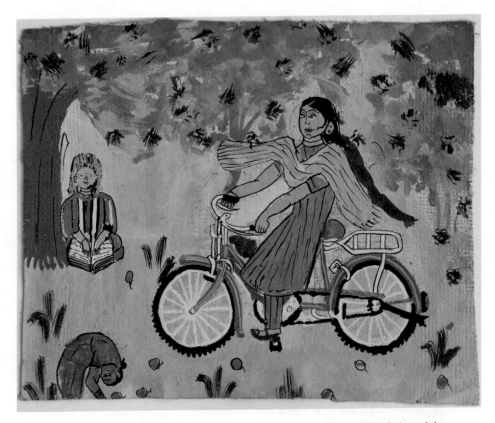

The author and Seema Samantray at the riverbed, 1988. Painted by
Tophan Moharana, January 1989

continue our work, Seema had had enough of cycling for the day and
gladly let Tophan bring the bicycle back to its place within the house.

It was an unusually hot day for December, and quiet. In the studio, the
apprentices were at work, some in deeper concentration than others. A
shrill scraping noise sounded from Laxmana's small slanting desk when
he shifted his position, otherwise nothing. Tophan sat across from the
younger apprentices, working on the ten avatars. The commission's ap-
proaching deadline could be felt in his efficient brushstrokes. Due to

the size of the painting, he occasionally had to sit on top of the image while working, his slim body folded double. Only a thin piece of material then was between his bottom and *Vishnu* in his various forms. Not that this bothered Tophan – he did what he had to do in order to paint the image and thus commemorate the deity. Occasionally he got up to stretch and to check on the progress of the boys.

Laxmana was drawing on a blackboard the size of a large handkerchief. "What is that supposed to be? A swan?" Tophan asked, echoing their guru but with a twinkle in his eyes. Laxmana grinned foolishly and began afresh, having been in the *guru kula āshrama* long enough to appreciate the advice of an older apprentice. Returning his attention to his own painting, Tophan adjusted his shawl, sat down, and got on with his work. An hour must have passed by when Siva entered the room from the inner courtyard where he had parked the bicycle. Returning from an errand in the bazaar or Puri perhaps, he wore a smart, white terylene shirt to supplement his orange and brown checkered *lungi*. The boys shifted uneasily behind their desks, Laxmana glancing sideways to see where Siva prowled. Siva, however, did not notice the sudden tension in the room, or perhaps he did not care. He clearly had other things on his mind. "The key" he said tossing it across to me before going out again, this time through the entrance leading to the lane. With his exit, the atmosphere shifted again, fidgety bodies, occasional whispers.

It was in relation to "business" that the bicycle proved most useful to the household. In the morning and afternoon during the winter months, when tourists were most likely to pay the hamlet a visit, one of the youngest apprentices would be chosen to keep an eye out for customers. The boy would stay on duty in the nearby town, in the spot where the then dirt road led from the town to the hamlet. The minute he spotted tourists approaching, he would run as fast as he could to inform his household. Whenever an apprentice came sprinting into the studio, Siva would find me to grab the key and ride off to be the first to meet the tourists. It was no wonder that his requests for a long-term agreement gradually turned into pleading. Perhaps by then, two months after my arrival, he had realized that the chances of getting his wish fulfilled were slim. "I really need the cycle in order to help my father ... who has helped you so much ..." I still did not have the nerve to turn down his request, only repeating my vague "We will see, I do

not know." Even I felt exasperated listening to myself, but I could not inform Siva about my plans. I am not sure why; maybe a sixth sense told me it was premature and unwise.

Having taken the key, Siva would race toward the main road then hop off the bicycle in time to catch his breath before approaching the tourists. "Hello, you want *patta chitra*?" Not waiting for a reply, he would continue: "I am son of the national awardee, come with me." He then would lead the tourists directly to our household passing other artisans and their exhibited wares on the way. Few of the other artisans would openly protest Siva's monopolization of potential customers, yet they still vied for attention of the guests, preferably before their visit to the famous painter. If the tourists decided to buy from Jagannath, they would be even less likely to want more paintings on their way out of the hamlet. After all, he had the most impressive display, always making sure to keep a large stock to cater to even large groups of tourists. The majority of customers had no clue anyway; they were unlikely to notice that some of the paintings were produced by painters from other households. Some visitors could not even see the difference between the work of an apprentice and a highly skilled artisan.

The bicycle also came in handy the day I decided to throw a feast. It was my birthday, and although only the birthdays of deities and young children are celebrated in the hamlet, I decided it was a good opportunity to give something back to the household. I asked Tophan and Siva for culinary advice. "We will eat chicken," Siva said, savoring the word "chicken," his large eyes sparkling. Tophan kept quiet but licked his lips as if he had already eaten the bird. After two months of thin dal, occasionally accompanied by a few miniscule river fish, I felt my own mouth watering. What a splendid idea.

"How many will we need and where will we get them?" "Three," the answer came prompt and had the ring of a round of haggling, a skill Siva mastered when dealing with customers. Siva looked expectantly at me, Tophan looked at him and recoiled, perhaps feeling Siva was asking too much. With sixteen people in the household, however, I did not think three of the usually scrawny chickens was an unreasonable request. It was Siva who biked to the market, returning with the squeaking birds tied up and dangling from the handlebar. It was also Siva who organized the slaughter on the earthen veranda behind the house. For weeks after, dark marks on the earthen walls from the trails

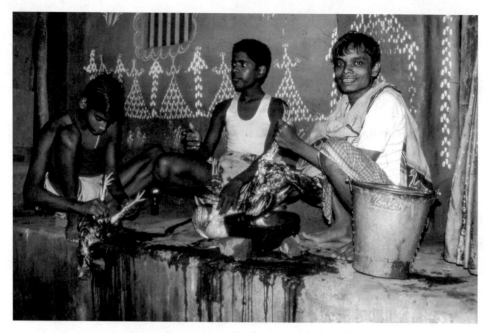

Apprentices of Jagannath Mohapatra slaughtering chickens, 1989

of blood competed with the white decorative patterns, *chitā*. The latter
had been made during the auspicious period, when farmers bring the
harvest home and women decorate their houses in honor of the god-
dess of wealth, *Lakshmi*. The stark contrast struck me whenever I would
return from the latrine outside the back of the house. The blood stain
served as a silent reminder of Siva's initiative and talent for organizing
entertaining events.

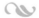

Yet another deadline. Even Siva had been painting for hours at a
stretch. Last night Jagannath, Siva, and Tophan had worked until mid-
night with only a slight interruption when the power had failed and the
kerosene lamps had to be brought in. Tophan had dark circles under
his eyes, and Siva's foul mood oozed out of every pore, affecting every-
body in the studio. The young apprentices knew better than to attract

attention and, for once, appeared as one common body of hard-working students. As if he could read their minds, Siva got up to inspect their work, one after the other. He moved down the line of students, their bodies appearing to shrink when he approached, only to then expand again to their normal size after he had passed. Some, however, were not so lucky. The slaps fell quickly, their sound briefly interrupting the eerily quiet room. Having paraded the room, Siva sat down to work but found that some of his coconut shell paint containers were almost empty. He shot up again, unlocked the cupboard and rummaged around without finding what he was looking for. We all waited, for what I am not sure. Siva suddenly turned to me: "Give me the key, we need colors." For once, it did not take me long to produce the key.

As Siva's errands to the market on the bicycle became more frequent, his former pretenses gradually vanished: "You give the cycle to me when you leave, I need it." Why did I not simply inform him that, by then, I had decided to give the bicycle to Seema? During our stay in the hamlet, we had developed a close friendship. When having a break from fieldwork, I occasionally stayed a weekend in Seema's home in a village outside the capital. We would spend hours on one of the big family beds, chatting about our experiences among the painters and our hopes for the future. Seema wanted to work after marriage, something that was easier said than done in Odisha at the time, when most families expected a daughter-in-law to stay at home. I had faith in Seema, however. She usually succeeded when putting her mind to something, as was evident the day she finally cycled on her own.

If nothing else, the bicycle would shorten the time she used commuting between her village and the university. Instead of walking to the bus stand, she could cycle. Giving the bicycle to Seema appeared to be the right thing to do, a small gesture to women's liberation with the added benefit of not having to favor one of the painters.

Surely I could have explained this to Siva. Instead, I kept quiet. Was it guilt? Guilt caused by my eternal debt to Jagannath who let me stay in his household? Or by the precarious inequality of this world, which makes it possible for someone like me – even as a student – to buy a bicycle on a whim while others can only dream, argue, or try their luck to get what could make a real, positive difference in their lives?

It was not only Siva's way of speaking that changed. During our daily ongoing conversations with the villagers, he would suddenly appear in

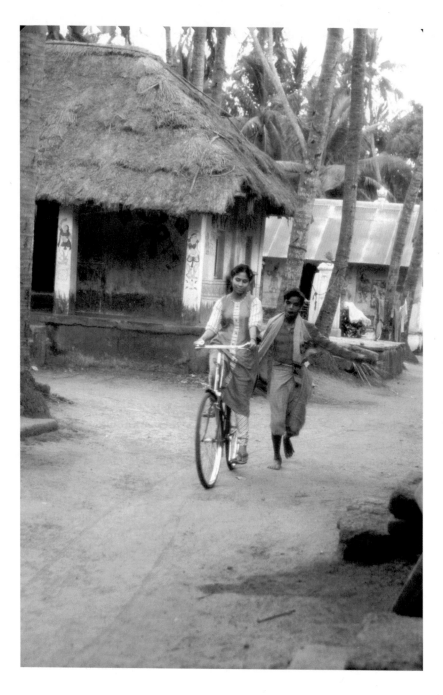

Seema Samantray cycling in Raghurajpur followed by Tophan Moharana, 1989

the doorway requesting the key. I found the interruptions irritating and problematic because he might overhear a remark not meant for his ears. Because I wished him gone, I did not hesitate to let him have the bicycle despite his increasingly hard treatment of the bike. I was not the only one who noticed the damage caused by Siva's use. "What is he doing to make it look like this, I wonder? Yesterday the front wheel did not shake like this." Seema was puzzled when she noticed the difference during one of our practice sessions. This was not just daily wear and tear. Something else was afoot. Tophan looked at her and for once he was not smiling, "He wants the cycle." "But why destroy it?" I asked, as puzzled as Seema.

A week before departure, Seema warned me to be careful. "Remember to latch our room; do not leave your belongings unattended." "Who would take our things?" Seema looked at me, "Never mind, just be careful. Everybody here knows we are leaving." I was not entirely convinced, but I had worked closely with Seema long enough to listen carefully to any advice of hers. Consequently, I did my best to limit my tendency to be scatty with my belongings. Apart from the bicycle, everything else was locked up securely in our room.

The day before we left, Siva took the bicycle to "go to the market." He did not come home before dark as he usually did. It was late when we finally decided to stop for the day, and there was still no sign of him. Where was he? And where was the bicycle? When we got up the next morning, the bicycle was back at its place outside our room. Still no sign of Siva. Odd really, because he knew we were leaving. We packed our belongings and said our farewells, but he did not come. Perhaps he felt he had said all that was needed. Seema stood in the lane in front of the house with our bags and bedding while I went to get the bicycle. That was when I saw it. The clear-cut gash across the leather saddle grinning goodbye. It was time to leave.

A Craving for *Idlis*

It was the worst at night just before he slept. That was when he missed his mother most, weeping himself to sleep inside his cocoon of a shawl. Tophan could hear the other boys, the older apprentices talking quietly among themselves and the slow breathing – the younger ones were already asleep, apart from one; perhaps he was missing his family too. He had only himself to blame. Nobody had told him to stay in the guru's home. He could have remained with his family in Puri. With his mother. Tophan could almost feel her presence, her gentle touch on the rare occasions he stole a moment of her undivided attention. Usually only when he had a fever. Then she would sit with him, quietly stroking him. That soft touch, a mother's touch, so different from how the older boys here lashed out. He felt his eyes prickling with tears. He must not cry. It was his own fault. If it had not been for his craving for steamed rice cake he would never have ended up here as an apprentice in the first place.

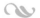

"He is a thief; he is a thief!" A group of children gathered around Tophan shouting at the top of their voices. Tears stood in his eyes, making it difficult to see who was who. Not that he dared look at anyone; the feeling of humiliation was too strong. Tophan had been so happy that

morning when he entered the school premises and, much to his surprise, found a two-rupee note. Just imagine: two rupees all to himself! He knew exactly what he wanted: *idlis* from the bazaar. He had recently passed by a stall near the *Jagannath* temple and had seen a man preparing steaming, fluffy, white, and absolutely wonderful *idlis*. Tophan's mouth was watering at the thought of this treat; imagine being able to fill one's empty stomach with freshly made *idlis*. He carefully folded the note, placed it in his math book, and went to his first class.

Some hours later, he wanted to sneak a look at his newly acquired wealth, but he could not find it. Where had it gone? He searched through his books, nothing. Someone must have snatched it. After much internal debate he summoned up the courage to tell the teacher of his suspicion.

"Take out all your books. Turn your pockets inside out."

The teacher paced up and down through the rows of uneasy children but to no effect. Tophan was inconsolable. Now he would never get his *idlis*. After class, he left the classroom carrying his books on his shoulder, just like the other boys. A boy walking behind him flicked through one of Tophan's books to cheer him up or, perhaps more likely, to tease him. That was when the lost rupee note reappeared. Previously stuck between the pages, it now drifted painfully slowly to the ground. He stood there willing the drifting note to vanish but to no avail. How embarrassing! He had suspected his classmates and should have left it there. But no, he had gotten it into his head to involve the teacher, who had been only too happy to exercise his authority in front of Tophan's intimidated classmates. And now they turned against him with the full force of their humiliation, calling him a thief.

His disgrace took place sometime in the late 1970s, the last day Tophan set foot in a school. He was twelve years old. The morning after the incident his elder siblings got ready to leave, but Tophan refused to accompany them. Neither his mother's pleading nor his father's scolding could make him change his mind. He stayed behind. After a couple of days, his father decided enough was enough: "Today you come with me to the bazaar." A healthy boy of twelve obviously could not sit idle at home when there was a family to feed. That is how Tophan began working full time for his father. In the morning, they walked to the temple area where they sold bright-colored prints of Hindu deities. In

the afternoon, after a lunch break, they returned to sell papier-mâché masks produced by the family at home.

Although no two days were alike, Tophan quickly realized it was generally much more difficult to sell anything on rainy days. No wonder his family often went hungry in the rainy season. Even the pilgrims, who traveled all the way to Puri to visit the temple and get a souvenir, were less likely to buy when it rained. Mother fuckers! He shuddered at the thought of returning empty handed to face his siblings' obvious disappointment, not to mention his mother's quiet, "Oh well, tomorrow might be better." Not again. There had already been several days this week without food, the hunger only briefly stalled on the rare occasions when his mother brought back scraps from the households in which she washed kitchen utensils.

One evening while they were selling masks, Tophan's father told him to buy a stack of prints to be sold the next morning. He handed over eleven rupees to his son. "Now be quick about it and return as fast as you can. We still have a lot of work to do." Walking toward the print shop, the money burning in his trouser pocket, *idlis* drifted like wisps of cloud across his mind. Among the numerous stalls, he came across a vendor offering lottery tickets. For only one rupee he could win five rupees. It was almost too good to be true. The more Tophan thought about it, the more he felt convinced he would win. The *idlis* were as good as his! He bought a lottery ticket and wondered how many *idlis* he should buy. Four perhaps. Yes, four would be just right. "Blank," the man said. Blank. Well, that was bad luck. Next time he might have more luck. Tophan quickly placed one more rupee on the desk and asked for another ticket, and then another. A little later, when reaching for money in his pocket, he grabbed thin air. He had spent it all and had nothing to show for it.

First Tophan panicked, but then he thought about it and decided he would tell his father he had lost the money. After all, the bazaar was a crowded place that attracted crooks. His plan might have worked had it not been for a friend of his father, who spotted Tophan spending money as if he were a wealthy tourist. The man informed his friend about Tophan's performance at the lottery stall shortly before he returned to his father. Tophan, unaware of his bad luck, stuck to his plan.

"Where are the prints?"

"Baba, I lost it all." (Tophan started crying.)

"You lost my money? I'll give you lost money. You just wait till you get home!"

Tophan was scared out of his wits and decided to run home to his mother.

"Mā, give me some food quickly."

"What is the rush? The *khiri* [sweetened milk-rice] is ready, but the rice has not cooked yet. Sit down and I will give you some food as soon as the rice is ready."

"No, I do not need rice, just give me *khiri*. I have to go, Baba is on his own in the bazaar, and he needs me."

Tophan quickly swallowed his sweet and left the house. He scanned the street and then ran in the opposite direction from where his father was likely to return home. He ran and ran, not really thinking. The more distance he could get from his father, the better.

He ended up at the railway station. He had only just arrived when it began to pour. Soon he began to shiver, feeling cold and very lonely; still, he did not dare to go home. After dark, he lingered around a small tea stall, attracted by the smells of boiling milk and spices. The owner spotted him but said nothing. Yet another street kid dressed in hand-me-downs, his shorts sagging like a sail without air and held up only by the good graces of a piece of string. "Get lost!" he shouted and threw a glass of water at the skinny boy. The contents hit their target with a splash but did not make any difference on an already sopping wet body. It frightened Tophan, however; he had hoped to find some comfort in the company of a grown up. He did not know where to go and decided to stay where he was, in the area of the station, but well clear of the tea stall. Two days went past and Tophan felt cold, frightened, and increasingly miserable. That was when he thought of his elder sister who had been married off to a man in Raghurajpur, close to Chandanpur town. Tophan remembered accompanying his relatives on the train to visit his sister's future in-laws.

It did not take him long to put his thought into action. Just as well the station was so crowded during the day; it was relatively easy for a small boy to slip unnoticed through the masses. He jumped on the next train but did not dare to sit down in case the ticket collector turned up. Swaying with the rhythm of the increasingly speeding train, he studied the floor, occasionally interrupting this activity with a timid glance at

the trouser legs of his fellow passengers. His father never wore trousers, nor his brother. An elderly man took pity on him:

"How come you are traveling alone? You are just a small child! Where are you going?"

"I must visit my sister."

"And where does your sister live, boy?"

"She lives in Chandanpur."

That is when the man told Tophan he was on an express train, which did not stop at his planned destination. Tophan had the fright of his life. What to do? The train was speeding up. The longer he waited the faster it would go. Standing next to the open door, he saw only one solution. He closed his eyes, jumped off, and rolled down the stony slope.

Agony. One side of his face was skinned, and his arms and legs were badly bruised. It hurt so much. Slowly making his way back to the station, he thought of his mother. If only she knew of his misery, she would sweep him up in her arms and tend to his bruises … "Now then, it will be all right." He could almost hear her voice. Reaching the station, he realized he would not have to wait long for the next train. This time he made sure to ask whether it stopped at his destination.

Commuters stared at his battered appearance, but, to his relief, they left him alone. He got off at his destination and was pleased to see that he could recognize the place. It was hardly two kilometers to his sister's home. The thought of his sister gave him energy for the last stretch of the journey. Soon he reached the lane where his sister lived. Tophan kept his head down, only now and then glancing sideways to make sure he would not miss his sister's home. A sneering remark came his way, but he was too exhausted to care. As far as he was concerned, the villagers could say or think whatever they wanted. His visit was none of their business. How naïve … it was very much their business. A street kid had nothing to do in the hamlet. He realized he had reached his sister's house, stopped, and waited, hoping someone would come to the door. He did not have to wait long.

A villager must have informed the family; someone grabbed him by the arm and led him into the house, where his sister's mother-in-law took charge.

"Heat up some mustard oil with a little garlic! He is shivering."

"What has happened to you?" Tophan heard his sister but did not know where to begin.

"Let him be now, can't you see he is in no condition to answer any questions? Do as I told you, heat up that oil."

The woman stripped him down until he stood in his shorts only. Her efficient hands made him feel safe, allowing fatigue to set in. Waves of exhaustion made it difficult to keep upright; had it not been for her tight grip, he would surely have fallen. His sister poured warm oil in the hands of her mother-in-law who began to massage his body to make him regain his warmth. A bath followed and then his sister fed him. Tophan could hardly keep his eyes open; he was so exhausted and relieved to be safe. Soon, he collapsed on the mat his sister had rolled out for him on the floor and slept soundly.

That is where his mother found him later that afternoon after two days of her unrelenting search. Some hours after Tophan had left home, his father returned without him.

"Where is our son?"

"I don't know where he is, and I don't care. I do not want to set eyes on him ever again."

As usual, his mother kept quiet; she knew better than to start an argument she was bound to lose. Instead, she searched their lane, but it was pitch dark and many people had already gone to sleep. She went home to spend a sleepless night worrying about her youngest son. Before dawn, she was up again, determined to find him. There was not a path or well in old Puri she did not examine, summoning up her courage and forcing herself to stare into the dark depth below. After two days, she lost her patience.

"You can have all the eleven rupees you want, I want my son!"

"I am happy to have seen the last of him. For all I care, he can stay missing."

In her desperation, Tophan's mother went to Mā, the mother goddess, and banged her forehead into the ground at the goddess' feet. That is when she thought of her daughter. Perhaps Tophan was with her.

She sat with him while he slept, thankful to have found him alive. Although he had clearly taken a beating, there was nothing seriously wrong with him. What a relief. After an hour or so, she gently woke him up.

"Time to go home, small one. Time to go home. We will go home together."

"Mā, I will not come, baba will kill me. I did something foolish."

"I know, never mind, come with me now."

"You might not mind, but baba will not easily forgive what I did, and neither will my brother."

Tophan's mother knew in her heart that her son was right. Her husband was still seething with anger at the thought of their loss, and her elder son would be only too pleased to teach his younger brother a lesson. Perhaps it was better if Tophan did not come home for a while. It was out of the question to ask her daughter's in-laws to accommodate her son. She contemplated the problem for a while, carefully considering her extended caste-based network of relatives. Whom could she ask for help without accruing too large a debt?

Tophan in hand, she crossed the lane to discuss the possibilities with Tikina, a distant relative. Tikina was married to a highly skilled painter and lived in a large household accommodating his apprentices as well as his brother and his family. One more child surely could not matter, particularly not if the child was willing to work. Tophan's anxiety increased as they got closer to Tikina's house, but it was nothing compared to the fear he felt when thinking of his father and brother, so he kept quiet. His mother walked up the stairs and hesitated for a moment on the red oxide veranda before she entered through the open double door.

It was the first time Tophan saw a studio. He could not believe his eyes. Everywhere he looked, boys were working on paintings of various sizes. Some were the size of postcards, others more than a square meter. One truly large painting kept several boys engaged at the same time. "Stay where you are till I come back," his mother said, just before she left him to talk to Tikina, whom she had spotted in the inner courtyard. While Tophan looked at all the activity, his mother spoke with Tikina. Tikina listened and then went to find her husband, Jagannath. The two of them spoke for a long time, so long that Tophan's mother grew worried; her proposal might be turned down. Did they already have too many young boys staying? Did they not need any help? Jagannath was the first to speak when he and Tikina returned to the courtyard.

"Your son can stay here only if he is willing to work."

"He will work, he is used to working with his father."

"He will do household chores – carry water and whatever else I or she [he nodded toward his wife] tell him to do. He might also work with the other boys in the studio but let us first see what he can do. We will feed him."

Tophan's mother bowed her head, both to pay her respect and also to hide the tears betraying her feelings of relief and loss. To return home without her beloved son was almost more than she could bear. She kept telling herself that he would be all right, the apprentices had all looked well fed. That was more than she could say about her own children. The decision made, it was time to leave. She had nothing more to do in the hamlet. Seeing his mother crossing the threshold to the veranda, Tophan did not trust his voice and said nothing, lest she should change her mind and insist he come with her.

The first night in Jagannath's household Tophan spent keenly observing the work of the other boys in the studio. They worked steadily, interrupted only when the electricity failed. Then Jagannath's niece Sobha brought out kerosene lamps and soon they were all back at work. As the hours went by, one after another went to sleep, the youngest between five and seven years of age being the first to fall asleep. No fuss, they simply rolled out a mat, wrapped themselves in their shawls to keep the mosquitoes at bay, lay down, and slept. Tophan soon found a corner and followed their example. That night he slept almost immediately. The next morning he got up before any of the other eleven boys who slept in the studio; he had work to do. His first task was to fetch water for the household, and with it, his new life in the hamlet had begun.

The days passed one after another. Tophan was kept busy throughout the day and often fell asleep the minute he lay on his woven straw mat at night. There was an advantage to being so tired. It gave him less time to think about his mother. He was also not the only one who missed someone; the muffled but distinct sound of sobbing from one of the other boys told him as much. The boy was another recent arrival, and although he was younger than Tophan, it still gave Tophan some comfort to know that he was not alone in his misery.

In between his household chores, he began to assist the older boys in the studio, filling in background color. It was the kind of task anyone with a pair of hands can do without fault, or as it were, almost without fault. He liked his painting tasks, did not mind the household chores, and truly enjoyed the meals. Hours before mealtime, wafts from the

cooking pots drifted through the courtyard. When called, the boys got their steel plates and sat one after the other in a row. The older boys were served first, followed by the younger ones. Tophan was one of the last ones to eat, apart from the women, who ate after the rest of the household. Sitting on his haunches, Jagannath generously spooned out ladles full of steaming rice and dal to the waiting boys and even offered second helpings. What more could one want? Apart from being with his mother, only one thing came to mind.

He wished the older apprentices would stop bullying him. Unlike his father's thrashings, their beatings were not fair. He always did his very best, but no matter how hard he tried, it was never good enough, or so they seemed to think. He was always obeying their orders, running here and there, filling in background color for hours at end. Still, they showed no mercy if he was too slow or the dots, with which he decorated the background, were not to their liking. The blows fell hard – and fast, in case *mausā* should turn up. Jagannath, for one, did not approve of beatings. Perhaps if he turned out to have a good hand, they might stop harassing him. Perhaps not, though. In fact, it might increase their mistreatment if he were to threaten their hard-won positions. That, however, was unlikely to happen within the near future. Their beatings were just something to accept; nothing in life is free.

It was so different with his peers and the younger apprentices. They could joke among themselves, although you had to be careful not to direct a joke against Jagannath's nephew. He preferred targeting others. Already a few weeks after Tophan's arrival in the household, the younger apprentices began to turn to him when needing help. Not with painting – after all, he had only recently begun to learn himself – but with other things, small tasks such as reaching for a T-shirt on the line in the courtyard or removing a splinter from a toe. In the morning, he often woke up to find that some of them had moved closer to where he slept.

When his mother came to bring Tophan home some weeks later, she found that he was gradually settling in. This had never been her plan; she wanted her son to be with her, but he would rather stay in the hamlet. For a second time she had to return home without Tophan. She did not give up, however, and returned regularly to the hamlet to try and convince Tophan to come home and, if she were being honest, also hoping to get a glimpse of her oldest daughter. She could not ask

to see her. She had no business in her daughter's new home. But if she were lucky, she might see her on her way to fetch water at the open well in the center of the hamlet.

One day, half a year after Tophan left his home, his father suddenly entered the studio. He did not say a word; he simply stood there. This time, Tophan did not insist on staying but quietly left with his father for his natal home. At home, however, he found that he missed his life in Jagannath's household: the daily routines, going to the river in the morning for a bath with his peers, working in the studio, helping the younger apprentices, watching the occasional tourist when they came to purchase a painting, lending Tikina a hand, and, of course, the meals. He summoned up the courage to ask his father for permission to return to the hamlet. As head of the household, it was his decision to make. Tophan's mother did not have a say in the matter. For once, his father listened to his son. Though Tophan was generally useful as an errand boy, his son's request was not without advantages. There would be one mouth less to feed in the house. Just as important, however, was the opportunity for Tophan to acquire a skill that, in time, might make a significant financial contribution to the household. His father decided to grant his request, and two weeks later Tophan returned to the hamlet to begin a new part of his life, now as an apprentice of Jagannath.

Forty years later, sitting on the roof terrace of Tophan's house in Puri, we talk about our lives and the years that had passed. Tophan stayed with his guru for seventeen years before his father asked him to return to his natal home to take up his own painting and to get married. Ten difficult years followed, but that is another story. These days, Tophan rarely uses his painting skills, instead working part time as a night watchman for a neighboring hotel. This job pays better than painting, and he has to provide for his family. It was not a difficult decision to make.

Our conversation drifts back to Jagannath's household and our common past. Tophan treasures his years with Jagannath, that much is evident from his facial expression. It is the steady meals that are imprinted on Tophan's memory. He describes in detail how they could choose

between *chudā* (beaten rice soaked in water or tea) or *pakhāla* (watered, fermented rice) in the morning, the generous helpings of rice and dal at lunch, passing around *tiffin* in the afternoon, and the lighter meal at night just before everybody turned in. Generous helpings of rice and dal outshine memories of frequent beatings by the older apprentices and even the endless hours spent painting, first as an apprentice and later as a skilled artisan.

Food has a central place in Tophan's life, whether in tangible form or in his imagination. It is hardly surprising. After all, it was Tophan's dreams of steaming, fluffy, white, and wonderful *idlis* that had provided a path to a new life.

The Helmet

"Unclean, unclean [*āinsha*]!"

The children shrieked and pointed to the motorcycle helmet in my hand, eager to see what I would do next. It was the first time they had come across a grown up acting so bizarrely, so out of touch with how things are done. I had snatched my helmet during lunch, preoccupied, as I was, about lice. I had had more than my fair share of the creepy, crawly pests over the last months and wanted to minimize the risk of another attack, whatever it might take.

In the autumn of 1991, Prasanta and I were invited to a Brahmin village fifteen minutes' drive from Raghurajpur to participate in *Kali Puja*, one of the most important festivals in eastern India. Educated middle-class friends from the capital warned me against going; the ritual sacrifice of more than a hundred goats was not for the faint-hearted. Steeling myself to face the bloody spectacle, I forgot about preparing mentally for the change of scene. It was one thing to hang out with painters in a low caste hamlet and quite another to visit *Shasana* Brahmins, who enjoy the highest ritual status in Odisha. This was high caste territory, and if I had thought this through, I might have been less surprised that the sacrifice would not be my only lasting impression.

The *Shasana* Brahmin village was situated off the high road. Compared to the crowded low caste hamlets, this village gave a sense of excess space. Coconut palm trees stood scattered in the open landscape, otherwise only marked by a broad dirt road. On each side of the road, large houses stood side by side, joined by their common walls. This row-house design was one thing this village shared with its lower caste counterparts.

Early in the morning, Baraju made his way to the Brahmin village on bicycle, and by the time Prasanta and I arrived he had been working on the figure of the goddess *Kali* for hours. He was responsible for creating the figure in time for the celebration and was determined that the goddess should be nothing short of magnificent. As with many other artisans, Baraju was happy to talk while keeping his hands busy. Our visit was particularly welcome in this setting. The Brahmins might enjoy a high ritual status, but it was his work that had attracted a researcher armed with notebooks and a fancy camera. This attention might help increase Baraju's status in the eyes of the Brahmins. While working he spoke of his guru, Jagannath, the man who had guided his work as long as he could remember.

"He is one of a kind. A real artisan. He paints *patta chitra*, he makes figures, and he instructs and acts in the yearly *Ramayana* performance."

"He is also a good cook."

"That is true; he is a good cook indeed."

I thought of Jagannath supervising the preparations for the frequent feasts held in the hamlet, stirring the bubbling *khiri* in colossal metal pots brought out for the occasion. Perhaps Baraju also thought about the lavish meals he enjoyed whenever Jagannath arranged a feast. He was smiling to himself, letting his mud-covered hand briefly rest on his stomach before slapping on more plaster.

As the morning progressed, so did the heat, and though Baraju's work place was conveniently situated near the *Kali* temple, there was no shade to be had. Despite our exchanges, the hours felt long. I could continue our conversation, take notes, and snap photographs, but I could not be of any help. Not only because I had never tried to make a figure but also because *Kali* was made for a ritual purpose. Only a person from the chosen family could contribute. Had I been ignorant enough to offer my help, Baraju would have turned it down without hesitation. Looking back, I shudder to think how the villagers might

have reacted if I had touched any of the materials. Surely, someone would have been upset. Although Baraju, as the chief artisan of the household, would be blamed and thus suffer the wrath of either the goddess or the villagers, I would have also been reprimanded. It is unlikely I would have been let off as easily as I had been in Jagannath's home when, a few weeks after my arrival in 1988, my ignorance had nearly spoiled a feast prepared for *Lakshmi*, the goddess of wealth and good fortune.

It was the day before *Lakshmi Puja* in 1988. Sobha, the niece of Jagannath, had completed decorating the inner and outer verandas with *jhoti* (rice-flour paste) the previous night. She had spent hours on her intricate designs, which now brightened the whole house. The time had come to start grinding rice-flour, the main ingredient in the cakes (*kākarā*) Sobha would fry and offer to the goddess. She brought the heavy grinding stone out in the courtyard, squatted behind the stone, and took up her work. I tapped Sobha lightly on her arm with my pen, threatening to make a mark. She had teased me mercilessly earlier the same day, and now it was my turn.

In the morning, Sobha had left a small packet wrapped in newspaper at my desk while I took a bucket bath in the washroom. Returning to my room, I opened the packet to find a rather large dark brown cockroach waiting for an opportunity to scurry away. Not a pleasant surprise. Sobha found my intense dislike hilarious. After all, cockroaches were just one of many pests sharing our living quarters with us. I was irritated. It was more than enough that Sobha insisted on blowing out one of the candles I used to write my field notes in the evenings.

"It's a waste to burn two candles, you only need one."

"I cannot see a thing, Sobha. I need more light."

"One will do."

"It will not do, I am telling you. I cannot see properly. They are my candles, I bought them."

I knew I sounded pathetic, but I could not help it. Sobha was sparkling and full of pranks, but when tired, her tricks got on my nerves. The morning she surprised me with the cockroach, I decided the time

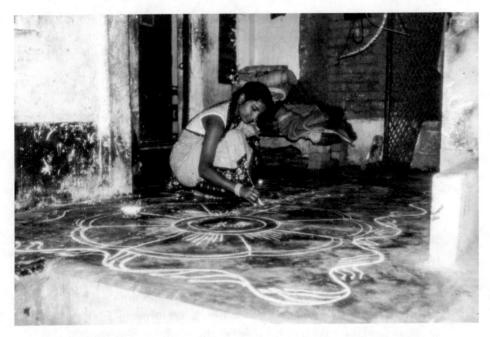

Sobha Mohapatra decorating the floors of Jagannath Mohapatra's house for
Lakshmi Puja, 1988

had come to return her teasing. The opportunity presented itself later
that afternoon, or so I thought. I could not have chosen a worse time
to pay her back.

Sobha withdrew her arm from my feints with the pen, but I persisted
with my threats. She was easy game as she sat there behind the grinding
stone. Once more I tapped her arm, and this time she not only with-
drew her arm but also forcefully said no, in the manner she otherwise
reserved only for children. The third time the pen landed on her arm,
Sobha jumped up and moved backwards while warning me: "Do not
make me unclean, this is for *Prasād*."

It was only then I realized my mistake. Preparing food for an offer-
ing requires ritual cleanliness. Although I had read about ritual pollu-
tion I had not until that moment taken in what it entailed in practice.
I had taken my bath in the morning and my clothes were fresh, but
my touch would nevertheless cause a state of pollution. As an outsider,
my touch would pollute Sobha, who would transfer the pollution to

the food, making it unfit to serve for the deity. Once polluted, Sobha would have to start all over again. It was my luck that Sobha, although she taught me a lesson, chose to shrug off the incident as if it had never taken place.

It was time to place *Kali*'s weapons in her two left hands. The sword was in place but the severed head seemed to give Baraju some trouble. At least he was muttering to himself while working to make it stay in place. I could not blame him. It really was sickly hot. After what felt like an eternity, a small boy appeared to inform us that lunch was ready. One of the Brahmin households in the *Shasana* village had invited Prasanta and me for lunch. More accurately, we were invited to eat lunch *in* their house but not *with* them. They would not have minded eating with Prasanta, a *Shasana* Brahmin himself, but as an outsider I was a source of pollution and a threat to their position. Eating with me might lead to excommunication among conservative practitioners. There was no risk of this actually happening, however. It was simply not an option.

Did I mind? Yes, I did mind! I absolutely detested the practice. I found the notion abhorrent, that someone might become polluted simply from eating next to me. All my good intentions about keeping an open mind as a guest in another culture vanished. Sitting there silently cursing my hosts, I realized I was nothing but a cultural bigot bringing discredit to any anthropology department. I had better pull myself together if I wanted to continue my work in rural Odisha. I had come of my own volition; the Brahmins had never asked me to visit their village, yet they were nevertheless kind enough to welcome me, despite my different background, when I showed up out of the blue.

Unlike orthodox Brahmins elsewhere in India, even conservative *Shasana* Brahmins commonly eat eggs, fish, and even goat meat. That day, fried fish was served along with richly flavored dal, bitter gourd, and green leaf. While we ate, a group of children played in the space next to us. They found my helmet in the corner of the room and soon took turns putting it on, prancing about. Of course, this was not the first time children had played with my helmet. From the day I had arrived in Raghurajpur during my second fieldwork, children would spend hours

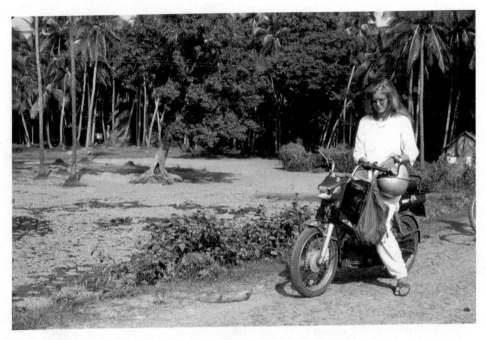

The author with her motorcycle helmet and Hero Puch, 1991

sitting on my scooter. One would put on the silver-gray helmet, holding on to it as if it might vanish, while another would place his hands on the handles, "Wron wron!" With that, they would be off on imaginary rides. That lasted for some time until I finally decided it had to stop. The attacks of lice were a nightmare, and one source of the pests was, I am sure, the children and their frequent use of my helmet.

Not wanting to risk another attack of lice, I told the children of my Brahmin host to leave my helmet alone: "Hey you, do not touch my helmet, let it go."

The little boy who had been waiting for his turn ignored my warning and put on the helmet.

"I told you to let it go! Now, take it off, put it over there."

I pointed to my stack of belongings in the corner. He thought it was hilarious. I was tired and irritable and got up from my lunch, crossed the room, snatched back my helmet, and glared at the amused children. I then went back to complete my lunch feeling rather pleased with myself. My no-nonsense approach had clearly worked, for the

children did not touch the helmet again. As it turned out, though, their reluctance to touch it had nothing to do with my scolding.

It was only later that I realized my mistake. Having washed my hands after the meal, I went to get my bag and the helmet. The minute I touched the latter, the children started shrieking, "Unclean, unclean!" pointing at the helmet. The helmet existed in a state of pollution as a result of my touch during the meal. Apparently, I had been in such a rush that I had not rinsed my right hand, which I had just eaten fish with. As any sane person knows, fish is polluting. The state of pollution of my hand was transferred to the helmet the minute I grasped it, and the helmet now was a threat to anyone who might unknowingly touch it. As it happened, I was the one to touch it and as a result, the polluted state of the helmet was transferred back to me.

While I worried about the discomfort caused by lice, my hosts worried about the order of their world. For a brief moment, I threatened that order. Where only minutes before I had told off the children, I was now on the receiving end of their reproof. Their shouts reminded me where I was and who I would always be, eternally an outsider. I felt ignorant and lonely; surely, my quest was doomed. I would never fit in. For now, however, the most important thing was to wash my hand and my helmet and free them both of pollution, never mind the lice.

The Wrath of a Deity

"I got the job after another *chitrakāra* ... He was killed."

"Killed? In an accident?"

"No, not like that ..."

"What happened?"

Baraju looked at his hands, perhaps considering my question, and then shifted his focus to look me straight in the eye.

"Well, she did not like his work."

"Who did not like his work?"

"*Kali mā.*"

Baraju continued his work on the large *Kali* figure; it was a pleasure to see him at work, a highly skilled maker of deities in all their various forms. The deity had not liked his colleague's work ... Well, that was unfortunate. But it was not what I had asked, and his response made me none the wiser. Perhaps I had misunderstood. I tried again. The patience needed to work with an anthropologist is something else. It was my luck that Baraju was a patient man.

"But why did he die?"

"She got really mad. She could not eat the goats because he made one of her right arms too short and her hand too little. Perhaps he was in too much of a hurry."

"She got mad?"

"Yes, she was furious. Some days after the *puja*, right after her fig-ure was immersed in water, *Kali* decided to pay the family a visit. The

painter was returning from the river when she struck. He fell to the ground and began to shiver violently. He soon caught fever and turned delirious. She ate him."

Ah, of course, that made sense, I finally understood – or did I? Eaten by *Kali* ... Clearly, my facial expression betrayed my feeling of disbelief because Baraju took it upon himself to warn me twice over.

"When *Kali mā* comes tonight, do not sit in the line of her vision, she might not like it."

"All right, if you say so, I will be careful," I said, with what I thought was a convincing smile.

I knew that *Kali*'s presence would be symbolically announced sometime during the night when a Brahmin priest would ritually open her eyes, allowing her to see and thus offer *darshan* to her beholders. I wondered how many would make use of this opportunity. When everything seems lost, *Kali* is the one who appears, making good use of her ample number of weapons to slay the demons threatening the world. She is fearful, to put it mildly, a deity to be treated with the utmost respect. The majority might want to avoid her gaze. *Kali* is many things but, by nature, not forgiving. It was probably my smile that convinced Baraju that I still had not understood.

"Just remember what I said. Be careful where you sit tonight."

I must admit I did not take it too seriously at the time, but there was enough in his words to convince me to make note of the conversation in my notebook. Thinking back to that autumn afternoon in 1992, I realize that I had understood Baraju's advice in the same way someone might acquire a theoretical understanding of the law of gravity, realizing what it implies only when hit on the head by a falling apple.

The potential wrath of deities occasionally surfaced in my conversations with *chitrakāras*. Unlike other painters, who only produced paintings for sale to tourists, many *chitrakāras* also painted and prepared deities for ritual use. I always listened to their stories with great interest, but for a long period I did not really take them in. They did not affect me, the way I was touched by other stories involving humans only. I could easily relate to accounts of human joy and sorrow, whereas the notion of a furious goddess left me unmoved. At the time, I did not think I would ever be able to relate to this particular aspect of their world. It would take more than stories for that to change – a closer experience participating in *Kali Puja*. Until that night, my

understanding depended on painters' accounts of their experiences with fierce deities. One such tale was from one of the narrow lanes in old Puri.

Why does poverty appear starker in a town or city when compared to a village? To be poor is surely taxing, wherever one lives. Coming directly from the bright sunshine outside, Tophan's house felt dark, the mud floors and walls of interlacing branches and brick absorbing more than their share of light. Perhaps my impression of the poverty was reinforced by the contrast of his home to the brick houses further down the lane. It was 1991, and Prasanta and I had accompanied Tophan to visit his childhood home, to hear about the ritual work his family did in accordance with the lunar calendar.

The household was in constant need and the money earned from ritual work far from covered the most basic necessities. Any unforeseen expense, such as a leaking roof or long-term illness, and they would have to go to one of the moneylenders who thrive wherever there are poor people without access to a cheap loan. Tophan's father hoped that the skills his son acquired while working for his guru would make up for the years he had been away from home.

The inside of the home tested my vision. I struggled to adjust to the dark interior, and the smoke from the kitchen made my eyes water. I felt claustrophobic in the crowded room and could not distinguish the new faces from one another. In the hamlets, people were used to my presence and even the children would let me come and go without any fuss. Here it was different. The members of the household took turns to see for themselves the foreigner Tophan had told them so much about. Was it really true what he had told them? The oldest child was the first to start the by now familiar string of questions.

"What is your name?"

"My name is Helli."

"You speak our Odia language?"

"Yes, I understand Odia."

"What do you eat?"

"I eat rice and dal."

As we spoke, the youngest child appeared from the folds of her mother's sari, quietly mimicking my pronunciation, "*bhāta, dāli,*" as if she were convincing herself that I actually had mentioned their staple food. Apart from Tophan, the small cottage accommodated his parents, his elder brother, Bhola, and Bhola's family. The brother's wife stole a glance from behind her sari when bringing tea, while other members of the household, more at ease, continued the questions invariably concerned with food and my family back home in … "America?" "No," I replied, "America is not my home country, my family lives in Denmark." "Denmark," Bhola repeated the word to himself. Denmark, not surprisingly, meant nothing to him. I grasped the opportunity to ask him about his ritual work repainting deities in temples and Brahmin households. I was interested in how painters perceive the relation between their ritual and secular work.

"Apart from the seasonal difference, what are the differences between painting for tourists and painting for religious purposes?"

…

His blank expression was more telling than years of schooling in anthropology. Obviously, I still had a lot to learn. This conversation would surely prove difficult, if not impossible, unless I gave up asking abstract questions. Tophan's brother was not used to talking about his work and had certainly never participated in an interview before. I rephrased the question, this time getting straight to the point without all the polite fuss commonly used in English.

"Describe the last time you painted a deity for a temple."

"Ehh?"

"When did you last paint a deity?"

"Yesterday."

"Yesterday?"

"Yes, yesterday."

His answers were hesitant; he was unsure what I wanted. I continued my probing. He was bored stiff, his eyes wandered around the room as if he were looking for an escape route. I was also bored and began to yawn uncontrollably. Soon, everybody was yawning and fidgeting. One by one, the family members quietly left the room until finally Bhola got up "to work," leaving Tophan, Prasanta, and me behind. Some people are not great talkers, which is one reason why questions can never substitute for observation or participation if you are really after learning

how people live. Many years later, Tophan told me that his brother was quite deaf and, just like many other men in Puri, consumed huge quantities of *bhāng*. Inexperience, deafness, and drugs combined – little wonder that particular interview had not been a great success. Unlike his brother, however, Tophan was used to my questions, and he was highly skilled when it came to describing life in detail, leaving it to me to sort out what I could use. It was then Tophan, rather than his brother, who recounted how his household had earned the wrath of a deity.

When painting for secular purposes, artisans are not obliged to take any particular precautions, the only concern being to fulfill the customer's wishes. This contrasts sharply with ritual work, where great pains must be taken to ensure that no one – and in particular not the deity in question – can find fault with an action. Depending on the deity – some are strictly vegetarian, others are meat eaters – certain foods and stimulants such as garlic and cigarettes are avoided days before the commencement of ritual work. In principle, that is. Not all artisans take the conventions too seriously. This would not be a problem if the artisans only had to work with benevolent deities. But fierce deities also need to be attended to. If a temple priest asks you to serve a fierce goddess, who are you to refuse? The money earned from this work is not much, but it is a regular yearly sum and, as such, makes a difference to an otherwise needy household. More important, however, is the ritual work itself. The majority of artisans consider it an honor to work for the deities.

The temple of *Sankata*, a fierce but not furious form of the mother goddess *Devi*, was situated just down the lane from where Tophan lived. Tophan's brother replaced their father when his eyes and hands failed him and he could no longer be relied on to repaint the deity with precision. Unlike many temple service tasks (*seva*), this one was comparatively easy. Bhola wrapped up his brushes and color containers in an old cotton *lungi*, placed the sling on his back, and walked the short distance to the temple to perform the simple task. It might have been the feeling of ease that caused Tophan's brother to shirk his duty, too lax indeed for his own good.

Bhola had served the *Sankata* temple for some years when Bhola's shirking came to bite him. As every year before, Bhola set off in time to complete his work before the goddess' *puja* was to take place. Nobody in the family gave it much thought. He had done his ablutions in the morning like everybody else. His *lungi* might have been worn thin, but

it was clean. He had not eaten his usual fermented rice to start the day, and he had kept his fast – or so they thought. He soon returned, ready to have lunch. In fact, he went and came back so quickly that the rest of the family had hardly noticed his absence. Having completed the job, he had no other responsibilities for the day and spent the afternoon resting. It was an unusually long rest. He did not show any signs of getting up, not even when the mosquitoes set in, their low buzzing threat unnerving everyone else. It was his wife who realized that he had caught a fever. First, no one took any notice. Fevers, after all, are common. They come and go. This fever, however, did not go. It lasted two months, at the end of which Bhola's temperature increased enough to cause serious anxiety.

Tophan, during one of his rare visits from his guru in Raghurajpur, was concerned for his brother but also, he admitted, for his own sake. "What if the well-being of the household came to rest only on my shoulders?" Needless to say, Tophan's sister-in-law was worried sick. "If he dies … how will we eat?" Tophan overheard her speaking to her mother-in-law, fearing what might happen to her and the children if her husband did not recover. She pleaded with the matriarch to summon a doctor, and later, when desperate, she turned to her father-in-law. I do not know what she was thinking at the time, but listening to Tophan's account, I could all too easily envision a young woman clad in a plain, white-cotton sari, her wrists stripped of colorful bangles, her forehead and the parting of her hair no longer decorated with bright vermilion. It is the image of a woman mourning, not only her husband but also the loss of her former status as married, unfairly exchanged for the inauspicious position of widowhood.

"*Dhana* [treasure], go get medicine. Tell the man your father has a high temperature. Quickly now."

Tophan's father was addressing his beloved grandson. The old man, who would otherwise spend his days sitting about, leaving household responsibilities to his eldest son, left no doubt about the sincerity of his instruction. The old man's sudden action confirmed that he could still act in his former clear-cut role as head of the household if needed. His grandson soon came back with medicine, but it did not make the slightest difference. The small boy was sent off again. "Tell him it does not work, we need another medicine. A strong medicine. Go now, quickly!" Strong or not strong, the medicine had no effect. Bhola's condition

worsened into delirium, a state that lasted several days. The old man was at his wit's end, fearing he might lose his son. He paced back and forth in the narrow room stopping only when he kneeled next to his son or prayed to the goddess, "Mother, oh mother …"

Even the children, who did not understand what was at stake, must have sensed the anxiety that had invaded their home. Otherwise noisy and active, they kept quiet and waited. Everyone was waiting. Few people can cope with that kind of tension for long. The old man had spent what money he had on medicine in vain. His prayers had not been heard. What could he do? Enough of trusting in medicines or faith in god. It was time for him to take things into his own hands. In an attempt to rouse his son, the old man first slapped him several times and, when that did not help, spat in his face. Suddenly his son began to speak.

"How dare you spit on me? You beat me, I will not stay anymore! I will go. He made me blind and one of my toes short. I will not stay here anymore. Make room for me. I will go."

Previously anxious, the onlookers now turned rigid with fear. What was going on? Despite being dumbfounded, the old man had the wit to ask a question. The answer, however, did not soothe his troubled nerves.

"Who is speaking?"

"You do not understand? You still have doubt? Reeking of garlic, he made one of my eyes smaller than the other, so I could not see properly. On top of that, he made me lame. I am missing one toe! That is why I came with anger and then you spit on me. Give me fruit *lassi*, otherwise I will not stay!"

That was when the old man realized that it was the goddess herself, *Sankata*, who spoke. This time he summoned his wife to get the necessary remedies ready to appease the deity.

"Get some *lassi*! Bring incense too."

"At this time of night? Without any money, how?" His wife looked at him, he looked at his son, and the deity made a new request.

"I want 108 oil wicks lit."

"We will make them, all of them."

The mother and the young wife quickly prepared the wicks and lit them, one after the other. Although the offerings did not have an immediate effect on the furious goddess, they slowly appeased her, reflected in Bhola's dropping temperature. Tophan's brother came to himself in the midst of his exhausted but grateful family.

Reflecting on what had made *Sankata* so angry, Tophan realized that Bhola had not kept the required fast but had eaten garlic the day before he went to paint her clay figure. She must have been perturbed by the stench from his mouth. Worse than that, Bhola had been in such a hurry that he had made her eyes of different sizes and had left out a toe altogether. Undoubtedly, he was incredibly lucky to be alive. Just as well *Sankata* was not a furious deity; in that case, he would surely be dead. The episode left Tophan deeply shaken and he swore to be careful in the future when creating a figure of *Devi* in one of her fiercer forms. Narrating his brother's experience, Tophan looked past me and said, "Whenever I paint, I never feel proud. I think of one thing only: they must be whatever they wish to be. I leave it to the deity. I completely surrender myself and only use my hand. Even if I commit a mistake, I will not get in trouble. When painting for worship, I always think like this, no matter which deity I serve."

Serving the fiercer deities, never mind the furious ones, clearly was not for the weak-minded. What a task, where minor mistakes had potentially fatal consequences. Then again, what were the alternatives? Looking up, I realized Tophan had completed his account and was watching me with a curious expression on his face. He was clearly waiting for me to say something, but what he expected, I do not know. I hesitated, taking in the surroundings in a vague hope that they might inspire something appropriate, but nothing came to mind. I was at a loss for words.

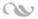

Despite the number of times painters told me about their intense interactions and negotiations with deities, their accounts never shook the foundations of my cultural beliefs. I understood their concerns intellectually and could see how they made sense as part of their world. But I could not share in their worry about fierce gods. Or that is what I thought before taking part in *Kali Puja* in the autumn of 1992.

Kali Puja was on *Amavāsyā*, the no-moon day, in the Odia month of *Kārtika*. Of all the days in the dark fortnight, the final one was my least favorite. The vacant moon left hamlets pitch dark, making it impossible to orient oneself without a torch or kerosene lamp. Like a Danish

winter. The only good thing about *amavāsyā* was the knowledge that, from now on, the moon would be waxing during the entire bright fortnight, again bestowing the world with light. *Kali Puja* takes place in darkness as black as the goddess herself.

Baraju had brought his younger brother to assist him with the task. Before beginning the construction, they went to the cremation ground to collect some mud for the figure, a requirement when making *Kali* in this part of Odisha. Next, they tied up bundles of straw in the shape of a torso, arms, and legs. Then it was time to apply a generous layer of mud until the surface became completely smooth. The process involved regular breaks, necessary for the mud to dry. Cloth is then draped over the figure before applying yet another layer of mud. No wonder they had been at it for more than a week. Baraju's hands were covered with mud, which dried whenever he took a break, making them look like the parched earth of a rice field during a drought. Even his *lungi* was spattered with mud. His brother assisted as best he could, doing the coarser work while Baraju focused on the aesthetic appearance. They worked for hours on end, Baraju continuously making sure that the proportions, and later the gestures and weapons, were right. Not that he made a fuss about measuring; he worked intuitively and with confidence. After all, he had worked alongside Jagannath for years whenever the guru had prepared the clay figures for festivals in Raghurajpur. Baraju felt fortunate to have learned from such an accomplished artisan.

While he was completing the figure, we chatted about this and that. Baraju was, as so often before, short of money. Even if he was always either working or looking for work, his family was in need.

"How do you manage?"

"Jagannath *mausā* will give me work. He always does."

"Who else can you ask for help?"

"Nobody. Other people do not care, but *mausā* is different. He is a good man with a big heart. He never refuses a craftsman in need."

My thoughts drifted back to the studio in Jagannath's house, of how often I had seen Jagannath's neighbor Sana working on a painting in a corner or Baraju himself, who after his apprenticeship had kept working for Jagannath, completing some project for the guru. Indeed, there was always a painter who had not been able to establish a regular sale of paintings at Jagannath's door.

Jagannath Mohapatra and Laxmana Moharana preparing Durga's figure, 1991

Apart from the brief interruption of a meal in a Brahmin household, punctuated by clashing priorities regarding impurities, Prasanta and I spent a pleasant afternoon in Baraju's company. The sun was standing low on the horizon. Soon, the mosquitoes would announce their arrival. It was time to go indoors. But the figure was not yet complete, so we stayed on to see the final details and transfer to the temple. With the assistance of some of the villagers, Baraju and his brother managed to shift *Kali* into her place in the temple without any complications. The transformation from straw and mud to a completed deity will never cease to amaze me. No matter how many times I have seen this work process, I have always found the result impressive during daytime and awe-inspiring at night. There she was, *Kali* herself in all her might. The strong colors, her ornaments and weapons, and the paper cuttings, which later would glitter in the dark, all adding up to something akin to … a goddess. Baraju clearly knew his métier. Looking at him going over the last details, I was struck by the confidence with which he carried out his work. Would he have taken on the job after his unfortunate predecessor if he had lacked confidence in his abilities? Perhaps; it might be a risky job, it might not pay well, but it is an income, and more importantly, an opportunity to serve god.

As the evening progressed, visitors arrived, some of whom had traveled long distances to honor the mother goddess. Some brought goats tied on ropes. Despite being led through the village toward the temple, the animals appeared calm, even content, quietly following their owners. It might have been sheer relief to get off the bus, bicycle, or motorcycle, in which they had been tied up in a sack on their way to the village. The goats walked briskly to the temple area and were tied up, ready for their final destination.

Prasanta and I hung about slapping mosquitoes and explaining our presence to curious visitors. It was a long, dark evening after an already long day. But an hour or so before midnight, a temple priest lit even more oil wicks in the temple. The flickering lights made *Kali* shimmer and glow, rousing the attention of all of us. The elderly and small children were summoned from their sleep and soon joined the crowd in

front of the temple. The ritual slaughter of goats in honor of the goddess was about to begin.

Holding a sword, as big as that of *Kali*, a priest crossed the temple platform stopping in front of a large woven basket placed at the feet of *Kali*. The first goat was pulled up on the platform. It did not appear to resist, not until someone seized it and held it in place. The priest slowly swung the sword high above his head and then returned the blade with lightning speed to land on the neck of the goat. The next goat in line was brought forward to wait its turn. This time the goat was less obliging. With a third goat on its heels, the animal was brought to its death place in front of the basket. And so it went, on, and on, and on.

In the meantime, visitors kept arriving with more goats. Unlike in the afternoon, the late-coming animals had to be pulled hard, occasionally even pushed or carried, to make the final stretch to the temple. They clearly sensed the approaching danger. No wonder. By that time, the scene had turned into a noisy and smelly confusion, a mayhem of terrified shitting and bleating goats, drums, and the sound of a sword swiftly swishing through the air. One head after another fell into a basket, the unseeing eyes staring, as if they could not believe what they had just witnessed. *Kali* could soon begin her feast.

I sat through it all during that long, dark night, a young anthropologist not wanting to miss out. The spectacle worked on us all, nobody present could ignore the priest and the sound of his sword: cheu …, cheu …, cheu … How could he keep going? I was not able to make sense of the spectacle at the time, but it affected me deeply. The smell from the blood flowing at the feet of *Kali* reached me and my stomach turned. I looked up to find that the deity was gazing at me and I suddenly realized where I was sitting. A shiver ran down my spine as Baraju's words came back to me: "When *Kali mā* comes tonight, do not sit in the line of her vision; she might not like it." In a seemingly insignificant movement, I quickly shifted to the side, well out of her sight.

A Long Journey

On the wall opposite the entrance to Bhaskar's showroom hangs an intricately carved wooden window frame together with various works of art. The pale pink background highlights the colors of the different objects. The display has been created by an artisan who knows the preferences of his customers.

Bhaskar's impressive network – which includes connections in the prime minister's office – says it all. He has done well. Unlike some other similarly gifted painters of his generation, his skills have not been wasted. Well fed, with coal black hair and a neatly trimmed moustache, Bhaskar, in 2017, looks younger than his forty-seven years, so different from some of the painters who often appear haggard. Nowhere was it ordained that he should succeed where other equally talented contemporaries would not.

Bhaskar's life took a turn when he was nine years old in 1979. It happened some hours after lunch. The day had begun like any other day. His mother got up before daybreak, closely followed by his two sisters. A little later, it was his father's turn, and then finally Bhaskar and his brother. The boys rolled up their mats from their place on the mud floor. Unlike their sisters, who were required to begin their day under

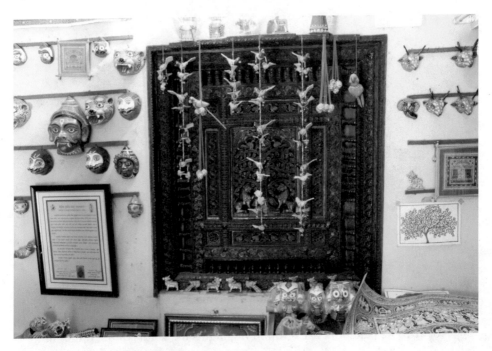

A glimpse of Bhaskar's showroom

cover of darkness, the boys postponed their morning ablutions until later when the warmth of the sun had broken the morning chill. Bhaskar grabbed his neem stick and cleaned his teeth and mouth; he was hungry. They broke their fast at first light with rice flakes soaked in tea. Later in the morning, they would get watered rice before heading off to school.

His father was an artisan of the old school, who could create numerous kinds of crafts, be it wood carving, figures of straw and mud, or wall paintings. He never made a name for himself outside his village, but locally he enjoyed respect for his work, including painting for the local temple and *rajah*. He was a servant of the local *Jagannath* temple in Ranpur, where he was paid a pittance for his work, always in kind, but Bhaskar's father never questioned what he perceived to be his duty. It was work for the deities and, as such, an honorable profession. Some tasks were frequent, like the yearly repainting of the temple deities; others were infrequent but no less important. One such rare and righteous task was to, approximately every twelfth year, carve new figures for *Jagannath* and his two siblings, whose old forms were then buried in the

forest. On that noteworthy day, a day that is engraved in Bhaskar's memory, his father was transforming a tree trunk into the new figures. He held a piece of the trunk in place with his feet and worked meticulously with a chisel, gradually removing layers of wood. It was hard work, for the wood was incredibly dense and required all of his force to ply.

Did his attention slip for moment? Or was it just bad luck? Suddenly the chisel slipped, sinking deep into his foot, the way a knife cuts through butter. He cried out in intense pain, and soon villagers gathered around him. One of them managed to remove the chisel from his foot, but that left a deep, bleeding wound. Someone brought medicinal leaves and placed them carefully over the wound to hinder infection. The leaves seemed to work, and though Bhaskar's father was unable to walk due to pain, he hoped to be able to return to work soon. The sooner the better. With a wife and four dependent children, he had to work.

Five days after the accident, however, the foot began to swell up; soon his lower leg had swollen too, ballooning his leg to the size of the tree trunk he had worked on only a few days before. The villagers grew anxious, both for his sake and also for that of their families. A husband and father unable to work would be a burden on the community and, apart from the local *rajah*, no one had a rupee to spare. The village headman decided that Bhaskar's father must see a doctor. A few of the men placed their unfortunate neighbor on a bullock cart and transported him to the doctor, every bump and stone causing agony. The doctor told them they had come too late; the leg must be cut at the knee. Truly bad news; how could he continue his work as an artisan with only one leg? The villagers pleaded with the doctor.

"Doctor-*bābu*, do what is necessary but do not cut off his leg, there must be another way. How will he work without his leg? We are begging you Doctor-*bābu*."

The doctor told them that one way or the other, treatment would be expensive. Bhaskar's family was in no position to cover the cost. Though they had been hopeful when setting out, the little group of men quietly and with disillusion made their way back to the village. They returned Bhaskar's father to his family. The infection continued to spread and soon his upper thigh also began swelling. Some of the neighbors took it upon themselves to go from door to door asking people to give whatever little they had. Once again, Bhaskar's father was placed on the bullock cart and transported to the doctor. They handed

over the collection, but it was not enough. That was when one of the villagers found the courage to tell the doctor that Bhaskar's father enjoyed the respect of the local *rajah* for his important contribution to the *Jagannath* temple. This new information swayed the doctor, and he decided to give Bhaskar's father a chance. He was transferred to the local hospital where another doctor was able to save his leg.

At the time, Bhaskar's father did not know when he would be able to work again. Despite help from their neighbors, the family was unable to manage without an income. Bhaskar's mother stretched what little they had, but hunger seeped into their home. It was worse at night, going to sleep on an empty stomach. As others would have done, they relied on their widespread network of kin and caste for help. A relation of Bhaskar's father offered to take responsibility for three of the four children. He took Bhaskar's eldest brother as an apprentice, arranged a marriage for his sister, and negotiated an apprenticeship for Bhaskar in a neighboring hamlet.

Accompanied by his uncle, Bhaskar traveled by bus to his uncle's hamlet, Danda Sahi, sixty kilometers from his home village, the longest journey he had ever undertaken. A couple of weeks later, his uncle took him to Raghurajpur where he became an apprentice of Jagannath. Nine years old, he arrived in Jagannath's studio to learn *patta* painting and earn a living. More than twenty-five boys of different ages worked in the studio that day in 1979. Unlike him, the majority of the children returned to their homes before dinner.

Before his stay with Jagannath, he had never painted *patta chitra*. But he was a quick learner, with an aptitude for drawing. When painting, he lost himself in his work. Unlike some of the other apprentices who had to trace over their guru's sketches on the floor an endless number of times before they were able to draw on their own, Bhaskar quickly got the feel for particular movements and soon was drawing swans and fish without assistance. He had good hands, just like his father. Jagannath was the first, but not the last, to notice Bhaskar's gift. It pleased Jagannath to have Bhaskar among his apprentices. The boy's talent reflected positively on his own skill as a guru, and with time the boy might contribute positively to business.

"Did you see that fellow with curly hair?"

"The tall one?"

"Yes, him, he is an important person, a big-man."

One of the apprentices got up from his work, stood on his toes to appear tall, and began mimicking a man gesturing vivaciously while crossing the floor of the studio. The smaller boys watched the spectacle, grinning quietly lest they might interrupt the older ones. From the interaction between the guest and their guru the previous day, the older apprentices sensed the former was no ordinary guest without realizing he was in a position to change their lives.

One morning a few days later began like any other morning in the studio in the mid-1980s. Before daybreak, Tophan opened the large doors facing the hamlet. Cold air streamed in, signaling that it was time to get up. The boys got out from their multi-purpose shawls, rolled up their mats, and one after the other, they found their way out into the courtyard, stumbling across to the kitchen area to get their tea. Tea in hand they would find a place on the veranda, shivering under their shawls. On winter mornings, they postponed their bath in the river as long as possible, sometime until just before lunch, the main meal of the day. They would then walk through the hamlet in small groups, chewing on their neem sticks and carrying their tongue cleaners in hand. A few carried their own plastic toothbrushes, all of which had seen better days, their bristles pointing in all directions. For now, however, they enjoyed their hot tea with rice flakes. Next stop was the studio.

The older boys would work in one part of the studio, the younger ones in another. Unless, of course, they were summoned to fill in color or perform some of the other tasks that did not require particular skill. The youngest boy, a grandson of their guru, was only five years old when he began working in the studio. The little boy had a lot to learn before he could be relied on to put in his share of work. For now, he was drawing on his blackboard. His grandfather had sketched a fish and told him to draw on top of it repeatedly until he could draw a fish in his sleep. The task would keep him occupied for hours at end. The slightly older boys were working on small paintings meant for sale at Puri Beach. Their work was uneven: wobbly lines, a nose too big, a pair of legs disproportionately short and of different lengths. But the majority of tourists would never notice such details, and the boys needed to contribute while learning the skill of painting.

The oldest boys were completing some orders from Kolkata; though the deadline was just days away, they were taking their sweet time finishing the work. The paintings would surely be completed, no doubt about that. The atmosphere was relaxed, and the older boys gossiped among themselves.

In the early afternoon, a visitor arrived in the studio. A few of the apprentices recognized him as the big-man who had dropped in some days before. The boys were used to tourists, Indian as well as foreign. They came regularly to look at the work of an awarded painter, or so they thought. Even with his many apprentices, Jagannath could not keep up with the demand, so he paid other painters from the district to keep his stock full. This visitor, however, was not like the others. The big-man looked unusual, tall with dark curly hair, a twinkle in his eyes, and white *deshi* (indigenous) clothes. He was so different from the usual government officials who turned up in the studio dressed in terylene shirts and pants, always looking bored, as if they would rather be somewhere else. The big-man behaved like no adult the apprentices had met before. He did not want to buy anything and, instead, chatted with some of the boys while looking carefully at their work. Before long, he distributed paper, pencils, and erasers and told them to make a drawing. At first, they were hesitant; he was a guest, and guests rarely give instructions in the home of their host. What would their guru say? The boys glanced uneasily at Jagannath, but one look at their guru convinced them that they should do as they were told.

The big-man promised that the boy who made the best drawing would win a prize of 501 rupees. Just imagine what one could do with that kind of money! Bhaskar thought of samosas, biscuits, and what not in quantities almost inconceivable. He sat down to promptly begin his horse; the man had specifically said he wanted a horse. A horse he would get. After half an hour the boys were told to stop, write their name in the corner of the paper, and line up one after the other in the studio. Bhaskar was the last in line.

"Have you done what I asked you to do?"

"My horse is ready for you to see."

Bhaskar was quite pleased with his horse but unsure about how it would be received. Unlike the majority of the other boys, he had not made the horse in the usual style of his guru, broad and short-legged. Instead, his horse was lean with long legs, as if it were floating through

the air. At least that is what Bhaskar had in mind when he had made the drawing. He handed over his horse to the man.

An excitement filled the room. Who would win? The man looked carefully at each drawing, placing one on top of the other. One, two, three … on and on it went. The boys rocked uneasily on their feet, whispering among themselves. When would he make up his mind? After what seemed like an eternity, he looked up and asked their guru if they could talk in private. Was he disappointed in them or pleased with what they had made? Hard to tell. The unusual visitor and Jagannath left the studio to enter the courtyard. They talked and talked and talked. Why did they need to talk so long? What were they discussing? Although there were many drawings to evaluate, surely it could not be so difficult to find the best. After a while, the visitor returned to the now quiet studio to find numerous expectant faces turned toward him. He looked at all of them, told them to keep up their good work, and then left. He just left! No one had been given the promised 501 rupees. Disappointment, if not outright resentment, quickly replaced the previous excitement. What a cheat! The boys began to mutter among themselves. Their guru entered the room. He did not say anything, nor did he need to. His presence was sufficient. Everybody fell quiet and soon were back at work, but Bhaskar was certainly not the only one who thought with regret about the 501 rupees he had hoped to win.

The following day Bhaskar's guru summoned him to talk in private. "What have I done wrong?" Bhaskar wondered. He had always just been one among the crowd; never had his guru wanted to talk to him alone. It was with some dread that he went to stand in front of Jagannath, his head bowed in respect.

"Bhaskar, you are going to America."

"America?"

Bhaskar was confused; although he had heard of America, he had no idea where it was or how and why he of all people should go there. He did not say anything despite the flurry of questions racing through his mind. If there was something Bhaskar needed to know, his guru would surely inform him in due time.

"You will need new clothes, shoes, and a suitcase. The man who came yesterday is an important man. He was pleased with your horse; this is why he chose you. He did not want to tell you yesterday because the other boys would get jealous."

Who would pay for all this? Bhaskar wondered, not daring to ask. He had no money himself, and his family struggled to survive after his father's accident. Asking them for help was out of the question.

The next two weeks were hectic. It turned out that Bhaskar did not need to worry about the expenses. Jagannath paid for everything, or at least that was how Bhaskar perceived what took place. His guru sent Bhaskar off to the local tailor who measured him and stitched two brand-new sets of *kurtā pyjāmās* for him. He also got two pairs of *chappals* (sandals), a small suitcase, and a plastic toothbrush. Jagannath told him neem sticks would not be available in America, but he was welcome to take some along if he wanted. Bhaskar thought Jagannath might be mistaken. As far as he knew, one could get anything in America, but he kept his opinion to himself. No need to anger his guru. Finally, one day two weeks later, he was ready to leave. His brand-new suitcase was packed and carefully locked with a heavy padlock. All he had to do now was wait. Waiting, however, was trying; he was as excited as he was frightened. Luckily, he did not have to wait long. The next morning a man turned up to accompany Bhaskar on the train to Delhi and take him to the big-man, the man who had chosen him because of his drawing of a long-legged horse. Just imagine, one single drawing!

Bhaskar spotted the big-man soon after his arrival in Delhi. It was difficult to miss him really. He stood out among the toymakers, performers, and artisans assembled in the Ashoka hotel, just as he stood out during his visit in the hamlet. His way of interacting with everybody was so odd. Who had ever seen an important person chatting and joking with ordinary craft makers? Sethi, as the man was called, was different, never putting on airs, always trying to make people feel welcome, no matter their background. If someone suggested dancing the traditional Gujarati folk dance, *Dandiya*, one could be sure Sethi would be the first one to throw himself into the dance. Bhaskar obviously did not know this at the time, but nevertheless, he felt relieved to see one familiar face among so many strangers. It had come as a shock when he realized that no one here spoke Odia. He was the only person from his state. Although all of the craft makers and performers were Indian,

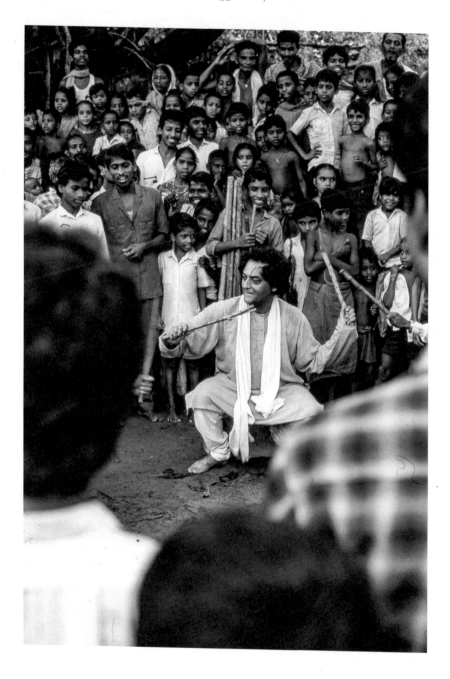

Rajeev Sethi joins in the dance, 1991

they spoke different languages and many only spoke a broken Hindi, just like Bhaskar himself.

A few days after his arrival in Delhi, in the summer of 1985, Bhaskar flew with thirty-nine craft makers and performers to Washington, DC, to participate in *Aditi: A Celebration of Life,* a particularly grand example of the global Festival of India events. Little did Bhaskar know, he was participating in a major symbolic event organized by the author and cultural activist Pupul Jayakar's principal organizer, the designer Rajeev Sethi.

As he boarded the plane, Bhaskar thought of his guru's detailed accounts of how one travels on an airplane. Did they really tie up one's body and arms to the seat? Better not to think about it. He would know soon enough. Before long, the engines began to roar, the plane took off, and he was on his way across continents and the Atlantic Ocean – the outcome of a combination of happenings: his father's accident, Jagannath's willingness to take Bhaskar on as an apprentice, and, not least, his drawing of a long-legged horse, floating through the air.

A Brief Glimpse of Joy

The temperate days were ending. Spring was upon us and with spring came Holi. The children and the young men had been looking forward to celebrating the festival of color for days. The holiday of 1992 was no exception. As in previous years, they would walk to the neighboring hamlets to play with color. Girls and young women stayed put in the hamlet; it was not for them to venture out of the boundaries of the hamlet to risk being assaulted by excited young men high on *bhāng* or alcohol. Still, we had fun. The children had thoroughly enjoyed bombarding me with color in the lanes, then disappearing into the houses as fast as a hermit crab retreats into its shell when I hurled color in their direction. By the time I reached Sula's home, my face was dark blue and green.

As usual, Sula was making masks by smearing layers of recycled newspaper with translucent glue, gooey liquid the texture of American pancake batter, and placing them on top of a clay cast. With practiced hands, she laid out one mask after another to dry, rows of masks gradually decorating the courtyard with the rounded, graceful Odia newspaper print. In a few days, she would paint them with primary colors – hours of work that resulted in a pile of colorful masks but only little money.

When she saw me approaching, she immediately interrupted her work, bolted up, and took flight running down the path behind the row of houses. I followed in close pursuit, both of us laughing. Back

and forth between the coconut palm trees, on and on we went until an older woman from the neighboring house called me.

"Helli, what are you doing? Do you not know? This is no time for Sula to run around like this."

"What is the matter *māusi*? Have I done something wrong?"

"Can't you see? Sula is married."

I should have known. Looking at Sula's slender frame and knowing what to expect, her pregnancy was indeed apparent between the folds of her sari.

"Why did you not tell me Sula, you could have told me to stop?" Sula smiled but did not look me in the eye. How could she have told me about her condition? After all, I was not yet married.

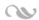

When Sula married, she moved to another town with her husband and his brothers, close to his work. He worked long hours and Sula felt lonely and bored. At home, she had never been in want of company or been forced to sit about futilely. There were always relatives or neighbors around and work to be done, whether household chores or mask making. Sula suggested she could take up mask production in her new home, but her husband's elder brothers would not hear of it.

"Such a waste, I could have been earning. Instead I just sat there waiting."

"Is that why you did not remain with your husband in his house?"

"Yes, he and I decided we would be better off if I stayed with my parents. Then I could make masks during the day instead of being idle."

Sula's husband paid her a visit every fortnight or so, staying in the house of his in-laws. What feasts they had when he came! It was not only Sula but also her younger sister and their parents who looked forward to his visits. He always brought small gifts, a snack, or some special food, yet it was his gentle ways and friendly smile that won over his in-laws; he was the son they never had.

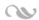

Sula's daughter Ranu was born in the sweltering month of June. Tophan and I were chatting on the veranda in front of Jagannath's house when a cycle-rickshaw approached the center of the hamlet. The hood was down, shielding the passenger from the scorching sun and curious onlookers. A woman was rocking back and forth trying to cushion the bumps in the lane; she was holding something in her arms … Sula, Sula had returned from the hospital. I rushed to bid her welcome back but stopped as I came up close. I could hardly recognize her; she looked ashen and worn out as she sat there in her bloodied sari. Still, I gave what I thought was an encouraging smile. Sula acknowledged my presence but did not change her forlorn expression. Was the baby all right? What about Sula herself? Had something gone wrong?

Two days later, I decided it was time to go and see Sula. She sat in the corner of the room facing the lane leaning against the earthen wall, the baby asleep on a mat next to her. Sula still looked tired but a little less grayish, and she did smile when she saw me coming.

"Come, sit … but not on this mat."

"I know … It's a girl I heard. How is she?"

"I am worried she will catch a cold."

A cold was the last thing on my mind in this sweltering heat. The room felt like a sauna, without even a slight breeze, just sweat. We sat without moving a limb, and still droplets of sweat trickled down our bodies. The rains, however, would soon descend upon us, announcing the beginning of the four months when the world is submerged in water while *Vishnu* sleeps floating on his snake. And with the rains come fevers and colds, maladies no good for a newborn. Holi and our goofing around suddenly seemed so long ago. Sula had passed into a new stage of her life, another world where joy is accompanied by apprehension.

Sula's mother appeared in the door with a woven mat for me. She passed the baby, making sure not to touch her or the mat on which she slept. After she had placed my mat at a safe distance, she told me to sit and then quietly left the room without touching anyone or anything. Looking at her careful maneuvers in the narrow room, I thought of the mother of one of my close friends at home. Her mother could never get enough of her newborn granddaughter and would make the most of any opportunity to hold or stroke the baby. Did Sula's mother long to hold her granddaughter in her arms? Perhaps she did, but she did not talk about it. What was there to say? Like everybody else, she would

have to wait for weeks until mother and baby had been through the ritual cleansing that permitted them to partake in everyday life.

The four months passed, and although a skin infection passed from child to child in the hamlet, leaving the sufferers with large, painful boils, Ranu was unharmed. As the first born she had no siblings, making it easier for her parents to keep contagious children out of the way. Still, Sula had been on her guard in case one of the children touring the hamlet should decide to pay the baby a visit.

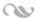

"What name will you give her?"

Sula looked at me expectantly. Her daughter was four months old and still did not have a name. My mind went blank; did I know any names that would be suitable for her little girl? I have never found it easy to reply on the spot. Sula, however, was waiting for an answer.

"Lalita, call her Lalita. It is such a beautiful name."

"Lalita – what are you thinking? You also named Manorama's daughter Lalita. It will not work."

Sula was right, of course. What was I thinking? I had still not become used to how villagers would ask me to name their child, expect an immediate answer, and, without hesitation, accept my suggestion. That is unless I suggested the same name more than once. I felt rather foolish and wracked my mind for another name.

"Ranu, call her Ranu."

Sula smiled. That was it. Her daughter was named Ranu.

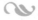

With the birth of Ranu, her father came as often as he could afford the journey back and forth between the town, where he worked and stayed, and the hamlet. Despite her father's irregular presence, Ranu responded with glee whenever he came. No wonder; when at home, he spent hours with her, tickling her tummy until she giggled or, when she was a little older, letting her bounce up and down in his lap. One afternoon, while her mother and I were chatting in

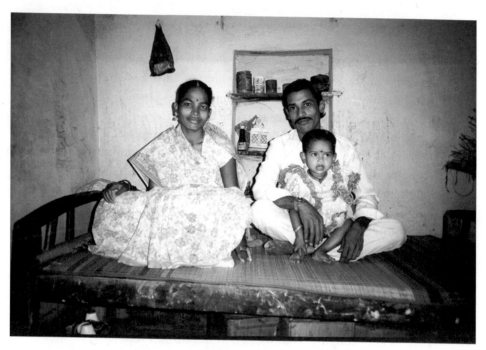

Sula Moharana with her husband and daughter, 1994

the room facing the lane, Ranu spotted her father appearing in the doorway and let out a shriek of excitement, raising her arms to be picked up. Who could resist such an invitation? Certainly not her proud father; he was happy to indulge his little girl. Of course, he was not the only young father in the hamlet who enjoyed his child. Fathers would stroll down the lane to pay a visit to a friend with a young child in their arms.

Not all fathers, however, were equally delighted when told that they had fathered a girl. Passing by to see Manorama's third and most recent baby girl, I found her in tears. These were no tears of joy but deep and unsettling desolation.

"But what is the matter with you, sister? The baby seems fine."

"It's a girl."

"It's a girl all right, but she seems healthy, arms and legs, everything is where it should be."

"You do not understand anything ... you have no idea."

"What are you talking about? You have been given a healthy child. What more could one want?"

"He will not let me be until we have a son. He wants a son who can become a master of his craft, just like himself. I will have to try again, I do not know what to do, what if I will never have a boy?"

"Surely a girl can also learn to paint. What is the need of a boy?"

Manorama did not even bother to respond to my detached observations but cried even harder. This was not the right time and place to discuss the injustice of a world that favors one gender over another. Manorama needed my understanding of her situation. My indirect critique of dominant norms, which she was in no position to change, only added insult to injury, leaving her cold and alone in her misery.

It's 2017, and I am planning another visit to the hamlet. The time has come to go through my old slides and negatives. I have so many that really belong to the painters. There is one I am searching for in particular: Ranu with her parents, the three of them dressed in their finery. Usually prancing around, Ranu, in her white and pink frilly dress was, for once, sitting quietly in her father's lap while I took a photograph. I want Sula to have this photograph; I must take it along this time. Who knows how long we have left.

I remember those visits so clearly, as if they were yesterday. While Ranu performed an unsteady dance, her grandfather passed by – "Have you heard Helli, she has learnt her first words?" "Yes, I have heard," but I could not make sense of what she said and wondered whether anyone could. Her mother of course, and perhaps her father. Her grandmother, meanwhile, brought some food she had prepared for Ranu.

"Here, why do you not give it to her?"

As always, Sula's mother had a point. I might as well make myself useful and give her parents a small break. When it was my turn to eat, I passed Ranu to her grandfather. Surrounded by grown-ups who wanted the best for her, Ranu could always find a pair of arms ready to cuddle, a hand to hold onto when passing the steep doorway, or an encouraging "go on" should she need it. A warm and safe environment for a little girl, or so it seemed at the time.

When Ranu caught a fever, nobody in the hamlet was able to help her. Her parents, her grandparents, and her aunt, they all did their best to care for her, but this was no ordinary fever; it would not let her go. Increasingly worried, her father took her to a doctor – but to no avail. Ranu stopped responding to her parents' pleas. Two and a half years old, she left them behind with an emptiness caused by her parting. Without her, no shrieks of joy, no new words, no laughter. Without her, nothing.

A Convenient Arrangement

Visiting the painters always brought back a flood of memories. On one occasion in 2016, as I stepped through the dim entryway to see Mera, a scene twenty years old came rushing back. It was 1994, the year before Mera was to be married into the household of an old squinting hag, Supeyee. Although no worse off than many others in the hamlet, the matriarch kept pestering me for money, lamenting the misery of her household. Her tone of voice, as well as her account of the misery, shifted based on my response. The more distance I put between us, the more she whined and the worse off the family became. Finally, in a desperate attempt to be left in peace, I offered her a loan. Thoughtless really, but at the time I saw no alternative. Having got her way, she invited me for lunch and made quite a show of it, spreading a large banana leaf to serve as a plate on the floor and sprinkling it with what turned out to be contaminated water. My stomach turned as I watched her preparations, perhaps because of my intense dislike of the woman or a premonition of my falling ill. Whatever it was, I decided to not have anything to do with her again if I could help it. Her husband, Sana, however, was an altogether different personality, unobtrusive but well liked by all. In order to see him I went to Jagannath's studio, the place where Sana had spent most of his married life. Here he worked away in peace paid by piece rate, a personal and financial blessing.

The house had not changed one bit in the twenty-one years after my first visit. It still felt constricted, the narrow rooms placed one after the other like the compartments of a train. In contrast to the dark bedroom in the middle, light entered the compartment rooms at either end through the doors and small windows. The atmosphere in the house, however, was different. We sat next to the window, and there she was, the old woman squinting down on us from her place on the wall. Next to her was Sana, her husband. Was it a coincidence that his picture seemed to have more marks from the sprinkling of water than hers? Did my imagination play a trick on me? Probably. After all, both of them were ancestors now and, as such, worshipped all the same.

"When did they die?" I asked, not sure what kind of relation Mera had enjoyed with her in-laws.

"She died a year ago, and my father-in-law died three years before her ... Your feet look bare without *olatā*. I will apply *olatā*, it will look nice."

"Yes ... I would like that." Although I do not much care for the bright red lines with which village women decorate their feet when applied on my own, I enjoy the intimacy of the application. It is something women do together and to each other as a sign of care. And it is usually a good opportunity to talk. Mera found the plastic container with *olatā* next to a bottle of nail polish and some *sindura,* the red powder that was a sign of her married status, and began to decorate my feet.

"She looks just like I remember her," I said vaguely.

"Yes, good riddance." Mera looked up briefly. Was she judging my reaction? I could not help laughing.

"I never liked her myself." In fact, over the course of my time in Raghurajpur, she was the only person I truly disliked. "How did you cope for all those years?"

"My father-in-law was a nice man; he was always good to me. But she gave me a lot of trouble."

I could easily believe that. Twenty years earlier, Mera's father, who was usually in a good mood, returned home one day clearly upset. "They want more," he said to his wife. "We had agreed, it was all planned, and then they suddenly want more." He shook his head in frustration. He was referring to the dowry negotiations related to his daughter Mera's wedding. Later in the afternoon, he told me about the arrangement, which involved no less than three families.

In a country where patri-locality, with a few exceptions, is the norm, a new bride moves to live with her in-laws. It usually involves leaving not only her family but also the place where she has grown up. Often, it can be a disturbing, isolating experience. When living in the hamlet in the late 1980s and early 1990s, I witnessed the arrival of a number of brides. I am not sure exactly what I had expected. I had read about how a palanquin will shelter the bride from prying eyes on her way from her natal home to that of her husband, but nothing had prepared me for what I saw. Late one evening, after hours of waiting, we heard a cacophonous racket from musicians and children shouting excitedly. Behind them followed a procession, in the center of which four men carried what appeared to be a wooden cage fit for a wild animal. Rather than an animal, however, it contained a terrified young woman who had to be dragged out the cage and into her new home.

Mera would not have to go through that daunting process if the families managed to settle the negotiation. This, however, was not the reason why her parents were negotiating with their neighbors, Sana and Supeyee. The issue was their lack of a son, a problem they shared with a couple of other families in the hamlet. Who was going to take care of them when they grew old? Mera's older sister had moved to a village when she had married. If Mera stayed in the hamlet, she would be able to help them.

Compared to Mera's parents, Sana and his wife were even worse off. One morning, their only son went to the river to have his bath but never returned. An unusually strong current had taken him by surprise. For this reason, they decided to adopt the younger son of a couple who had a surplus of sons and hardly any land. The arrangement would benefit both households – Sana and his wife would get a son and a daughter-in-law who could take care of them in their old age, and the parents of the adopted son would not have to worry about splitting their house and land between their many boys. In other words, the marriage between Mera and her husband was an advantage for everybody concerned, or so it seemed at the time. Was I the only one who wondered how Mera would fare with her future mother-in-law? Unlikely, but everybody knows that women will eventually marry and leave. That is how it is. And in any case, to get something, one must give something in return.

Mera had certainly paid more than her share. Less than 600 feet separated her new household from her childhood home. Still, she was

not permitted to walk down the lane to see her parents. Before her marriage, she had been free to move all over the hamlet. As a married woman, she was allowed to leave the household only to fetch water from one of the wells, always in the company of her mother-in-law. Mera had been well liked in the hamlet, quick to lend a hand or crack a joke. Supeyee put an end to all that, expecting her to move through the hamlet as a shadow of her former self. Although it was extreme, it was not unusual in the hamlet at the time. What was unusual, however, were the regular beatings. Everyone in the hamlet knew what was happening behind closed doors, but no one interfered. "It is for them to decide. It is out of our hands."

"For seven years, I cleaned her ulcers and her body when she shat herself in bed," Mera said. "That was bad enough. Worse, however, were her punishments. If I did not see to her immediately when she called, she would smear her own shit on the walls. I then had to clean up the mess." No one likes having to clean shit off walls, but in a society preoccupied with cleanliness, there is more at stake than dislike. I shuddered to think of the humiliation Mera must have felt at the time.

"Before she fell ill, she used to hit me. Give her a chance and she beat me. I might be sorting rice grains in the kitchen and suddenly, bang, I got wacked. But she also enjoyed starving me, I will never forget what it feels like to be truly hungry. My father-in-law felt sorry for me and, given the chance, he would sneak something to me. During the first years of our marriage, my husband tried to reason with her, but then it was his turn to get a firing. What could we do?"

Mera completed my right foot and began on the left while I took in what she had said. "I did not like it when she hit me, but I got really frightened when she started using *guni* (black magic). I thought I might die. Had it not been for my mother, I do not know what I would have done. The minute she saw my mother-in-law leaving the house, my own mother would come to the kitchen bringing counter-medicines from the bazaar. She used the path behind the houses to make sure my mother-in-law did not see her."

"When did you say you got married?"

"In 1996."

"Almost twenty years ..."

Mera looked at me as I stared at the old couple on the wall. "When she finally died, my husband refused to pay for the funeral rites. 'She

made our lives hell, why should I pay?' he said. I did not think that was right, so we paid despite what she did to us."

Mera sat back, having completed the decoration of my feet. The concentration of color was so strong that the line almost looked green in some places. "Twenty years …" I was unable to shake off the feeling of those wasted years. Mera, however, was not one to dwell on the past. She stood up, gazed at her in-laws, and said with a grin, "But now, at last, we are free." She and her husband were still young, they had three children, their own house, and a tiny plot, and she could lend her aging parents a hand if needed. Everything considered, their parents' arrangement might not have been convenient to all involved but it was indeed far-sighted.

A Friend for Life

His thoughts drifted, savoring the memories of his journey to Washington, DC; one image replacing another, not unlike the clouds passing outside his window. Bhaskar turned his back to the passenger sitting next to him, only partly to gaze at the floating spectacle. He also needed time on his own to contemplate the whirlwind of the last two months. So much had happened during his stay in Washington, he felt as if he might burst at any minute. How could he ever relate the experience to his parents and siblings, to give them a sense of the world he had been part of this summer? And what about the other apprentices in the studio, would they believe what he had to tell? Just as well he had his photo album; that, at least, proved he was not making things up.

Bhaskar bit his upper lip and, for a brief moment, wondered about the salty flavor. He had been crying. Leaving the friends he had made in America was not easy. Some of them, of course, were traveling with him on the plane, but soon they would all go their separate ways. Would he ever see them again? Somehow, he did not think so. Although they all lived in India, it was unlikely they would ever get an opportunity to visit each other. Sethi, yes. He might see the man if his work with arts and crafts brought him to the hamlet again. And what about Richard, his American friend; would he get a chance to see him once more? Perhaps. In fact, it was probably more likely that he would see Richard than his fellow citizens who had participated in *Aditi: A Celebration of Life*. Fifteen-year-old Bhaskar realized that his travel abroad was a rare

opportunity only few Indian craft makers would ever get. Flying home, he savored every bit, like the satisfaction after a great meal.

Bhaskar did not understand why he kept falling asleep during the hours when he was supposed to work at the National Museum of Natural History in Washington, DC, during the summer of 1985. It was embarrassing really. Repeatedly, he felt his eyes close while working over a painting. More than once, one of the other craft makers elbowed him to keep him awake – that is, if they were not asleep themselves. Rumors began to circulate among the craft makers and performers; it might have something to do with the food, or perhaps the climate? Or maybe Indians could not cope with this environment? One morning, a few hours after they had begun to work, Sethi woke him up. Bhaskar was confused and half-asleep, but nevertheless deeply ashamed. Was this any way to show gratitude to the man who had made all this possible?

"So sorry, I am very sorry. It will not happen again. I do not know why I am so tired. I cannot keep awake."

Sethi did not seem angry. In fact, he looked amused.

"When do you feel tired?"

"I am tired already before lunch, I do not understand."

"It is called 'jet lag.' Your body needs to get used to a different time zone. It will take some days."

Bhaskar had never heard of time zones, but he was relieved to know there was nothing seriously wrong with him or the other artisans. Gradually, he got used to living in the United States and soon began to enjoy himself. In the afternoon, an interpreter arranged visits in the city. Among Bhaskar's photographs is one taken from the top of the Washington Monument, which, Bhaskar said while we flicked through his album in the winter of 2017, is now closed to the public.

In a section of the museum, the organizers had simulated the appearance of a rural Indian village, a setting in which all the artisans and performers could do their work. It looked nice, clean, and well kept, unlike any village Bhaskar had ever seen at home. All of the craft makers and performers had to work on the museum grounds between 10 and 4 o'clock every day, except on weekends when they taught their

skills to museum visitors. During the first days of his stay, he managed to sell three of his guru's paintings. He was pleased with this achievement. It meant he did not have to return empty handed. Bhaskar was not the only artisan who tried to sell his work. The exhibition grounds, however, were not a marketplace. A museum employee intervened and arranged for a signboard forbidding the purchase and sale of crafts in "the village." It did not take long before the artisans found alternative ways to sell their work, transforming their hostel into something akin to a showroom.

During the weekend, Bhaskar taught American children how to paint. At least he tried his best. Thirty years on, he did not remember being a particularly effective instructor: "I was a young man at the time; I did not know how to teach." He lost his patience whenever the children did not listen properly to the woman who translated his guidance. Had they acted like that in Jagannath's studio, they would never have lasted a day. Still, it was fun to spend time with the children. They often stayed with Bhaskar for hours while their parents went elsewhere in the museum, and this provided him ample opportunity to pick up English words and phrases.

His newly acquired linguistic skills came in handy a few weeks later when he met Richard. Throughout the *Aditi* exhibition, Richard regularly visited the museum grounds on his days off, enjoying the rare sight of performers and craft makers at work. Bhaskar recalls how Richard asked him to draw Buddha and was so pleased with the drawing that he ruffled Bhaskar's hair while telling him his work was enough to drive anyone crazy. The next day, Richard brought chocolate. They spent an increasing amount of time together. Indeed, Bhaskar's photo album from his journey contains several photographs of their many adventures. Among the things Bhaskar recalls vividly was their day playing Frisbee in a park. A moment after their fun, especially, made the most profound impression on Bhaskar. Richard offered him the opportunity to stay in America as his adopted son; he would live in a house with Richard, his mother, and his sister. Bhaskar was unsure what adoption entailed. "Will I have to stay in America?" he asked. Richard confirmed that yes, indeed, he would get the opportunity to stay in this amazing country. America might offer a way of life many people would be incredibly happy to take on, but not Bhaskar. He wanted to go home to his family and friends. Although Richard was disappointed, he could

understand Bhaskar's choice and told him not to worry. They could still
meet in India. Richard suggested he might visit Bhaskar and his family
in Odisha one day.

During his stay in the United States, Bhaskar earned more than 45,000
rupees selling crafts. The incredible sum resulted partly from the paint-
ings Jagannath had asked him to sell but also from Bhaskar's own work
produced during his stay. His uncle from Danda Sahi advised Bhaskar
to keep some of the money for himself. His guru was known to be gen-
erous to students, teaching and feeding them. Payment, however, was
another matter. Upon his return, he handed over a large part of the
money to his guru. Jagannath, Bhaskar hoped, might send 5,000 rupees
to his family, who really could have done with some help. His guru was
pleased with him, that much was clear: He was "a pride to Odisha and
to our hamlet," and Jagannath wanted to celebrate Bhaskar's achieve-
ment. Bhaskar kept quiet on the issue of money, for it was not his place
to say anything. On the occasions during his journey when he thought
about his fellow apprentices, he hoped they would not become too jeal-
ous. It had never crossed his mind that his relationship to his guru
might change, that he would be turned into a local celebrity.

Jagannath kept his word and gave a feast in Bhaskar's honor upon
his return. In grand fashion, the artisan invited the local villagers, guests
from other neighboring villages, and government officials from the cap-
ital to honor the deeds of his apprentice. So many people! Bhaskar felt
overwhelmed but, admittedly, also proud to be the center of attention.
His friends from the studio gathered around him, and they were all so
excited that they almost missed Jagannath's speech. The majority of the
guests, however, soon turned their attention to the proud guru. Dressed
in his best tassar silk *kurtā* (long tunic) and a *dhoti* (garment wrapped
around the waist), Jagannath delivered his speech. He enjoyed events
like this, which gave him an opportunity to exercise his skills as a per-
former; it was not for nothing that he continued to organize religious
performances in the hamlet. As the words began flowing, he spoke of
the proud tradition of Odishi paintings, the role he himself played in
the revival of this craft, and – after what Bhaskar perceived as a small

eternity – the accomplishments of his apprentice who had brought honor to the *guru kula āshrama.* This last and briefest section of the speech came to an end when Jagannath ceremoniously placed a garland of flowers around Bhaskar's neck. The next thing Bhaskar knew, villagers were lifting him off his feet and ferrying him up and down the hamlet lanes. Bhaskar recalls this day as full of joy and excitement. Never in his wildest dreams had he expected to receive so much attention.

A week after his return, Bhaskar asked his guru for permission to visit his relatives. Jagannath sent him off without any fuss. He even supported the idea, saying that his parents would be waiting to hear the news of his journey. He felt embarrassed to return home empty handed, but he wanted to keep his savings. And apart from Jagannath's blessings, the guru had not given him anything. Reaching home, he realized just how badly his family needed financial assistance. His father was still unable to work consistently. The stark contrast to the life he had enjoyed in the States made it impossible for him to share his wonderful experiences with his family. He vowed, there and then, that he would do whatever it took to change their fate, and after returning to the studio, he gathered all his courage and asked his guru for permission to speak to him.

"*Mausā* ... my father is not well, he is still not able to work full time, and my family needs my help. This is why I ask for ... a salary ... 125 rupees a month ..."

Bhaskar did not dare to look at his guru while addressing him. Jagannath, however, listened. He did not doubt Bhaskar was telling the truth, but he was just one of many who requested the artisan's help. Jagannath had his own family to think of, and he could not help everybody. He did not reply immediately, and Bhaskar wondered whether Jagannath had in fact heard his request. Did he dare to repeat his question? As it turned out, Jagannath had heard every word. When he finally replied, his response did not give Bhaskar much comfort.

"Yes ... we will see about that ..."

A few weeks after his return from America, he received a letter from Richard containing a large black and white photograph of Bhaskar. On

the back of the photograph, Richard had stuck a small, typed note: "To: Bhaskar Mohapatra. From: Your Friend-For-Life… Richard." It was, and still is, a photograph of a strikingly handsome young man. Half a year went by, and then one day, there was another letter from Richard. Business at the American Embassy in Delhi had brought him to the city, offering a good opportunity to see Odisha and, of course, Bhaskar. He arrived loaded with gifts for Bhaskar: new clothes, shoes, toys, and a camera. I remember the camera well. Bhaskar proudly showed it to me three years later when I lived in Jagannath's household.

Richard stayed in Puri almost three full days at the old BNR Hotel, a lodging named after one of the leading railway companies of the Raj, Bengal Nagpur Railway. What adventures they had! Bhaskar was picked up from the studio each morning to go sightseeing. No drudging work for him, the visit was almost as good as his time in the United States. Among other things, they went to the famous sun temple, Konarak. Bhaskar was quite embarrassed at first as they passed a series of erotic motifs, one after the other. Would it ever stop? What would Richard think? Richard, however, laughed and told him about the history of the temple, and said he might learn something if he focused on body proportions and their shape. The next morning they spent in Puri. First, they circled the great *Jagannath* temple, as Bhaskar described its interior beauty. The afternoon was spent strolling through the bazaar in front of the temple. In the afternoon, they ambled along the beach looking at the large white and orange conch shells displayed in the numerous stalls and the hump-backed camels with their brightly colored saddles of reds, yellows, blues, and greens. The days passed all too quickly, and soon Bhaskar was back behind his desk in the studio.

Half a year went by, but his family had still not received a single paisa. That was when Bhaskar decided to go on a hunger strike. He did not say anything to his guru, that was unimaginable; he simply stayed away when the other apprentices ate their meals. It lasted for two days. He was so hungry. Had it not been for his friends, he might not have been able to carry it through. They passed him biscuits or some such snack

in secret, only just enough to quench the worst of his hunger. Soon, the villagers began to notice.

"What is the matter with you?"

"Why are you behaving like this? Do you not have any respect?"

He was advised to forget his protesting. After all, this is no way to behave to one's guru. However, Bhaskar was steadfast and stuck to his silent remonstration. After three days, a collection of the villagers decided to end the affair, and one of them spoke with his guru. Jagannath agreed to give Bhaskar a monthly salary. It was inarguable that his work made a positive difference to the household. He was given his salary, but the newly acquired wealth came with its own set of problems. He was soon to realize the difficulty of being the only one among his group of friends with money in his pocket. Three weeks after his first salary, he had spent more than half on snacks and frills and felt too embarrassed to bring home the remainder to his family. Once more, he went to his guru, this time to ask that his salary be sent directly to his father. For a second time, Jagannath accepted his request, this time praising him for thinking about the well-being of his family. The family, however, never saw a single rupee. The financial demands on Jagannath were never-ending with extended relatives, apprentices, and neighbors depending on his support and goodwill.

Weeks turned into months and months to years. Bhaskar never stopped his attempts to spur the guru into sending money to his family, but his efforts were always stonewalled. Seventeen years old, he could wait no more. He decided he would establish himself as an independent artisan. When he heard that a rickety cottage in the hamlet was for sale for 11,000 rupees, he decided to spend the remaining savings from his trip. He did not have all the money needed, but with the help of his father, who managed to raise 2,000 rupees and some friends in Bhubaneswar, he was able to buy the cottage in his father's name. It was a bold move, a move he could not possibly have accomplished without the support of his family and friends. Failure was out of the question. He sat from morning to evening producing *patta chitras,* painting no less than ten hours a day. After a month, he had earned 3,500 rupees, a respectable amount, yet he decided he must work harder and increased the number of working hours to twelve. He missed going to the river with his friends but stayed where he was, turning out paintings. The next month brought in 4,000 rupees. After a few months, he managed

to repay his loans. He was particularly pleased the day he returned the loan from his father, who had raised the money in his village. Although he was lonely at night – no one should have to sleep on their own – and had to be content with food from the market stalls, he felt pleased with himself.

Many would have been satisfied to stay put. But Bhaskar wanted more than turning out paintings for tourist consumption. After a year in his new house, he decided to rent it out and moved to the capital in the hope of getting more challenging work. To say he succeeded would not do justice to his achievement.

Work for a renowned painter in Bhubaneswar brought him to Delhi, where he was to stay for a fortnight touching up paintings purchased by a big hotel. He was supposed to return directly to his employer after completing the job, but always on the lookout for an opportunity, he decided to pay Sethi a visit in his Delhi office. Sethi made use of his contacts, and within a day Bhaskar was on his way to Mumbai where he was to decorate the walls of a brand-new hotel. One job led to another and three years went past.

Twenty-three years old, Bhaskar was a homeowner; he had traveled abroad and had worked in some of India's megacities. The time had come to settle down – or at least get married. A prospective bride was found through the extended caste-based network, but married life did not stop him from taking on work outside his state. For years he lived as a migrant worker, returning to the hamlet every two or three months to see his wife and children. His youngest daughter was only six months old when disaster struck.

With a super cyclone advancing on the Odisha coast in October of 1999, the population living in low-lying areas was advised to leave for higher ground. All the same, many people remained in their homes, having nowhere to go. Bhaskar, however, brought his young family, as well as his photo album, to his childhood village further inland. That was a fortunate decision. Nine days after the cyclone struck, when the roads to the hamlet were again passable, they returned to find their home destroyed. Two coconut palm trees had crashed into the

roof and a wall had crumbled. Most of their belongings, including some of the saris Bhaskar had brought his wife from his travels and his stock of paintings representing months of work, were lost in the mud. Among other things, the government provided plastic sheets to shelter people from the rain, but it was impossible to stay in the cottage. Although their neighbors hardly had space for themselves in their narrow home, they let Bhaskar and his family move in for as long as it would take him to clear out the debris from their broken home. Bhaskar's wife shuddered as she recalled what they went through after returning to their house. "The ants," she said, "Helli, you can't even begin to imagine, they just would not leave our baby girl alone. She cried and cried; it broke my heart, what could I do? I had nowhere to put her but on the floor."

For once, the ever-dynamic Bhaskar was at a loss as to what to do. He had lost his savings, his house was broken, and his daughters were too small to manage for long without proper shelter. Surely, they would get a fever if he did not find a way out. Sleepless nights followed, Bhaskar restlessly speculating about his options, when suddenly he remembered his friend Richard from the United States. They had not spoken for some years, but Richard had written "Your Friend-For-Life" on the back of the photograph, had he not? It was worth trying to get hold of him in this time of need.

The next morning at the crack of dawn, Bhaskar sat down to write a draft of a telegram. He paid to have it translated and sent it off to the United States. And then he waited, hoping it would reach his friend. Within a day or so he received a reply. Richard had not forgotten him. The American requested a photograph of Bhaskar and his family in front of their broken cottage, so Bhaskar hired a studio photographer from the local bazaar. In the photograph, Bhaskar and his wife stand in front of their shattered home with their children. The top of the baby's head is just visible, shielded behind her mother's sari; the older sister is clinging to Bhaskar's hand. Bhaskar dispatched the photograph to the post box address Richard had provided. This time, the reply was again prompt. Richard must have sat down to write the minute he got the letter.

Richard was clearly a practical man. He inquired about their needs and suggested that Bhaskar should look for a piece of land on which to build a suitable house. The couple were likely to have more children,

but even if they did not, surely the two girls would grow. Their current house, in Richard's opinion, was too small to accommodate the family for very long. Their correspondence went back and forth.

"How many rooms will you need?"

"Two and a kitchen. One room in which I can work, one in which we can sleep, and a place to cook. That is all."

"What are you thinking? Surely your wife and daughters need a latrine and a bathroom."

"We can go to the river."

Bhaskar did not want to appear like a spendthrift, particularly when it was not his money to spend.

"Do you want your wife and young daughters to go to the river? What if they need to go at night? No, that will not do."

Richard told Bhaskar to get hold of an architect, order him to draw up a house plan, and meet Richard in Delhi. Richard provided Bhaskar with the money needed to buy a piece of land, and they discussed the design made by the architect. Richard found it somewhat lacking.

"Why does the house not have a roof terrace?"

"It costs money."

"Yes, well that is my headache, not yours."

Bhaskar returned by train to Odisha to acquire the property, a piece of land just outside the hamlet, and Richard provided the money needed to build the house. Bhaskar followed all of Richard's instructions apart from one. He did not sell his broken house, as advised by Richard, to raise money for furniture. Instead, they managed without and gradually fixed their broken home in order to rent it out. This provided the family with an admittedly small but stable income for fifteen years

As Richard had predicted, Bhaskar's family grew in the years following the destruction of the super cyclone. With four daughters, Bhaskar and his wife are now grateful that Richard had the foresight to advise them to leave behind their old house. Unlike so many of the families who have stayed on in the hamlet, they did not have to tack on new floors to accommodate their family.

My time with Bhaskar passed quickly as we reminisced over photographs from our youths. So much had happened, so much was still fresh, and so much lived now only in the pictures. As I got up to collect my things in Bhaskar's home, one detail nagged at me. I wondered about Richard. Who was he?

"Are you still in contact with Richard, and do you have his address by any chance?"

"We lost touch years ago, although I still have the post box address. I do not know where he lives. If he is still alive."

Bhaskar's wife who had sat with us in silence butted in.

"He is our god … He will always be with us no matter where he is. He came to us in our hour of need."

Her husband agreed with a wobble of his head. It was Bhaskar, however, who had the final word.

"You must write that in our story. Who knows, perhaps one day he might read it."

Too Good to Be True

Sunlight streamed through the entrance door and the small window, which, like other windows in the hamlet, was not glassed and had wooden bars blocking the entrance for potential trespassers. It was winter, 2017. An image of the elephant god *Ganesh* from a Hindu calendar decorated the wall across from a framed collection of photographs. Among the photos hung one of Seema and me posing in a studio in Bhubaneswar from the late 1980s, another of Lingaraj and me eating one of countless meals sitting side by side from 1991, and a third I took of Lingaraj's father, Mukunda, in 1992. At the time, Lingaraj made a living painting and not least selling *patta chitras*. He had done well. It had been a thriving household with a promising future.

"Mā must have heard us. She will be waiting. Come now." Prasant, Lingaraj's eldest son, tugged at my sleeve. On our way to the kitchen, we passed Suna, Prasant's eighty-one-year-old grandmother, now nothing but skin and bones. Full of days, she was resting on a mat in a tattered sari, which, like her, had seen better times. Just like the room facing the lane, the multi-purpose room next to the kitchen appeared unaltered. It was our faces and bodies, rather than the rooms, that most clearly reflected the passage of time. Some of us had grown up, others were growing old, and one was slowly withdrawing after a long and full life. Gray hair had replaced black, brown, and gold.

Mina, Prasant's mother, left whatever she was doing in the kitchen and came to receive us. She, for one, looked much as she did when I

last saw her. Not a single gray hair. In fact, her hair was blacker than ever before. Mina initiated a conversation with me and smiled when she heard my rusty reply in Odia. As her mother-in-law gradually lost her strength, Mina's had increased. A mother of three, two boys and a girl, she had transformed from the timid young woman I once knew. While we were catching up, Suna joined us. Bent like a boomerang, she could see only the floor and found her way with her hand trailing along the walls of the house, which had sheltered her since she had arrived as a young bride of fourteen. She might be frail, but she did not want to miss out.

A television was positioned on one of the built-in shelves. No need to visit a neighbor in order to watch TV, unlike in the late 1980s when villagers met every Sunday night to watch *Ramayana* in one of the three households wealthy enough to have a television. Next to the television, colorful fish gracefully moved about in an aquarium, while a bright green parrot stood quietly in an open cardboard box on the floor. Perhaps Lingaraj had continued his old habit of showering his children with gifts.

"Where is Lingaraj?"

"He is upstairs."

"On the terrace? What is he doing there? It must be hot!"

"Go and see for yourself."

Where the terrace had once been there were now two rooms, one larger than the other. The house had, after all, changed too. I found Lingaraj bent over a black and white *patta chitra* the size of a large bath towel, working his way slowly but steadily through different events in *Krishna*'s life. When young, Lingaraj spent a lot of his time traveling to exhibitions to sell the work of other painters and thus did not always have time to paint himself. Previously slender, Lingaraj had turned "healthy." The most striking difference, however, was his sagging shoulders and forlorn expression. What had become of the agile man I once knew? I sensed other changes too without being able to put my finger on what they might be and decided to open our conversation with a comment on the physical surroundings.

"It's a good place to make paintings."

"Did you not see this room before?"

"It's been nine years; the room was not here when I last visited."

"True, it was not. It's a recent addition."

Lingaraj let his brush rest on top of the color container and stretched his back. I was glad to see he had done well. While initially critical of painters-cum-dealers who made an extra income selling other painters' work, I had gradually concluded it was not so simple. Who was I to judge how the painters made ends meet? Craft makers who were not themselves good at selling their work depended on someone they could trust; Lingaraj was one such person. Apart from painting, Lingaraj mastered trading, skills he had acquired from his father Mukunda's elder brother. Lingaraj's uncle taught painting in the government handicraft-training center in the capital. Although I never met him, I have heard enough about him to know that he was an accomplished initiator, gifted with impressive networking skills, cleverly used to enhance interest in traditional painting. Perhaps it was during the years in his uncle's house that Lingaraj became aware of the importance of a good network. As with many other young men of his generation, he applied for and got a three-year stipend to enroll in a government craft-training institution. He did not learn to paint in the training center – no one really does – but learned when working for his uncle after classes. However, after four or five years in the capital, Lingaraj decided to return to the hamlet. He had seen enough to make up his mind. Even highly skilled painters, willing to put in hours of work, often had difficulties earning a decent living. It was the contacts he had established, combined with an embodied knowledge of what it takes to make a good painting, rather than his painting skills that changed the economic fortunes of his family.

"I see you are working. You used to be so busy traveling to exhibitions."

Lingaraj smiled and, for a moment, I thought I saw the glint in his eyes that I vividly remember from his youth.

"I worked very hard then. I never turned down an invitation to participate in an exhibition. Looking back, I wonder just how many days I spent traveling with the Indian railways. Did I tell you, I once got the opportunity to go to Singapore? Many painters would never have gone but I went."

It was news to me that Lingaraj had visited Singapore, but I recalled how often he used to travel for days on end, leaving his family behind.

As usual in the early 1990s, Lingaraj's mother Suna was on the roof working. This winter afternoon the temperature was pleasant despite the direct exposure to the sun. Squatting, her bony knees protruding behind her sari, Suna primed wooden figurines and placed them on the terrace to dry in the sun. There they stood as a regiment of soldiers awaiting orders from their superior.

"My son is going to Delhi tomorrow; he has been busy."

"I know, I have been trying to get hold of Lingaraj for days."

Whenever I asked for him, he had always "just left" or was "on his way." Days, even weeks, before an exhibition, Lingaraj was running here and there to pick up other painters' work if they could not, for some reason, bring it to him, or to remind them of the upcoming deadline.

While Suna was working upstairs, her husband, Mukunda, was working in the light from the doorway downstairs. He was painting the figurines his wife had prepared some days ago. For years, the household had depended on selling their work through the cooperative society, which at the time guaranteed a regular flow of orders and payment fixed according to size. Although this arrangement ensured a minimum payment, there was no point making any real effort since one never got more than the fixed rate per square inch. This was one reason why Lingaraj's business acumen made such a difference to the family's livelihood. Ever since he began trading in paintings, their standard of living had gradually improved.

On Mukunda's right was a pile of bare wooden figurines; on the left lay numerous exemplars of *Balabhadra,* the elder brother of *Jagannath.* Like his siblings, *Balabhadra* was easily recognizable with his stump arms and vast eyes, so completely at odds with the other deities in the Hindu pantheon. Mukunda was likely to spend the rest of the day on the monotonous work and a chat was most welcome. Just like his wife, the thoughts uppermost on his mind were his son's forthcoming journey.

"Lingaraj will go to Delhi by train."

"Is he going on his own?"

"No, it is not safe to travel alone with paintings – there are thieves … He will go with his friend."

Two days' train journey in second class was wearing but not unpleasant. If only the police did not show up. They took special pleasure in harassing villagers like Lingaraj, who were traveling with a valuable collection of paintings.

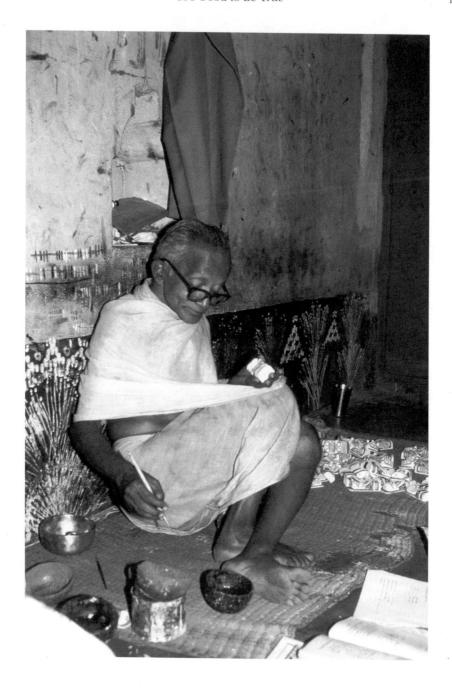

Mukunda Moharana painting wooden figurines, 1989

"For how long will he be gone this time?"

"Fifteen days I think, maybe more, maybe less."

Our conversation was briefly interrupted when a young boy from the neighboring hamlet appeared in the door with a roll of paintings under his arm. "*Mausā*, this is for Lingaraj *bhai.*" Mukunda took the paintings, carefully rolled up with interlaying sheets of newspaper, and went to the interior of the house to hang them up out of harm's way.

If Lingaraj was successful, he could take it easy for a few days, hang out with his peers and close friends who, like him, had grown up in the hamlet. The news of his homecoming would spread like wildfire, encouraging his suppliers to come by to get their share. Of course, the sale was not always good, in which case Lingaraj had to disappoint the people who had come to depend on him for selling their work.

"Apart from the cooperative, who buys these figurines?"

"Tourists like this size but good money mainly comes from *patta chitra*, not this kind of work."

"Is that the reason you decided Lingaraj should learn to make *patta chitra*?"

"In our hamlet we make *patta chitra*; that is how it is."

"Well, you did not always make *patta chitra*, did you?"

"We did … but we needed to eat and no one was willing to pay a good price … before Zealey came."

"Well, the Indian government supported crafts production at the time …"

"The government, tsk … the government … those people are no use. They sit all day in their 'office.' If it were not for Zealey, no one would be painting today."

"But what about the training center?"

"What about it? When Lingaraj grew up, there was an interest in *patta chitra*; that is why I, and many others, decided to enroll our sons in the training center to learn."

Sending Lingaraj off to live with and work for his brother, who taught in the government training center in the capital, had proved to be a good investment. One only had to spend a little time with the family to realize that theirs was a successful household.

Two weeks later, Lingaraj came home carrying a load tied up in an old *dhoti*. We all gathered around him as he untied the bundle in the bedroom. The replacement of the roll of paintings with an oddly

shaped bundle was a good sign. Sure enough, unfolding the material, Lingaraj revealed a brand-new blue plastic scooter. What extravagance! Prasant, Lingaraj's firstborn, was the only one who showed absolutely no interest in the scooter; he was too small to understand what his father had brought. It would be a while before Prasant could use the vehicle. For now it would simply serve to signify their good fortune. Other families spent whatever they earned on basic necessities. Lingaraj, however, could afford to indulge his loved ones now and then. As he moved the scooter, a stack of brand-new clothes appeared. His father, of course, was the first to receive his new *dhoti*, and then the turn came for his mother, who got a new sari. Finally, it was Mina's turn. She had kept in the background but came forward when summoned by her husband. Like her in-laws, she did not say anything when receiving her gift but smiled, her eyes fixed on the floor in front of her.

"When you came with your children and your mother-in-law [in 2007], I had already made plans to expand the house, saving quite a bit. You did not know, did you?"

"You are right, I did not know, nor did I think of asking."

"You are not the only one who did not know. I did not tell anyone. No need to put ideas into people's heads."

In the beginning, his savings simply served as security. He had seen in the hamlet what happens to families visited by misfortune ... what it means to have to worry about the next meal; his children could do without that experience. When Lingaraj's second son was born and the savings continued to accumulate, he began dreaming about adding an extra floor to their house, the only possible way of extending their living space. If only he worked hard enough and continued to put money aside, he might succeed.

As far as I could see he had done just that, succeeded in his quest. The room on the roof was a testimony to his accomplishment. Lingaraj sat quietly observing my observation of the result of his labor.

"Who would have guessed thirty years ago that one day you would be the proud father of three as well as the owner of a two-storied house with a bath and a latrine?"

Lingaraj leaned back and briefly closed his eyes. Had he heard what I said? He might be tired; perhaps I should leave. I quietly got hold of my things, the camera, the telephone, and the notebook. That is when Lingaraj's posture suddenly changed. He leaned forward and said something I could not decipher. He must have sensed my confusion because he repeated what he had just said:

"It's not what you think."

"Eh? What are you talking about? I do not understand."

"The extension … my savings … it is gone. My father was still alive then, but I never told him about the loss. How could I? I did not want him to worry at that stage in his life …"

Lingaraj paused, perhaps summoning up the energy to go on.

"I acted behind his back, without my father's knowledge. How could I tell him I had failed him?"

"What happened?"

"I trusted the wrong men. This is my only regret, I trusted the wrong men. One after the other, they ate my savings. I have nothing left."

A GOLDEN OPPORTUNITY

It all began one day when a young man, Krusna, requested Lingaraj's help. Lingaraj had taught Krusna mask making in one of the courses financed by the local government. Perhaps it was the recent extension of Lingaraj's house that made Krusna think Lingaraj could afford to help. Krusna had been informed of a rare opportunity that made it possible to get a loan of two lakhs (200,000 rupees) without offering security. If one could deposit one lakh to a financial institution, a loan of two lakhs would be available exactly one month later. If Lingaraj lent Krusna a lakh, he would return the loan as soon as he got the promised amount. Krusna did not dare to approach his father or uncle for support; instead, he approached his former guru. Lingaraj felt honored – he liked the idea of being someone akin to a big-man who people turn to when in need. His hard work and his extended networks had clearly paid off.

Lingaraj agreed to help, but decided to see the institution for himself, just to be sure it was not a scam. Arriving at his destination, Lingaraj was met by a line of people snaking down the lane starting in front of a newly opened office. Lingaraj approached first one, then another,

and a third to ask them what they were waiting for. Without fail all of them had brought cash in order to secure a loan. This was encouraging, but Lingaraj nevertheless decided to ask the manager; one could never be too careful. He confirmed that Lingaraj had it right, this was indeed how the offer worked. Lingaraj decided to go ahead with the deal.

Krusna gave Lingaraj the papers of his family property as security without informing his father or uncle, and Lingaraj then deposited his own family home as security to get a lakh from a moneylender at 3 percent interest per month. He had no second thoughts; he was certain to get his money back within a month, at which time he could pay off his debt. A month went past but there was no sign of the money, nor of Krusna or the manager for that matter. It was as if both of them had sunk into the ground. Two weeks later the government seized the institution and shut it down. That is when Lingaraj began to get seriously worried. The interest rate was ticking. What should he do? He would have to take on some other loans to pay the moneylender back. Helpful at the time, Lingaraj approached him for a loan, but the moneylender soon turned into a monster. He kept sending his goons to remind Lingaraj of his debt – as if he could forget.

One day Krusna's uncle turned up in Lingaraj's home. "Thank god, my father was not at home." The visitor was agitated; he wanted the documents proving ownership of his property. Lingaraj was at his wits end. If he returned the documents, he might himself end up in serious trouble. He told his guest the property papers had been deposited as security for the loan, for which reason he could not return the papers before the debt was paid. This was not a lie, not really, but only partly true. After all, Lingaraj had the visitor's documents, but why go into these details? Lingaraj requested one lakh in cash as well as lost interest in order to procure the documents. To his relief, the family somehow managed to raise the money, but they never returned the interest. They were not wealthy; Lingaraj could understand how difficult it must be. However, having invested his savings in an extension of the house to make room for his sons and their future wives, he did not himself have money to cover his debt. To be left in peace, he began looking for alternative and cheaper loans.

For years, Lingaraj was paying interest on the various loans he had accumulated. The regular visits from moneylenders kept him awake at

night. "I became lazy, my mood affected my family. They all suffered." He told his family about his troubles only after his father died and they decided to sell the small piece of land behind the house to pay off as much of the debt as possible. Although it was a relief for Lingaraj to share his burden with his wife and children, he never regained his former spirit. He no longer traveled the way he used to, dealers could no longer be certain that he had a good stock to sell, and gradually his network dwindled. Instead, he took up mask and *patta* painting full time, hoping that his sons might have more luck in the future.

THE JOB OFFER

Being a young man with nothing but a school certificate from the local village school is not easy in contemporary India. Like the majority of craft makers in the hamlet of his generation Prasant, Lingaraj's son, used WhatsApp to deal in paintings. But unlike some of the other young painters and dealers in paintings with twelve years of education or more, who quickly saw what Instagram had to offer craft makers and asked tourists to set up a home page advertising their crafts, Prasant took a while to fully exploit the potential of his smartphone. Years went by, and Prasant dreamed of ways to make money but was stuck in his hamlet with no work to speak of. Lingaraj realized his son was not to blame for this state of affairs and worried his younger son might face the same difficulties. One day, unexpectedly, Lingaraj got a call from a distant relative who told him about a job opportunity at the Delhi airport – a perfect job for his youngest son.

"There is a good job in Delhi airport for a young man. What do you think? "

At first Lingaraj did not reply, he was not sure what to make of this.

"Your son can participate in the job interview, if only you pay 10,000 rupees."

"Did you hear what I said?" the man yelled as if Lingaraj was deaf.

"Yes, I heard you all right. What expenses will there be apart from that?"

"Well, a train ticket to Delhi, new clothes for the interview, shoes and all. But do not worry about that, he is sure to get the job."

"If you say so …"

"When he has got it, you need to pay another 50,000 rupees to the man who is organizing everything."

"50,000!"

"Relax, no need to worry, he will get a good salary. Before you know it, you will have made a return on this investment. There are a couple of things that are necessary to get permission to work in an airport, such as a passport, for example. What do you say?"

Lingaraj did not say anything. He had learned a lesson when last tempted by a good offer. Some months later, however, the relative called again. He warned Lingaraj that he was about to miss a good opportunity if he did not act fast. There were five airport jobs waiting for his son and his friends. All they had to do was say yes and, well, pay. Then the boys would become part of this venture. "Can you get hold of four boys more? Then they can all travel together."

Lingaraj spoke with three of his friends from the neighboring hamlet who, like him, had at least one grown son who was unable to find work. The men discussed the pros and cons and decided to try. They contacted a moneylender and got a loan of three lakhs at the usual monthly interest of 3 percent. Within a week, the boys were sent off to Delhi where they found they had to pay for accommodation and food. The money provided by their parents would soon run out. Hesitant at first, the boys soon telephoned home to ask for additional funding, and Lingaraj was not the only one who took on an extra loan.

As promised, the investment soon paid off. All five boys got the jobs and the second installment of 50,000 rupees per job was paid. Promptly after a month, they got their first salary. Not less than 14,500 rupees each! An exorbitant sum of money. When Lingaraj received 10,000 rupees from his son, he knew he had done the right thing. However, he was not allowed to enjoy his good fortune for very long. The next month the manager informed the boys of a new policy affecting their salaries. Instead of 14,500 they would get 9,000 rupees a month, or at least for one month. After that, one could not be sure. A devastating blow. The fathers unanimously decided to call their sons back home. There was no point in them staying on. Lingaraj shrugged his shoulders, "I sold, I ate; we are living hand to mouth."

Sleepless nights dominated his life once more, until one day he could not stand the pressure anymore. Realizing they might end up being thrown out of the house in which his father was born, he decided

to approach the bank for a loan with an interest rate of 7 percent a year. With this money, he could return his debt and thus put an end to the unwelcome visits from the moneylender's men.

"This is how you lost your savings?"

"Yes, all of it. There is nothing left. Even the house is not mine anymore."

"What do you mean? Surely you still have your house!"

"In order to get the bank loan, I had to provide security. The bank got the house, I had no choice."

"Your house! But what if ..." My voice trailed off; no need to mention what was surely a cause of anxiety. "I am sorry to hear this."

"At least nobody pesters me anymore. I will never again take on another loan."

"You sold, you ate."

"This is why I have no interest in my work anymore. What is the point? For more than twenty years I did nothing but work – and for what? You tell me! What do I have to show? Nothing. Nothing whatsoever. We must all work to live. These days, however, I only work as much as is absolutely necessary. One day at a time. Nothing more. One day at a time. That is all."

Sitting cross-legged on the floor, Lingaraj rocked back and forth like a ship in troubled waters. Did he expect me to say anything? What was there to say? For a while, we merely sat there, each of us lost in our thoughts. Lingaraj slumped back to his former position leaning against the wall. When he finally spoke his voice was subdued, with an undertone of defeat: "My life is broken, but the boat goes on."

Still Standing

The news of Sula's most recent loss reached me in Puri some days before my planned visit to the hamlet in November of 2016. I was told there had been an accident a while back and nothing more. This time it was her husband, last time her daughter. He had been there then, to share the burden with her, and now he was gone too.

Arriving in the hamlet some days later, I went straight to Sula's house, but she was "at work" and would only be back after dark. At work? I was not surprised to hear she was working; she has worked for as long as I could remember, painting masks in her courtyard. But the way it had been said gave me no indication of where she might be.

"Where is she?"

"In Bhubaneswar."

"In Bhubaneswar! What is she doing there?"

"She is in the 'office.'"

In the office; it made no sense. With only five years of schooling, Sula was unlikely to land a job in an office in the capital. That would be difficult even for one of the young women in the hamlet holding a bachelor's degree. I decided to leave the matter for now, as Sula would tell me soon enough.

Later in the afternoon, walking down the lane, I noticed that since my last visit a second floor had been added to Sula's house. When did that happen? I concluded it must have been while her husband was still alive. It would be highly unlikely that Sula would take on a construction

project of that scale on her own, even if she had the money. And as a widow, well, it would be a challenge just to manage daily expenses, never mind financing an extension of the house.

Chatting in the gentle November sun with a couple of village women, I spotted Sula in an off-white sari with a dark green border sitting sideways on a motorbike behind her eldest son, Narayan. He must have picked her up when she returned from work. She got off next to the bright new temple of the village-goddess and walked toward us, twenty-two-year-old Narayan trailing behind with the heavy bike. Her hair had lost its luster and her cheeks had hollowed, enhancing her fine-boned features and giving way to sharply demarcated lines, like a tree in autumn stripped of its leaves. She might be easily missed in a crowd, but as she came closer, there was something about the way she carried herself, something I had not seen in her before. Stamina and warmth combined into an expression of confidence on her face.

"You have come after so many years!"

"Yes, it's high time don't you think?"

"Have you brought your children? And what about your husband, where is he?"

We caught up after nine years, chatting about this and that, but avoided the upheaval she had experienced since we last met in 2007. Concerned as I was about my ability to express myself appropriately, I did not refer to her loss. Twenty-two years earlier, Sula had been saddened when I did not come straight to her after hearing about the death of her firstborn, Ranu, the little girl I had named. I had postponed my visit by one day to summon the courage I needed to face the family in their grief. The delay had been perceived as a sign of my indifference. And here I was – aware that Sula knew that I had heard about her misfortune, with an opportunity to express my sympathy – and still I kept quiet.

Because of my ineptitude, it was Sula herself who brought up what I feared to address. On hearing that Prasanta, my research assistant since 1991, never married, Sula looked at him briefly, shifting her focus to the distance: "That is good; marriage only brings trouble." Her oldest son stood next to her, his existence at one and the same time a disclaimer

of her statement and an indication of the magnitude of her misfortune. I took hold of her hand but still said nothing apart from confirming that we would come for lunch on her day off from work. "What do you want to eat?" Sula asked, "Which kind?" *Āinsha* – or polluted – was the colloquial term she used to refer to non-vegetarian food. Though I doubt pollution was on her mind. She just wanted to give a feast, and among non-vegetarian Hindus, a feast calls for fish or meat.

When we came the following Sunday, Sula's father, Dharam, was working on the veranda facing the lane. For the first time ever, he responded to my polite greeting, "*Mausā*, how are you?" by picking up two paintings in the hope of selling. He obviously had difficulties hearing and seeing, which also explained why, at first, I took his paintings with their unsteady lines to be the work of children. In this respect, his fate was not different from other *patta chitra* painters who, due to failing eyesight or shaky hands, gradually lose their skill to draw thin, fine lines.

Oblivious to the noise and activity in the house, Sula's mother was resting on a mat on the floor. Clearly enjoying himself, her youngest grandson was imitating dance sequences right next to her, his attention transfixed on the television. The music was accompanied by the clattering of pots and pans from the inner room of the house where lunch was being prepared. Squeezed in between the wall and a staircase, Sula roasted spices, *chhaunk*, on a two-burner gas stove. The fragrance and smoke were enough to force a series of coughs from anyone foolish enough to come near. One of her sons, fourteen-year-old Deepak, assisted her, his confident actions reflecting his familiarity with cooking that, to this day, is still a highly unusual sight in an Indian village.

Passing through the vapors, we were ushered to sit in the bright bedroom from where Sula could easily chat with us while still supervising Deepak's work. Light flowed into the room from the courtyard where a dog was snoozing next to a small solar panel charging in the sun. The dog ... could it possibly be one of the puppies I remembered from a previous visit, back when I had been accompanied by my children and my mother-in-law? Unlikely. After all, nine years is a long time for an Indian village dog. A lifetime, if not more. Even for me it felt like an exceptionally long time. For Sula, well, it was a different life then.

We had just settled on the veranda one late morning in 2007 when one of Sula's youngest boys, five-year-old Alok, appeared from the scrubland behind the yard balancing a spinning bicycle wheel with a stick, his twin brother Deepak in close pursuit. Realizing the awaited guests had arrived, the boys forgot all about the wheel and joined their elder brothers, Narayan and Debashis, sitting a slight distance from the rest of us on the veranda. Their mother had told them about our visit, but the two of them were too young to recognize me. Plus, they had never met my mother-in-law or my children, Aliya and Mathai, aged nine and seven. It was the kids' first time to the hamlet, a visit that had taken some convincing on account of my father-in-law, a doctor based in Chennai, and his worrying that his grandchildren might fall ill in rural Odisha. Timid at first, Mathai kept close to me, but when nine-year-old Debashis got up to play with a puppy that unexpectedly toppled out from the dysfunctional latrine, curiosity got the better of my son. Soon more puppies came out to play and Debashis's brothers joined the game – four puppies and five boys in one happy confusion. At first Aliya was content watching the spectacle from her secure position right next to her grandmother, but the tiny puppies with their large paws were too tempting. For a while, the two older generations on the veranda watched the children in silence. Sula's father gently wobbled his head from side to side in rhythmic approval while his son-in-law chuckled at the show. My mother-in-law appeared uneasy, ready to get up if necessary. My gaze shifted from the confusion of hands and paws to Sula. As always, Sula was composed as she sat in the maroon sari I had given her shortly after her marriage, but for once she allowed herself to relax with the rest of us, her husband at her side, taking in the happy spectacle. A precious moment, ever so brief, but imprinted in my memory.

Soon, however, conversation began flowing again. So much had happened since we had last seen each other, most importantly the birth of Sula's twins and Aliya and Mathai. Before the birth of her daughter, Sula had moved back home to live in her parent's house where she could earn an income making masks. After Ranu's death, Sula stayed on with her parents, continuing to paint as she had always done. Brittle, perhaps, but not broken, Sula kept going. What else could she do? Although her husband spent long periods in town where he worked, Sula had not been alone in her grief. Her parents had been there to

share the burden with her, a close-knit family. The mutual emotional support was later followed by mutual joy when the boys were born, one after the other. I do not know exactly how this mutual bonding played out over the years, but I know it included Sula's husband. As dictated by convention, he was treated as a son of the house, and from what I heard and saw, that was in more than just name. He had been like a son.

While we chatted, Sula's parents went inside the house to unfold their mats. It was that time of the day. The puppies were already fast asleep and so was Mathai. Aliya dozed, her head resting in her grandmother's lap. Sula's eldest boys were drawing while the twins must have picked up where they left off some hours previously; the bicycle wheel had disappeared from the yard.

"Helli, come, you must see the room where we work."

"Do you not work here on the veranda?"

"He works there," Sula indicated the veranda in front of the house where her father usually worked. "But the rest of us work upstairs."

Picking up the hem of her sari, Sula showed us up the unfinished staircase and onto the roof, where a man was working on a wall to complete the room intended for Sula's eldest son after his marriage. Apparently the second story was a recent addition and not, as I thought, an initiative of her late husband.

"It must be expensive, Sula ... materials, salaries, and all."

"Yes, money is needed. Most of it I pay with the money they gave me." Who, I wondered, would come forward to help a widowed mask painter? Sula was not the only woman in the hamlet who had lost her husband. I made a mental note to ask Sula when there were fewer people around.

Looking across the lanes from our place on the roof, Sula spotted her friend Mera standing at the path in front of her home chatting with a passer-by.

"We are talking about you. Why do you not come?"

"Why should I come?"

"Helli wants to see you."

"Helli can come here, why should I go?"

Despite her teasing, Mera joined us on the rooftop a few minutes later to discuss the ongoing construction work and, of course, comment on the activities of villagers below us and what they might be up to. It was hot in the sun, not unpleasant but warm enough to make us seek shade. Sula led the way from the terrace to the spacious bright room intended for work. A pattern of missing bricks decorated the bare walls, letting a mild breeze pass through. Here, the family could work comfortably on their *patta* paintings and paper masks without getting in the way of the daily chores of the household. Although the room was not yet complete, it obviously already served its purpose. Work utensils were stacked in the corner, brushes and shells of coconuts serving as containers for black, bright yellow, red, green, and blue. Papier-mâché masks, waiting to be decorated, were stacked next to an incomplete *patta chitra* depicting *Ganesh*, popular among tourists from Mumbai and abroad.

"How do you find the energy to make masks on your rare days off, Sula?"

"What shall I otherwise do? I might as well work."

My bodily acknowledgment of Sula's statement was mirrored in Mera's sideways bobbing of her head, as if a puppeteer had synchronized our movements. Although Sula now had a regular income from her work in the city – not to mention the money her two eldest boys earned from painting *patta chitras* and making clay figures for *puja* – she saw no reason to discontinue what she has always done to earn a living. Making paper masks might be low-paid work, but it had its advantages, not least of which was that she could work from home with her sons. While they painted *patta chitras*, she could paint masks and catch up on their news.

Mera returned home while Prasanta and I made our way to the veranda. Sula followed up on Deepak's work at the gas stove. Apparently, his efforts had not been in vain, for Sula soon decided time had come to serve lunch. First, she rolled out a mat on the floor, and then she brought two large metal plates with steaming hot rice. Quietly moving to and fro, as a butterfly in a flowerbed, she bounced between the corner-stove and the veranda.

"Do you want more rice? Brinjal perhaps? What about fish?"

"My stomach is full. Sula, come now, sit with us, you must eat." She would eat in her own time; first, she had to see to her parents before she could allow herself a break from the never-ending string of chores.

After she had eaten, Sula talked about her plans for the house. The construction work was being done one step at a time. First one section of the staircase, then another, followed by the workroom, then the bedroom, and finally, one day, a proper roof to replace the blue plastic, which now sheltered the family against sun and rain. But how, I wondered, just how could Sula afford to invest in their house with so many mouths to feed? While she explained the details, Sula's eldest sons came to see what we were doing. "Old woman talk," they must have thought, for they turned their attention to something more important. Bent over their smartphones, the boys stood slightly apart from us, both of them utterly absorbed communicating on WhatsApp. It was a familiar sight, reminding me of my own children. In response to my comment about the striking popularity of mobile phones, which were absent in the hamlet nine years earlier, Sula confided that she was happy her salary allowed her to be generous with her four sons who have lost so much. Sula had provided her sons with smartphones but put her foot down when Debashis asked for a computer for his training at the art college in Bhubaneswar. "A computer costs almost 30,000 rupees! Can you imagine?" I could easily relate to the demands of her children and her struggle balancing between must-haves and nice-to-haves. With six mouths to feed and a house under construction, a computer was unlikely to get high priority.

One by one, the boys went off, leaving Sula, Prasanta, and me behind. Left on our own, it was possible to bring up some of the questions that had been roiling in me since I first heard of Sula's second loss.

"Sula, I heard the news about your husband. I am so sorry."

With a slight tilt of her head, Sula acknowledged my words but did not reply immediately. Was she pondering where to begin? Maybe she needed to summon up the strength to tell me things she most likely preferred to leave behind.

"They killed my husband."

I knew of her misfortune, but when told that Sula's husband died in "an accident," I assumed that, like so many others before him, he had lost his life on the Indian roads. Sula sat silently while I took in what she had just said. I looked at Prasanta to gauge his reaction. Had I understood her properly? Judging from Prasanta's stunned expression, I had. But why? Sula's husband, as far as I knew, had no enemies.

"What happened?"

Sula Moharana's sons on their mobile phones, 2016

"His company asked him to follow up on some machinery. As he did that, he realized some of the traders who sold spare parts to his company were siphoning off resources, and he decided to file a report."

After catching wind of his intention, the traders invited him out for a drink. Did they hope to change his mind? And did they fail? Or did they intend to set an example? Whatever the reason, they must have planned it carefully. People do not usually bring along petrol for a night out. They offered him a drink, first one, and then another. For a man who rarely touched alcohol, the effect was marked. That was when some of them poured petrol on his clothes, and then one of them lit a match, "setting him on fire."

Her affectionate husband ... burning like a torch. I could not shake off the image as I sat there listening to Sula, self-possessed as always but speaking without presence. As if she were talking about something mundane, a topic far from her heart. A way of coping with her destiny, maybe? At a loss for words, I just sat there numb.

"Do you have a photograph of him?" I finally managed to ask.

Sula got up and returned with a tiny photograph the size of a large stamp. And there he was, just as I remember him ... as if he might come in any minute, having run all the way from the neighboring town to receive their guest and excusing his delay.

"Were the arsonists ever caught?" I asked, as if that could bring him back. As if I had forgotten the reality of craft makers' lives in a country where wealth and connections are the only hope of decent treatment by the police.

"There was no court case." Sula had intended to go to court but was advised against it, "They said I might not get the job." As is common when an employee passes away prematurely leaving dependants behind, the firm, in which her husband worked for more than fifteen years, offered one family member employment as a peon in the central office. Not yet eighteen, Sula's eldest son could not take the job, so it fell on Sula to ensure the family's well-being through the offer of a continuous monthly income of 11,000 rupees. Recently widowed Sula, who had rarely been out of her hamlet, entered a new stage in her life: traveling back and forth between the hamlet and the capital on her own, moving through the city, and working in an office, so different from her previous experience of caretaking and mask painting in her natal home.

Unlike her husband, who migrated between the town where he worked and the hamlet every fortnight or so, Sula had to commute

daily, except for Sundays and every second Saturday. The journey was at least one and a half hours during rush hour – demanding in winter and utterly exhausting during the hot and humid months of summer. In this respect, Sula's life was no different from millions of other Indians who commute daily by public transport to their place of work. Unlike most of her fellow female commuters, however, Sula did not have the benefit of house servants.

"How do you manage, Sula?"

"The people in the office are nice. They have been good to me."

"But what about household chores?"

"The twins cook," she said, sitting upright and looking me straight in the eye, "Narayan picks me up at the station, and by the time I return home, the food is ready for us to eat."

Sula had taught her sons to take on responsibility for the common welfare of the family. One day returning home from work, she found the room facing the lane redecorated in bright green "to attract customers," as one of her sons proudly explained. More than the renovation, however, it was the boys' daily time-consuming chore of cooking two (of the three) daily hot meals that stood as testimony to her success.

Slowly but surely, Sula's story fell into place, but a few pieces were still missing. Even with a fixed monthly income it would be difficult to finance an ongoing construction project. How did she carry this through? Apart from a job, the firm had also offered Sula two lakhs (200,000 rupees) in compensation. Two lakhs for a life. Sula decided to invest in building a second floor containing two rooms and a terrace to accommodate her family, which, with four sons, was likely to grow significantly. It would have been a large-scale and expensive project had Sula decided to do it all in one go. Instead, she expanded and furnished the house gradually, making sure she always had something left over in case of an emergency. After all, one never knows.

Sula's day off passed quickly; I decided it was time to say goodbye. Just as we were about to leave, Sula gently tugged my sleeve, "Four daughters-in-law, what do you think?" Quarrel was the first word that came to mind. Instead, I said, "A lot of talk." Sula smiled. Did she think I still had a lot to learn? Or maybe she was just allowing herself to dream of a burden lifted from her shoulders and the joy of grandchildren? Whatever it was, Sula stood there smiling – still standing, despite the calamities that have wrecked her life.

Just Luck?

Driving along Puri Beach in 2016, we passed thousands of people gath-
ered to celebrate *Kārtikeswara Puja,* an autumn festival during the Odia
month of *Kārtika.* I had come in search of Tophan. The town I once
knew was hardly recognizable among towering construction projects.
I felt overwhelmed by the growth. Where a long stretch of beach used
to be there were now buildings as far as the eye could see. I realized I
would no longer be able to find my way in a place I had once known
like my childhood neighborhood. Noticing my bewildered expression,
Prasanta informed me we were passing through "the most posh area of
Puri." For someone who had grown up in Europe, it did not look like
much, but prices in the area were exorbitant. I thought to myself, "so
what exactly are we doing here?" After all, we were tracking a painter
who, last I saw him, had been struggling to feed his family.

Tophan was at the gate, moving a heifer from one spot to another,
when we arrived. A bald crown signaled the years that had passed since
we had last met, and for a brief moment I wondered about the changes
he no doubt spotted in me. What had not changed, however, was his
smile; it still reached his eyes, the same way it had when we lived under
the same roof. Tophan showed us in, pushing aside a nursing calf at
the entrance.

The merciless climate had taken its toll, weathering the house.
Damp blotches in shifting nuances of gray covered the walls and stairs,
interrupted by missing fragments of cement. Clothes were drying on

the railing all the way from the open passage to the second floor, the different sizes indicating a succession of children. Across the flight of steps, a newly built, bright white building of several stories could be seen in the distance. Given a few years, it would no longer stand out but would gradually give in to the environment, like everything else.

It was a big and spacious house. Even the largest houses in the villages were tiny compared to this. The two-story house contained a common room, a kitchen, a bathroom, several bedrooms, and a separate section that potentially could be turned into a small shop. The cherry on top was an enclosure for the cow and calf – an unheard-of luxury for a family of six. What about the floor upstairs, I wondered. Who lived there? Given the washing on the railing, I decided it was likely to be a large family. Whoever the inhabitants were, they surely paid rent, which would provide Tophan's family with a basic income.

In an attempt to make sense of it all, I asked Tophan to start his story right from the beginning, from the time when we last met. He looked at me laughing. "Ok," he said, "but it is a long story."

"That is all right by me. I want to know it all, and do not tell any lies." Tophan laughed and wobbled his head in consent.

Before Tophan began his account, he took us on a tour of the house, first stop being the flat situated on the first floor. Apart from the most basic furniture, the apartment contained only a number of locked and neatly stacked metal suitcases. His tenant turned out to be a single foreigner who spent some months of the year in Puri but wished to keep a flat of his own to store his belongings when not in town. The arrangement provided the family with a stable income and was an ideal arrangement for both parties. Next stop was a large roof terrace offering a view of the *Jagannath* temple and, at this time of day, a pleasant cool breeze. "When did I last see you?" Tophan asked and answered himself: "It must have been when I came to BNR Hotel with my wife to show her to you." Or, I wondered, to show me to her.

I have a vivid memory of their visit in 1997 to the old railway hotel, one of the buildings left from the time of the Raj. A photograph of the happy couple standing on the veranda, the Bay of Bengal visible in the

background, obviously helps my memory, but more important is the strong impression the young woman left behind.

Familiar with the setting from previous visits, Tophan confidently led the way up the well-worn wooden staircase to the first floor, his wife a few steps behind. They passed a number of waiters who, due to different disabilities, were permanently employed by the Indian railways. The majority had been working at the BNR Hotel longer than anyone cared to remember, their ill-fitting uniforms appearing as worn as the hotel itself.

At first sight, Usha, Tophan's wife, gave the impression of being timid. That would not be unexpected, given the completely alien environment, but she surprisingly slid into an easier demeanor, chatting and laughing with us – so different from the young brides I had seen in the hamlets who, for months after their wedding, hid behind their saris as soon as an outsider entered their new homes.

Tophan and Usha's visit took place a few months after their wedding, their joyful presence giving the impression of honeymooners. Wed couples all over India can be found sightseeing and playing with their newly acquired status as husband and wife. Together, they might explore hitherto forbidden territory, some even holding hands in public. Tophan and Usha never gave in to that kind of display during their visit but conveyed a strong sense of intimacy. It was so strong, in fact, that I made an entry in my notebook after they left: "I feel happy for him; it seems to be a fortunate match."

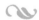

Tophan surely could do with some joy. The visit must have presented a much-needed break from the stark realities of his life, which for years had been characterized by a constant struggle to make ends meet. Perhaps it was scarcity that led to strife between his family members. Twenty years later, Tophan shook with humiliation when describing how his brother's wife had scorned him in front of his future in-laws when they came on their first visit: "A great painter like you, one should think you could afford some fruit [for his in-laws] without borrowing money from me. Why don't you go and sell some paintings so I can get my money back?"

"I felt so bad; what would my in-laws think? I just wanted to leave the house. But where could I go? Nowhere. How could I ever afford a place of my own? It was difficult enough to feed an extra mouth." Tophan stayed on in his family home after his marriage, as is common practice.

Despite the mutual understanding between him and his wife, the first year following that episode was bleak. "I started drinking and smoking. It was bad." Tophan was hanging out in the small seaside restaurants frequented by foreigners to escape his misery.

"How could you afford that?" I interrupted. Tophan explained that foreigners generally paid for his drinks. I thought of his young wife stuck at home with an older and unhappy sister-in-law; it must have been sheer misery for her. "It was at that time, one year after my marriage, that I met William and his friend John. This is why I say my wife is a goddess; she brought me luck." William. His name had come up again and again during our conversation. Who was he? "He was a nice man, honest and sincere." Tophan met up with the two men several times that winter, enjoying their company and what, to him, appeared to be a care-free life. The two spent every winter in Puri, to escape what in northern Europe is a dark and cold season, and the following year Tophan picked up the acquaintance where they had left off. Four years went by; they met regularly, always on neutral territory, and their relationship gradually developed into friendship. Unlike William, John did not speak any Hindi, so Tophan slowly developed his limited English vocabulary.

One evening in the beginning of the new millennium, four years after they had first met, William asked Tophan to show them his home. "I was horrified," Tophan said. "I did not want them to see how we lived." He tried his best to wriggle his way out, but William insisted. Tophan brought them home. When they met the following day, William had given him a good scolding: "Just like a father," Tophan said with affection.

"Why did you never tell me just how poor your family is? How could you spend evening after evening with us in restaurants when your family was at home in those miserable surroundings? What were you thinking?" William, however, did not stop at that, and within a fortnight, he arranged a workspace and showroom for Tophan – just the kind of place Tophan had always wanted but was never able to afford.

William used his contacts to ensure that potential customers frequented the showroom. "I worked, and people came to see how a

painting is made or just to buy. I did not have to worry about selling my work. Helli, can you believe it? Within a few years I saved up a lakh." I felt slightly guilty; it was actually quite difficult to believe. I knew Tophan to be a fairly steady but unexceptional artisan, as well as truthful – not necessarily the best combination of characteristics if you want to make a profit. Never in my wildest dreams had I thought he would be able to save up that kind of money. William asked Tophan what he wanted to do with the money and helped him buy a small plot of land at what was then the outskirts of Puri, no more than a stretch of sand really. The area has since developed from a periphery into one of the costliest areas of Puri. Unlike the cluttered streets of the old town center, the area offers space, relative quiet, and true luxury, a breeze.

We must have spent at least an hour on the terrace when Tophan decided we had better go down to have lunch. I could hear Usha working in the kitchen, but food was not ready yet, giving Tophan time to complete his story.

"You have still not told us how you got the house."

"I told you, it is a long story."

After they had retired, William and his partner decided to sell their house in Scotland to live the last part of their lives in a warmer climate. They made a deal with Tophan. They would finance the construction of a two-storied building on Tophan's plot and live on the second floor, while Tophan and his family would stay on the first floor.

Tophan described how he was working on the site when a man unexpectedly turned up demanding 50,000 rupees on top of a 500-rupee monthly protection fee. Tophan was scared, unsure of what to do. He was in no position to refuse the local mafia or, for that matter, complain to the police. As far as he knew, the police might have been paid to ignore the illegal activities. Nobody can refuse the mafia in Puri, the exceptions being foreigners and, of course, the wealthy and well-connected locals. Should the mafia trouble these people, they can rest assured that police will take immediate action with an efficiency unheard of by the common people.

Tophan decided to tell William about the visit. Listening to Tophan's account, William hardly said a word but went straight to the police. "The next day, the guy who had threatened me came back. 'There has been a misunderstanding,' he said, 'I made a mistake.' Helli, imagine that, the mafia said sorry – to me!" Tophan could not believe his luck

but had the good sense to tell the man the incident was of no concern; they had already left it behind. It was at that moment Tophan made a mental note of the advantage of having a foreign lodger in the house.

I tried to visualize the different lifestyles of the inhabitants of the two floors. It was not easy. As far as I could tell, there were no traces of William and his partner. Had they ever been there? Still waiting for lunch, Tophan told us about William's death. First, John had died, leaving William behind. Some years later, William contracted cancer and soon followed his partner. Tophan was at his bedside doing his best to soothe the old man in his final hours. "Am I dying now?" he asked, and only a few minutes later, he was gone. "He just went like that," Tophan said, showing how William's expression had suddenly changed. Eight nightmarish days followed. "I did not realize how complicated it is when a foreigner dies." William took care of his friend, when he passed away. When William went, there was nobody. "I was frightened. I had to get hold of the police, and they told me it was a matter for the British Embassy. I was not allowed to arrange for his burial before the embassy had permission from his relatives." Despite the ice Tophan had purchased from a factory, the body was rapidly decomposing, and he had no alternative but to ask the police to inform the embassy that they needed to go ahead with the burial. Tophan shuddered as he recalled the scene. Unlike in Scandinavia, where corpses are quickly whisked out of sight, people in India are accustomed to seeing their dead kin. But not for more than a day, not in this climate. Depending on religious background, the majority of people are burned or buried within twenty-four hours of their death.

It turned out that William had left his flat and all his belongings to Tophan and his family, the people who had taken care of him when he needed it most. The family did not need any more space, so Tophan let out the top floor to another foreigner. While listening to Tophan, I noticed a small *patta chitra* hanging on the wall. I could recognize Tophan's hand and asked him where he works these days. "I stopped painting years ago, when I realized there was no need." Compared to painting, an activity that strains the eyes and is hard on the back, life as a landlord and night watchman was far easier. "Some years after William's death," Tophan said, "there was a fire. I had been ill with a fever which lasted for months and was having a rest when I noticed a strong smell of smoke and some unusual sparks from the electric

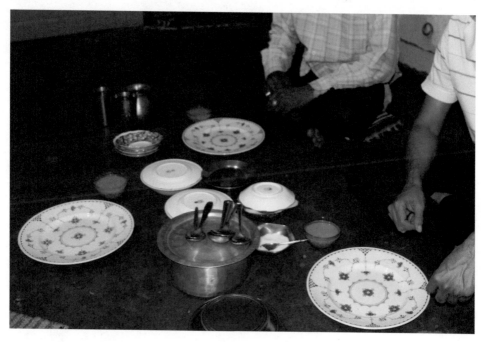

Lunch served on Blue Denmark, Puri, 2016

cables in the ceiling." Tophan ran upstairs with only one thing on his mind: the documents. He must not lose them. How could he otherwise prove that he was the rightful owner of the plot and house? The fire was already raging, and it was with great fear that he entered the flat to retrieve his documents. When they were safe, he and the family tried to save as many things as they could, but most of William's belongings went up in smoke, including, as Tophan put it, "the dining table."

A dining table. Hard to imagine one here in this setting, but in the flat upstairs? Perhaps it was not entirely inconceivable. Confused and hungry, my mind was reeling. It was with relief that I heard Usha approaching from the kitchen. She placed mats on the floor and then went back to get dishes. Expecting the common metal plates and cups, I was surprised to see her carefully laying out hand-painted porcelain, Royal Copenhagen, or Blue Denmark as it is called when produced in England. Seeing my disbelief Tophan laughed, "We have crystal glasses too."

Something to Celebrate

Screened off from the hamlet by the guesthouse, I sat in a woven cane chair on the terra cotta terrace gazing at the local pond. Split leaves of coconut palm trees rustled in the gentle breeze, but apart from that it was quiet, exceptionally quiet for an Indian village in the hours before lunch. What scenery ... A mirage no doubt, but one I enjoyed while contemplating my first walk through the hamlet in nine years – autumn 2016.

It was so different and yet all the same. New buildings with traditional design dotted the lanes. Old, renovated buildings remained but with new garish facades, added floors, metal roofs, and wall paintings of deities with the flexing muscles of a bodybuilder. Villagers still busied themselves producing and trading crafts. More, in fact, than ever before. I imagined if Halina Zealey could see this ... what would she think? In another chair, an American visitor sat sipping steaming hot chai, served by one of the young men who ran the guesthouse. He poured her a refill and then interrupted my reverie:

"Helli *apā*, you are sitting all on your own ..."

"Indeed, I am. Do you work here?"

"I do this and that. What about a selfie?"

"A selfie? Oh yes, of course we must have a selfie."

The visitor watched our interaction with interest, cup in hand, before chiming in:

"How come they all know you?"

"Oh, well that is a long story. One of these days I'll write it down." The guest laughed as I got up from my chair to pose with the young man, a man who I have known since he was a toddler.

It was *Kārtika* (October/November), the most auspicious lunar month of the year. This period is marked by ritual celebrations and presents an opportune time to visit for someone who enjoys festivals. Some rituals are done by women in their homes on a daily basis and others are performed by little groups of women in the center of the village. The most important, *Kārtikeswara Puja*, concerns the whole village.

One late morning later that week, I dropped in to see Manju. She was completing a colorful chalk drawing of *Jagannath* and his siblings on the floor in front of her potted Tulsi, a sacred plant. I sat with her while she recited a couple of *puranas* from a pamphlet in Odia describing the deeds of *Vishnu*. A quiet moment in the warmth of the winter sun that we both enjoyed. I felt at peace and hoped this little break would somehow stretch in time. Manju's morning prayers, she said, gave her the strength needed to run her household. I could easily see how.

Later that day, Manju joined a small group of women in front of the *Krishna* temple to worship *Radha Damodar*, one of *Krishna*'s many names. Here they took turns sprinkling the stone floor with colored chalk to make intricate designs. As the day unfolded, these designs were gradually erased under the squatted shuffling of the women. From their grounded position, they arranged flowers, chopped fruit, and oiled lamps, their hands fluttering like birds in a strawberry field. Like their actions, their exchanges, "Pass me the knife," and, "Is this what you want?" indicated just how busy they were. I wondered whether *Radha Damodar* might visit the eldest participant, as the deity had already done on a couple of occasions during the last fortnight. If he came, surely we would know. Then the woman would go rigid, clench her fists, and start shaking. There was no indication of that happening today.

That afternoon, two other American visitors watched the activities from a distance. When everything was ready, they joined to participate in the ritual. What they made of it I do not know, but they seemed to enjoy themselves. One had even learned the art of *huluhuli*, a tongue-twisting exercise used on auspicious occasions that I will not master in this life.

Kārtikeswara Puja took place when the dark fortnight ended and the moon altered from a slender crescent to a full moon, *Purnima*. Some days before the ritual, Sula's son Narayan had begun preparing *Kārtikeswara*'s

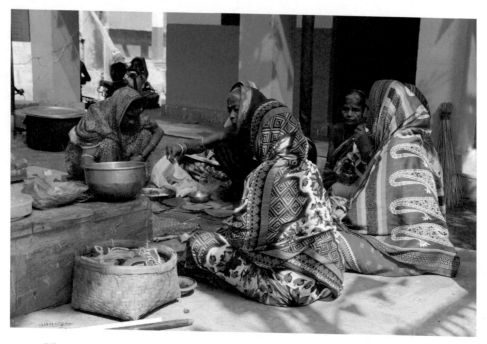

Women preparing a *puja*, 2016

figure. His work did justice to the deity; Jagannath could not have done a better job himself. On the day of the *puja*, a Brahmin from Janakadeipur village was summoned to cook the food and offer it to the deity.

After *Kārtikeswara* had eaten, Sarat Chandra, an old apprentice of Jagannath, took over handling what was now *prasād*, food blessed by the deity. Since Jagannath's death, Sarat Chandra had held the responsibility of serving during village feasts. He took the ladle, and with it he stirred the cooking pots – each the size of a tractor wheel – before dishing out generous portions to us all: villagers, anthropologist, and foreign visitors alike.

I have participated in many feasts over the years, but this was different. I could not help thinking of my experience as a young woman in the hamlet when not a soul apart from Lingaraj had been willing to eat with me, yet here we were, a hodge-podge of religions and languages eating together in one continuous line. To me, and most of the attendees of my generation in the village, it was a most welcome change. For the young, well, it is how things are done in Raghurajpur.

Spectator Bird

At home in our kitchen in Denmark, my son and I were discussing his upcoming high school exams in May 2019 when the first news of "Fani" reached us. A super cyclone was rapidly approaching Puri. Standing next to our kitchen island in the bright northern light of spring I watched the red vortex move across my mobile screen, a sea-monster heading directly toward the old temple town. Twenty years ago, Bhaskar was but one painter who lost his home to a super cyclone. Whose life might Fani now turn upside down? Although I did my best to concentrate on my son and his exams, my attention kept wandering to the painters and what the future had in store for them. The running updates were no comfort.

Two days later, Friday, May 3, 2019, Fani made landfall in Puri with a fury worthy of an angry goddess. All lines were dead; it was impossible to get hold of anyone I knew. When calling, all I got was an eerie silence. What was happening? How were Sula and her family? And what about Tophan who lives close to the sea, how would he fare? My own world continued as if nothing had happened. I got up, listened to the news, did my yoga, wrote for a couple of hours before setting off to work, returned home on the train, cooked a meal, and read for leisure. Fani was not mentioned again, already pushed out of the news stream by other more pressing matters. All the while, the fate of the painters was at the back of my mind, surfacing every now and then and distracting me from whatever I was doing. The constant reminders grew

tenfold when, a week later, messages began to pour in on WhatsApp, each accompanied by photographs documenting the destruction.

"Fani, my village, my house."

Mera's son's message was not exactly informative, but as the caption of a photograph laying bare a broken home with only half a roof and the family's formerly proud palm trees uprooted and blocking the entrance, it sufficed.

"Odisha Puri big storm, Raghurajpur, 200 house art work shop damaged, people no food, plz help me and your friends."

One of the young painter's combination of nouns and adjectives was difficult to ignore, and like the other message, it was documented by photographs of roof structures ripped of their thatch, metal roofs scattered on the ground, a motorbike lying in a heap of fallen palms and rubbish, a wheelchair on a roof overturned like a turtle on its back, and wooden construction material scattered everywhere, as if someone had turned a box of matches upside down.

"Plz help me and your friends." The plea left me no peace of mind. I wanted to help, but I was not sure what to do. How exactly does one help a village?

In one photo, Manju's husband stood before the family bed, a bed just like the one I shared with their children in the early 1990s. Then their house had provided shelter against the elements. With the roof torn off, however, the sky was clearly visible above the bed. In May, with blistering sun and an oncoming monsoon, it was no wonder he appeared forlorn, standing there slightly hunched with a damaged painting held as a shield in front of his chest.

Months' worth of work had been lost in a matter of hours. How would they eat? Like other households in the Puri district, Manju's family received 2,000 rupees (approximately 25 euros), 50 kilos of rice, and polythene to cover their damaged roof in disaster relief from the government. A non-governmental organization provided them with a month's supply of pulses, flour, soap, nail polish, eyeliners, toothbrushes, detergent, and mosquito nets. It was just enough to keep them alive but not anywhere near enough to finance a new roof. I could possibly finance this roof – one new roof that is, but what about all the other missing roofs? How could I help one family but not another? I began to dread the incoming messages. If only I ignored them, refused to read them, I might just be able to shut it out of my mind. Some days

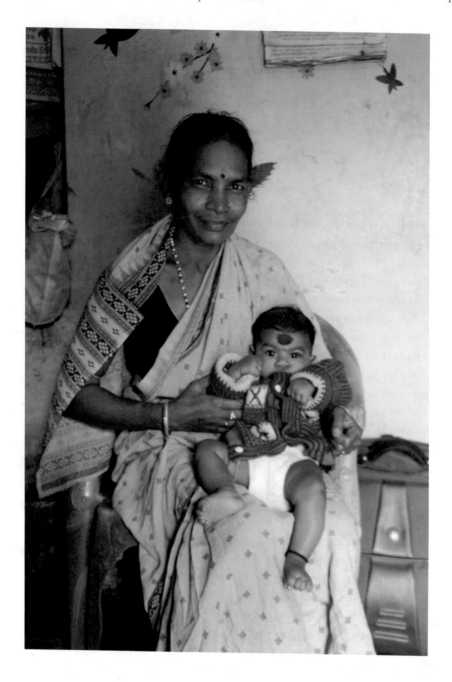

Sula Moharana with her four-month-old granddaughter, 2019

I managed to forget, or almost forget, but never for long. The needs were overwhelming, and here I was, in a comfortable house with a roof over my head and totally incapable of offering the necessary help. What was my personal obligation and where did it stop? For the first time since I had trained as an anthropologist, I envied researchers from other fields who believe in objective detachment.

The leaves of the old beech trees at the back of our garden were turning golden; autumn was upon us. I was at my desk writing and had been at it for hours. I was tired. Time to stop. I wondered if there was any news from my then 92-year-old mother-in-law, whose playful use of emojis often brighten my day. Instead, I found a WhatsApp message from Sula's son Narayan. What was he up to? I had not heard from him for a while. In the attached photo, a baby girl, snuggled in a new bright pink patterned blanket, gazes at her father. The picture made me smile, as did his accompanying messages, "Anti, my little girl," followed by, "Sula has become grandmother." There she was, Sula, clad in one of her off-white saris and sitting in a plastic chair in the brightly colored front room decorated by her sons, cradling her newborn granddaughter. I felt happy for her.

Our lifeworlds are separated, marked by geographical and cultural distance. But they are not distinct worlds. They have never been. Unlike the letters I received after my first fieldwork, social media updates are not cushioned by time. Whether misfortune or a joyous event, news of the painters' lives transmits instantly without compromise, sometimes in the guise of a curse and other times as a precious gift. Emotional involvement born from close encounters over a lifetime, however, does not imply a shared life, merely the ruffled wings of a spectator bird.

Voyages through Time

PAINTING MATTERS

During a visit to the National Museum in Copenhagen in the summer of 1988, I reckoned my advisor was right in describing the Puri painting as "intriguing." Intriguing, yes, and large, larger than the wall of my student living room. The painting depicts the *Jagannath* temple in Puri.[9] Standing at a distance, I was amazed by the effect of a limited palette of five basic colors: earthen red, deep yellow, blue, black, and white. Simple, but somehow just right. I moved closer to decipher the numerous small illustrations that filled out the entire surface. No empty space, no place to rest one's eyes. From one constellation of figures to another, the illustrations were arranged across the canvas in a manner that appeared random. Who were they all, and what were they doing? I had only a vague idea, and the exhibit offered no more than the most basic clues.

Feeling slightly foolish, I recalled a letter I had read some days before sent by a Danish collector, Benjamin Wolff, in 1850 to the curator of ethnography at the National Museum in Copenhagen. In his letter, Wolff offers to donate the painting to the museum, hoping "It will be welcomed and contribute to the education of the people of this country regarding some of India's many peculiar circumstances and customs."[10] Wolff, apparently, had not found the painting straightforward, something I could easily appreciate as I stood there bewildered

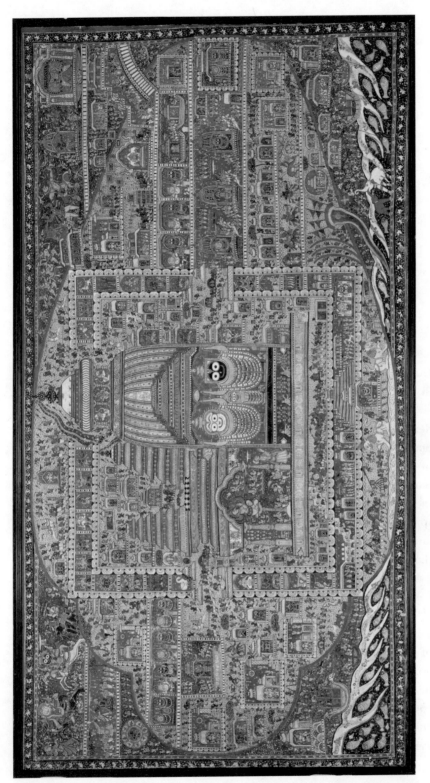

The Puri painting. Courtesy of Denmark's National Museum (2.10 m x 3.80 m)

but nevertheless captivated. He warned the curator, "You are likely to find the painting ... very odd," and offered a key, "Without which neither you nor anybody else would understand very much."[11] Unlike the museum guests who were kept in the dark – the key was stowed away in the archives – I had read Wolff's letter and was comparatively well informed; still, I was mystified. There was so much Wolff had not cared to explain. What might other visitors make of this? I wondered. Would they also like to know more about this painting and its makers?

The painting was a horn of plenty, full of stories waiting to be recalled. Of course, it would require a viewer with cultural skill and familiarity with the particular iconography and mythology. I did not possess the adequate interpretation skills then and had to accept that despite standing there looking at the painting, I could not really see it. All the same, I found the iconic representation of the temple interesting – pleasingly chaotic and attractively mysterious. I imagined walking through the temple complex using the painting as guidance and wondered whether anyone these days, more than 150 years after its creation, produced similar paintings.

The Puri painting that captivated me in my youth was commissioned by the *rajah* of Khurda, a local king, who in the 1820s was the chief patron of the *chitrakāras* settled in his area.[12] In the painting, the *rajah* can be seen standing left of *Jagannath* and his siblings, a tall figure indicating his magnificent status as representative of *Jagannath* on earth. A commission such as this would have been paid for in advance, making it possible for the artisans to acquire raw materials and ground colors and spend the necessary time to carry out a work of this scale. It was a task for several painters from the community who would collaborate on completing the order, a different situation from the last half century when the few old painters who still made these depictions of the temple (called *thiā badhiā*) worked on their own. Their vertical, often crudely executed paintings were and continue to be a far cry from the horizontal Puri painting, but they are still recognizable as a comparatively simple representation of the temple. Considering the different work environments, the transformations are not surprising. In contrast

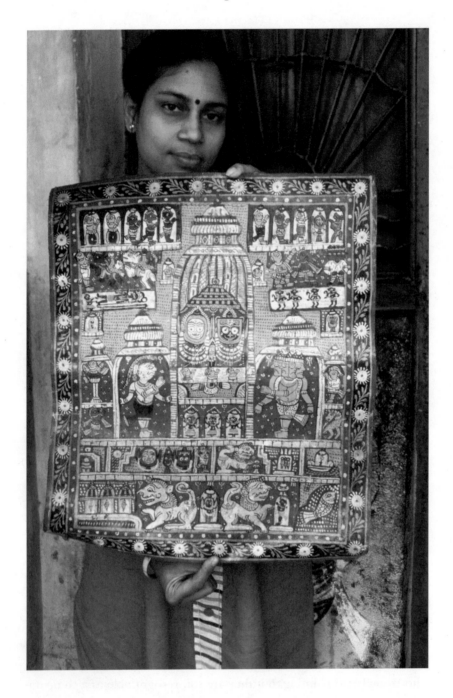

Seema Samantray with a *thiā badhiā*, 1989

to their ancestors, contemporary painters who make *thiā badhiā* cannot rely on a wealthy patron. If they have a patron at all, it is of a different kind: another better-off painter who provides raw materials for exclusive rights to sell the painting.

The iconographic temple representations had lost popularity by the time I arrived in 1988. Customers had taken to cartoonlike paintings with central motifs from the grand epics *Ramayana* or *Krishna lila*. In these paintings, chronologically ordered scenes from the life of *Vishnu* (in his form as *Rama* or *Krishna*) frame a central motif of *Rama*'s coronation or *Krishna* with his beloved *Radha*. This linear narrative form, inspired by, among other things, Odishi palm leaf–engraved manuscripts, was introduced in the early 1960s by the State Handicrafts Design Center to cater to a broader clientele – apparently a successful development. It certainly makes it easier to decipher what is going on in a painting. One only has to be familiar with the mythological stories and have an idea of the deities' typical representation to follow the story line. Even those who do not know these stories easily grasp the idea of following events in the life of a deity from birth onwards.

Over the years, the popularity has continued, spurring painters to keep increasing the number of illustrations. Where in the late 1980s a single row of events usually surrounded a scene, perhaps with a few enlarged scenes on each side, depictions in the early 2020s flaunt several rows of illustrations accompanied by a number of vertical rows on each side of the central motif.

Likewise, increasingly elaborate borders have proliferated as well. A single painting might have several intricate borders and colorful columns with intricate designs framing the central motif. The color scheme has also changed. The simple palette of five colors was outdated when I came in 1988, the majority of painters using whatever color might please their customers. Their pragmatic attitude was often deplored by regional and national art specialists who saw these trends as a threat to Odishi painting, a critique that generally was ignored among people whose main concern was to make a decent living for themselves and their families. Thirty years later, this is still the case.

As the Puri painting indicates, the painting style has a history. Considering the competitive melee in Raghurajpur in the last thirty years, it is easy to forget the continuous fluctuation in the production of paintings over time. Ebbs have been followed by high tides, the latter

lasting long enough to forget that ebbs might return, the market rising and falling over time. Despite the popularity of cheap prints produced in Kolkata and available in Puri around the turn of the nineteenth century, paintings on cloth and paper were still produced in Puri in the 1930s, some of which can be seen in *Prints and Drawings* in the India Office Library in London.[13] The library records mention that the civil servant and art historian William George Archer purchased the paintings in Puri and an unspecified suburb of Puri, possibly Raghurajpur but more likely the neighboring hamlet Danda Sahi. Only twenty years later, however, the American couple Halina and Philip Zealey found few painters in these villages making a living from painting. Philip Zealey's work for a private voluntary Quaker organization, the American Friends Service Committee, had brought the couple to Odisha.

What happened between the 1930s and the early 1950s to cause this decline? One important factor was independence. The royal families, who until then had ruled on behalf of the British Empire, were forced to pledge allegiance to either India or Pakistan and later surrender their territories and revenues. With this change in financial circumstances, the royals discontinued their former ties with local craft makers. The Maharaja of Puri, the Queen of Charakote, and the Prince of Chikiti, for example, discontinued their employment of *chitrakāras* after independence.[14] Although they might never have had many in their patronage, the arrangement at least meant some craft makers and their kin could rely on getting the occasional large order. Local *rajahs* had previously commissioned work not only for themselves but also for the purpose of gifts. The Puri painting at the National Museum in Denmark is a case in point. In the early 1950s, the Indian government set up institutions to support handicraft production all over the country, but it took some years before they began to function as intended, particularly when it came to reaching village-based craft makers. The period just after 1947 must have been particularly difficult for *chitrakāras* and helps explain why Halina and Philip Zealey found few active painters when they first arrived in Odisha.

Halina deplored the "very inferior work" in a combined report and application for funding sent to her husband's organization. The painters, she found, were "somewhat demoralized" by the cheap pilgrim market but were capable of producing "very fine work – the

best of its kind in the tradition" if encouraged.[15] Philip Zealey saw the deterioration in skill as a direct consequence of the decrease in demand, and like his wife he found it important to generate renewed interest in the craft.[16] Halina and Philip Zealey's involvement with craft makers took place just when the initiatives of the local government began to show some results in Puri. A few years after their arrival, some thirty households of painters in Puri had acquired full employment and many more partial employments as a direct result of the local government.[17] In Raghurajpur, however, painters had yet to see the effect of this initiative. What they saw instead was Halina's personal commitment to supporting their community. When I came to the hamlet, almost forty years after her involvement, painters still referred to her as *Lakshmi*, goddess of wealth, as they had done during her stay in Odisha.

In 1976 Halina Zealey donated her collection of crafts from Odisha to the Museum of Mankind in London accompanied by a list of objects and comments. Among the paraphernalia is a *patta chitra* of *Ganesh*, the elephant god in his five-headed form, painted by Jagannath Mohapatra. Halina notes the painter is respected for the "purity of style and fineness of the brush-strokes."[18] It is finely executed work.

Did Halina Zealey's insistence on refined execution influence the tradition of *patta chitra*? The art historian Joanna Williams does not think so.[19] Zealey's preferences might not have directly altered the tradition, but her taste in painting did significantly influence contemporary painting in the hamlet. Zealey's praise of the five-headed *Ganesh* and her decision to award Jagannath spurred him on. Over the years, Jagannath got several awards and, more importantly, taught numerous apprentices who could carry on his characteristic style of relatively short and compact figures.

One thing painters have in common across time and generation is their dependence on customers and their preferences. Odishi paintings have always been made for distinct groups. These groups have a significant effect on the specific execution of paintings, and when the customers change, the paintings change to match. Pilgrims come to Puri to see the *Jagannath* temple. What matters to them is content. They want paintings (or prints) to commemorate the pilgrimage and for distribution when returning home. They often have limited resources and prefer to travel light; small paintings on newspaper of *Jagannath* and his

siblings, whether on their own or in the temple complex, fulfill both requirements – as do cheap prints.

For the *rajah* and other wealthy patrons, content was important too. Just as important, however, were painters' skills in execution. These wealthy benefactors could afford to pay for finely executed large cloth paintings. To them, aesthetic was as important as content.

With independence, commissions from the local *rajah* and royalty ended. Simultaneously, prints gained popularity among pilgrims and fulfilled their needs for images. With the change in governance, painters turned elsewhere for their livelihood.

When the Indian government and Halina Zealey encouraged painters to use cloth rather than newspaper as the medium for their paintings, they revived a form of painting that had been exclusively made for royalty and wealthy patrons. These paintings found a new clientele among Indian and foreign customers, often tourists, and with a burgeoning digital marketplace also buyers who do not travel to Odisha.

While this type of painting on cloth has a large new market today, the roughly executed *jātri pattis* on newspaper have become rare. Instead, painters recycle old newspapers to produce masks, which, like *jātri pattis,* do not require a large investment of time. A few mask makers are highly skilled painters themselves who, despite their good hands, have never made it as a *patta chitra* painter – good hands are not enough to make it and maybe never were. In a world governed by social media, however, virtual skills are increasingly important to make a decent living from painting.

Where specific reference to *Jagannath,* the all-important god of the region, was key to please royalty, wealthy Bengalis, and pilgrims, contemporary Indian customers favor representations with a broader appeal. *Vishnu* has many forms, *Jagannath* being one of them, that are favored in Odisha. *Krishna* and *Rama,* two of *Vishnu's* main forms, however, are loved by Hindus all over India. These forms, in other words, are a safe choice for someone who paints for a living.

A HERITAGE VILLAGE

The villagers of Raghurajpur have never been totally cut off from the world. As *sudras,* traditionally of relatively low status and power,

possessing little or no land, they have depended on patrons living outside the hamlet. What exactly they did for a living previously was determined by their specific caste. A *chasa* (farmer), for example, most commonly worked as a day laborer in the surrounding fields, whereas a *chitrakāra* combined agricultural work with painting for pilgrims, other visitors to the *Jagannath* temple in Puri, temples, and Brahmin patrons. Households have always been part of networks reaching beyond the local hamlet. Well-connected painters – and these days, people of different castes have chosen painting as their livelihood – have contacts in some of India's large cities and sometimes even across continents.

Raghurajpur is closely tied to Odisha state policy on tourism and handicraft production. In the mid-1970s, the local government made an effort to improve craft makers' economic and social conditions by establishing a cooperative society. For years, this solemn, out-of-place cement construction was the first building one saw when entering the hamlet. It still is one of the first buildings, but it no longer stands out partly because of a thorough facelift but also because cement constructions these days are common.

The initiative of the local government alone cannot explain the increasing number of visitors belonging mainly to the Indian middle class. Regional and national experts committed to the development of Indian crafts have also played a role in the changing hamlet. The work of regional experts already bore fruit in 1987 when the King of Puri inaugurated a festival celebrating the hamlet of then 500 inhabitants as a "crafts village."

The nomination of the hamlet as a "heritage village," however, in 2000, was the culmination of a year-long engagement by national experts. Raghurajpur shares its distinction with other hamlets developed as "heritage villages" by the non-profit organization the Indian National Trust for Art and Cultural Heritage (INTACH). It was set up in 1984 on behalf of Prime Minister Indira Gandhi and is just one of several legacies of Pupul Jayakar, an advisor on cultural affairs to the prime minister. Better known outside India is the Festival of India, a string of events held across the world in which she played a pivotal role. As the name suggests, INTACH works to conserve heritage through renovation and development projects.

Since the first decade of the new millennium, INTACH has conceptualized and partly financed the construction of a number of new

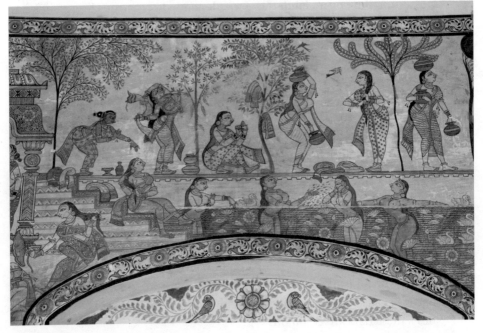

A section of "Four Seasons," a wall painting by Bijay Kumar Parida, settled in
Bhubaneswar, 2017

buildings situated at carefully selected spots in the hamlet; the first was
a guesthouse completed in 2007. A dining hall, an amphitheater, and
a string of showrooms followed to support a continuous, multifaceted
cultural production. The traditional architecture of the guesthouse and
its wall paintings in earthern colors made by a recognized painter from
Bhubaneswar, Bijay Kumar Parida, reflect the mission of INTACH.

From the guesthouse, a brick path leads along the pond to the am-
phitheater. Like the guesthouse, the arena has the organization's unmis-
takable sign, a refined aesthetics with deep cultural roots. Massive blocks
of stairs lead down to a square platform on which Gotipua or Odishi
dancers occasionally perform. Cows and stray dogs, however, are the
most frequent users. The boys practice the traditional dance forms in
the home of their guru, shielded from sun and rain, as they have always
done, when they are not on a tour to perform in one of India's cities.

Some of the building projects of more recent date, financed through
public money, reflect a broader concern in tune with the decision to

Guru Gangadhar Nayak decorates one of his Gotipur pupils, 2017

develop a heritage village. Cultural aims, it appears, go hand in hand with economic and social development. The library might be cement and ready made, but the architect has made the most of its position at the edge of the river where it floats on stilts to withstand the rising waters during monsoon. The building is spacious, light, and welcoming, suitable for a library, but has nevertheless gone to waste. Leading local residents pulled strings to secure funding to build the library and thus strengthen their position as men who make a positive difference to the hamlet. Passing by one day, I imagined what the architect envisioned when drawing up the plan and enjoyed what I saw in my mind's eye: another world. A brief glimpse before I was catapulted back to the world of the hamlet. Damp patches feasted on the walls of the vacant building that someone, who does not need to ask permission, uses for his own benefit to store rice and shelter his cows. It surprises no one; after all, it was built with government money and that kind of money all too often is poured into the sea.

Just like the library, villagers rarely use the showrooms at the entrance of the hamlet but find the space convenient as a setting for

marriage functions and the celebration of the spring festival (*vasanta utsava*), a yearly event organized by the State Tourism Department and Eastern Zonal Cultural Center. A red brick wall frames the square area and shields a veranda divided into individual sections like pearls on a string. The tilted roofs float on the angular brick pillars and match the numerous brick lamps at the edge of the lawn – or they did until the super cyclone Fani struck in May 2019. Here, craft makers are intended to work side by side, just as they do in the Crafts Museum in Delhi. But unlike the Crafts Museum, this place is generally empty. The advantage of working at the entrance of the hamlet where customers arrive does not make up for the drawbacks. "What for?" Lingaraj asked me in lieu of a response to my queries. "Here in my house I have seen my children grow up, I have my colors and brushes, and I look forward to enjoying my grandchildren. Why should I go there?" Apart from personal reasons, economics play a role in craft makers' decisions not to use the workshops. Why pay 5 percent of the sale price for the use of the facilities and risk missing a customer passing by one's house when it is possible to sell free of charge from home? Why indeed.

At the river, one house stands out among uniform colors of cobalt blue, magenta, pink, and mint, the shade of its ochre front wall changing with the weather: dark on wet days and bright yellow in sunshine. The owner, a painter who has done well, has decorated the wall with an intricate wall painting. During one of my recent visits, he was proud to show his refurbished floors. The beaten dirt floor was replaced by red oxide, a traditional and cooling floor as he pointed out. He was right; the floor felt pleasantly cool under my bare feet. So did the marble floor of a house further down the lane. Big slabs of this expensive stone extended from the terrace right down to the common dirt lane.

Whether one kind or the other, the renovated floors indicate a degree of wealth unimaginable in the late 1980s. They also reflect two forces that shape life in the hamlet: on the one hand, a quest for safeguarding and nurturing tradition in its broadest sense and, on the other hand, a quest for monetary gain and the things money can provide. What drives these forces are not necessarily as different as they might appear. The painter who has spent time decorating the front of his house might treasure the traditional style, but he is also aware that it is popular with many visitors and potential customers.

The careful development by INTACH has reinforced a traditional aesthetic at a time when old buildings are giving way for much wanted renovations, including cement walls, metal roofs, and bright colors. As the heritage site attracts more customers, the wealth grows, albeit unevenly, allowing some villagers to realize what previously had only been dreams. These dreams might not be in line with the aesthetics expected of a heritage site, but who cares? Certainly not the people who enjoy the benefits of a renovated house. And as far as the tourists are concerned, they are still impressed by the hamlet. Everywhere they turn they see deities or dancing girls, figurines of *Jagannath* and his siblings *Balabhadra* and *Subhadra* in wood or stone, wall paintings depicting the adventures of deities, or *patta chitras* with illustrations of the great epic *Ramayana* or *Krishna lila*.

NOTES ON LANGUAGE

If the name of this well-known tourist destination were to be changed in an attempt to provide anonymity, it would be a symbolic exercise. These days, anyone who sets their mind to finding Raghurajpur would be able to find the hamlet regardless of what I call it. Throughout the book, I have called Raghurajpur a hamlet to distinguish this particular community, but for simplicity of language, I have referred to the inhabitants as villagers.

I have kept most names of the central characters but changed others to ensure anonymity after thoroughly talking it over with the people concerned based on Prasanta's careful oral translation of the stories. When asked whether they would prefer a synonym, the painters without exception replied, "No, it's the truth, people should know the truth about how we live." For some, however, I have nevertheless opted to use a synonym, and they have accepted my reasons for doing so.

Although Odia is spoken across the state, certain colloquialisms are characteristic of how Odia is spoken in the hamlet. The dialogue, I hope, gives a sense of the painters' pragmatic attitude to life, their direct approach and subtle humor. I have indicated long a's in local concepts but otherwise not transliterated Odia words. Concepts listed in *The Collins English Dictionary*, names of people, and places are written as they are commonly presented when using the Latin alphabet.

FIELDWORK AND PERSONAL LOCATIONS

In the summer of 1988, three years into my study of anthropology, I decided I had better get a taste of fieldwork, since it appeared essential to become an anthropologist. Fieldwork was the basis of the literature in our curriculum and always figured into conversations with teachers. Anthropologists seemed to wear their fieldwork as part of their identities – a tooth around a neck, a hand-woven textile displayed on the walls of an office, an electric bleeding Madonna competing with books for space on a shelf. But fieldwork was not part of the study program at my university. However, during a time when students in Denmark were free to plan their own study, I was able to do fieldwork if I so fancied. I chose South Asia because I was familiar with India after three months of backpacking and the topic of crafts because material culture was also then an important part of my life. Moreover, I thought crafts presented a convenient passage into the world of their makers. The Puri painting, perhaps, could provide a first link to contemporary makers of *patta chitra*.

Half a year later, in the winter of 1988, I had settled in Raghurajpur in the household of the renowned painter, Jagannath Mohapatra, who belonged to a community of *chitrakāras*. It was his ancestors who had made the Puri painting all those years ago.

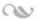

When I first arrived in Raghurajpur, we were young, the main characters in this book and me. Now their hair is streaked with silver, just like mine. Our bodies have changed, as have our societies. Anthropology, also, has transformed. In the late 1980s, anthropologists, typically western and white, still commonly traveled to far away destinations to "do fieldwork," another word for data generation. Anthropologists turned up somewhere out of the blue to negotiate work conditions with their "informants." That was acceptable as long as one reflected on representation.[20] If this arrangement was collaboration, it was of a different kind from what is acceptable today.[21] My surprise in 1988, when I realized that my host expected a book as a result of my stay, appears naïve today. Certainly it was, but it also reflects a certain period

and a different kind of anthropology. In 2017 I was taken aback, not only because Niranjan questioned the benefit of my work for the painters, but also because it was the first time a painter had asked. Today, anthropological project proposals are expected to carefully consider the question, "What's in it for your interlocutors?" A part of the ethnographic material used to write the stories in this book is the result of bygone times, for me as a young anthropologist, for the painters, and for anthropology. The stories, however, are the result of a collaboration more in tune with the times.

During my first fieldwork in 1988–1989, I was lucky to work with another young student of anthropology. To find a female research assistant at the time willing to move to Raghurajpur with me for three months was not easy. Smaranika Samantray, or Seema, however, was about to plan fieldwork as part of her MPhil degree at Utkal University when I came along. An independent spirit, Seema was fortunate to have parents who had faith in her and were supportive of her endeavors. We discussed our different needs in a corridor at Utkal University, decided to collaborate, and soon after settled into Raghurajpur where we shared a small room, a desk, and a big bed. Seema has kept in touch with some of the families and with me. Our lifelong friendship has been maintained through letters, irregular visits, and later WhatsApp and Facebook. When I returned to Puri district in 1991 for a period of eighteen months as part of my PhD, Seema had acquired highly sought-after permanent work as an employee in India's only public sector insurance company, Life Insurance Corporation. This was the beginning of what has been a life of constant movement from one town or city to another across four Indian states and no less than fifteen housing facilities.

With permanent employment, Seema could no longer work with me. Working temporarily as a research assistant is no substitute for job security in India. That led to my ongoing collaboration with Prasanta Mishra, or Bubu, who shared my interest in story writing, if not also in anthropology. He has put up with my questions with diligence and humor for many years, personal characteristics that later shaped his practice as a teacher. When we met, Bubu had recently completed

his BA in history and political science and was slowly coming to terms with a personal loss and the aftereffects of an illness, one that had put a stop to pursuing his talent for Hindustani classical singing. Working with me provided work experience, distraction, and a break from questions about his future plans. Like Seema's family, Bubu's was part of the rising Indian middle class, but Bubu's family's way of life was quite different, set in a dissimilar environment. Seema stayed with her parents in a multi-caste village a bus ride away from the capital but spent the majority of her time in the capital, where she studied. Bubu lived with his family in Puri, a place that was and still is an ancient, mainly Hindu, conservative temple town governed by conformity and watchful eyes.

Like Seema, Bubu had an easygoing demeanor and quickly won the hearts of the painters. Occasionally, however, the older generation of painters found Bubu's flexibility inappropriate for a *Shasana* Brahmin, the highest caste in Odisha, and they did not hesitate to say as much.[22] More than once, a painter of an older generation told us to swap places after realizing the implications of first offering me a place on a bed and then rolling out a mat on the floor for Bubu. After all, it was inconceivable at the time that a *Shasana* Brahmin should sit at the feet of someone like me of lower caste.[23] Over the years, Bubu has developed his own relationship with the painters. When one year he did not have time for working with me, more than one painter asked me, "But where is Bubu? When will he come?" The difference in Seema's and Bubu's lives in the early 1990s is insignificant when compared to the villagers' lives at the time. Still, Seema and Bubu were not as far removed from the way of life in Raghurajpur as people who have lived their entire lives in an Indian city. India is a country of many layers.

After my stay in 1991–1992, I paid Odisha regular visits until 1998 when my daughter, Aliya, was born. Six months old, I brought her with me to Chennai, where my husband's parents live. As an assistant professor, I worried that my decision to take a one-year maternity leave might be detrimental to acquiring tenure. I could not do fieldwork in Odisha on my own with a baby, and my husband was not in a position to leave his job in Denmark. Cushioned by my Indian family in Chennai, I imagined I could do a bit of work in the city, and I managed just that.

Already in the late 1990s, Chennai was a pulsing city of more than four million people. Social class, rather than religious community or caste, was reflected in the different areas and lifestyles of the city. Ours

was an upper-middle-class area of well-educated people, homeowners with cars and servants who took care of the mundane and time-consuming tasks of Indian life like cooking and cleaning. Even in that neighborhood, relative wealth has increased over the last thirty years. It is the middle class, broadly defined, that has benefited most from the incredible change Indian society has undergone since 1991, back when the Indian government decided to open the market. Deciding to pause my work in India, I returned to Denmark three months later. It did not seem right to repeatedly keep Aliya from her father, and I had no intention whatsoever of leaving her behind. Instead, I turned my professional attention to the experiences of minority children in Danish preschools, an issue closer to my personal life.

In 2007, I returned to Odisha to visit Raghurajpur with my children and my mother-in-law. It was alien territory to Aliya and her younger brother, Mathai, who were familiar with city life in India but had never before spent time in a village, never mind a hamlet. I am pleased I got the opportunity to introduce my children to some of the painters.

Nine years later I returned once again, having devoted many years to the needs of my children, university administration, and educational development. During this stay, painters shared with me the ups and downs of their lives since we had last met, each expressing the twists and turns of life that only time can create. Thus began the work that led to this book.

Afterword: The Painting of
Painting Stories

More than thirty years after I first saw the Puri painting displayed at the National Museum in Copenhagen I still enjoy the *patta chitra* that adorns our living room wall, a painting I now possess the visuals skills to see.[24] It depicts a single scene, *Rama*'s meeting with *Bharata* in the forest. The painter, a master of poses, has drawn *Bharata, Sita*, and *Rama* and his followers surrounded by animals of the forest. Their feather-light appearance reflects the expertise of Binod Moharana, an artist who acknowledges the skills of his predecessors while infusing tradition with new forms in order to paint for the future.[25]

Below the painting, on our bookshelf, three small paper masks and a set of roughly carved and painted wooden figures of *Balabhadra, Subhadra*, and *Jagannath* are displayed. As a young anthropologist, I had hoped crafts would give me a passage into the world of their makers. They did, and it is this social world that is most important to me. The difference in execution, material, and perceived value of these crafts mirror their makers' different skills, purposes, and circumstances and is a silent reminder of the lives of painters and their stories.

Crafts and a specialized set of visual skills are some of the outcomes of my fieldwork in Odisha. The stories and reflections in this book are my

attempt to paint a fuller picture of the lives and experiences of Odishi artisans. In these last pages, I share the events that triggered my story writing, sum up what painting means to painters, and explain my reasons for choosing the particular narrative form and prose.

During my visit to the village when Sula shared the loss of her husband with me, I realized I could not carry on with my usual anthropological routines. Something had to change if I wanted to give her story the gravity it deserved. Plus, my personal fatigue with university administration and duties was growing by the day. Whereas I did not feel I owed the university anything, I could not say the same for Sula and the other painters I have worked with. Some weeks later, at my desk back at home in Denmark, I pushed aside my other obligations and simply wrote, hoping to come to terms with what had happened to Sula. As I wrote, an image slowly took form. Sula had always appeared soft-spoken and slight, and during my last visit certainly drained, but her actions, when tallied on page, spoke of extraordinary determination and stamina. Eight months later, I shared my narration of Sula's account with her and added that I admire her and some of her village sisters for their endurance. Gazing into the distant scrubland behind her house, Sula quietly responded, "I had to be strong." She turned her gaze to me and said, now more audible, "It's true I have been strong, so strong," and then spoke directly to her friend Mera: "If other women hear our stories, they can learn from us."

Something happened that day to Sula and to me. We found some common understanding through storytelling. For both of us, it was a transformative experience, though in different ways. My recounting of Sula's experience and our common reflection allowed her to endow her fate with new meaning. Her changing expression confirmed what storytellers and writers have always known. Stories may not only reflect events but can also transform their meaning.[26] Contemplating the ethnographic material I have accumulated since the 1980s, I wondered what might be buried in those notes and memories and whether it could be of any value to the painters.

The months following my visit to Sula in 2016 were dark. A typical Danish winter can be a bleak affair. The sun rises late and sets early, and there are days on end when it never shines. One is not easily tempted outdoors during those months. Indeed, deskwork appears comparatively tempting. I set to work, searching through a heap of fieldnotes

and diaries. Sorrow, rage, embarrassment, astonishment, joy – emotions, some of recent origin and others experienced at various stages of life during fieldwork or visits with my family to the village, came back to me, imploring me to continue what I had begun in recording Sula's loss. Feelings, whether mine or those of the painters, inspired me to write ethnography differently.

A year later, I shared new story drafts and reflections with painters. Unlike my earlier experience in the late 1990s of sharing my analysis of their art worlds – an exercise that left most of the painters glaze-eyed – the stories resonated.[27] Tophan was thrilled to be reminded of his youth, Lingaraj wanted the world to know how it is to live as a village-based craft maker in India, and Sula felt that sharing her story with other women might offer some meaning to her suffering. Common to all the living painters who play a role in this book was their keen interest in our exchange. Their engagement with the stories grew into a collaboration, both narratively and in a joint hope to come to terms with our lives. The painters have not only contributed as experts on their lives and lifeworlds but also as critical listeners, never hesitating to let me know if they disagreed with my interpretation or found it inadequate. While my own voice and interpretation carry through, the painters have contributed to shape these stories. I am sure, however, they would have told them differently. I am also responsible for selecting the stories and their arrangement. I wanted to write stories that the painters could recognize as their own, but I also wanted the stories, in their unity, to paint a picture of life as a village-based artisan. *Painting Stories* is written with painters, for them, and the world. The mosaic of texts reflects some of their deepest concerns, whether dilemma, difficulty, or dream, as well as my belief in biographical depth, coincidence, and life as a social game influenced by a specific time in history.

PAINTING STORIES

Painting Stories, in a narrow sense, refers to how painters depict images of well-known scenes. *Rama*'s coronation ceremony, *Krishna* with his beloved *Radha, Arjuna*'s battle in Kurukshetra, connected scenes from Hindu mythology, or more rarely, the temple of *Jagannath*. But even a simple papier-mâché mask or a figurine refers to a deity from Hindu

mythology and thus carries a story. Aside from craft matters, the title reflects my wish to paint a picture of the life of artisans through stories accessible to the general reader. In this sense, *Painting Stories* denotes a particular kind of ethnographic writing.

"Painting" is a noun and a verb, both materiality and activity. As a noun, painting in this book refers to images on cloth, paper, or walls from Hindu mythology presented either by themselves or in combination with other images. As a verb, painting expands to include other media like papier-mâché, wood, and dung.

The meanings that are associated with painting are inherent in the stories, but I did not foreground them in this book, as is common in traditional anthropological texts. Instead, I have focused on painters' fates, hopes, and actions as they have played out over time, existential matters that concern us all.

In the following paragraphs, I will nevertheless explicate these meanings to show how analytical concepts can grow from ethnography in the form of stories. I do this with one of my former students in mind. I had just read aloud some passages from two of the stories in this book when the student questioned the relevance of storytelling in academic anthropology: "How is this useful to anthropology?" I do not recall my answer at the time. Today, I would say there is analytical value in narrative. The stories in this book are no exception. There are concepts we could, if inclined, draw from the patterns of the painters' lives and experiences. Ethnography can birth both compelling narrative and analytical concepts essential for social analysis.

Hindu deities are honored in temples and homes on a daily basis. But once a year, on a given deity's birthday, a painter will sculpt and paint a new figure or touch up a wall painting of the deity. There are many deities in the Hindu pantheon and, accordingly, plenty of celebrations. And work. Painters who carry out these tasks receive only symbolic payment, yet many continue what is seen as "work for god." For bigger festivals, such as *Lakshmi Puja*, women decorate the walls and sometimes also the floors of their homes with intricate designs in preparation for the celebration. At this end of what is a continuum of *celebrative caring*, painting is done for the well-being of the household. Not only are things painted, but people are also decorated. The faces of Gotipua dancers are decorated with white and red dots before

they go on stage. Children receive similar ornamentation on their birthdays. Moving through the hamlet sporting their bright new set of clothes and their face paint, they are noticed, their presence celebrated. Feet are painted too; women's feet, that is. Whether a welcoming act or a preparation for a ritual marking a new life stage, "your feet look bare" is an invitation to be cared for, the initiation of an intimate interaction between women, whether offered to a guest or a daughter to be married.

Painting can also contribute to create a *sense of belonging*. Old people, some of whom can hardly see, spend their day on verandas painting masks, wooden figures, or roughly executed paintings. This allows them not only to chat with passers-by, to be part of their community, but also to contribute to their household the best they can. Women with caretaking responsibilities paint masks or *jātri pattis* in their limited spare time so as not to "sit idle" or for companionship. Whether old or young, female or male, the self-worth resulting from these activities substantiates a sense of belonging.

Of all the painters I know, only a few who do not depend on the income continue to paint for a *sense of fulfillment*. Binod Moharana is one of them.[28] More often the artisans paint in the hope of getting *recognition*. Recognition and fulfillment, however, are not easily separated. Some painters spend their entire working lives striving to get an award – or yet another award – chasing official recognition for their contribution to Indian traditional crafts. They scrutinize last year's awards looking for signs of the judges' preferences before starting on a new entry. They might question the competence of judges and suspect corruption, but nevertheless they let their assumed preferences steer the painting process. A few can afford to ignore the opinions of others by establishing a name for themselves or securing a government position and pension. They enjoy experimenting with form and color, a creative endeavor that fulfills their sense of purpose in life. Whether striving for recognition, fulfillment, or both, few are fortunate enough to get an award that may lead to monetary gain.

Painting thus offers an expression of *celebrative caring*, provides a *sense of belonging*, delineates a *path to recognition,* and, in rare instances, results in *fulfillment*. When read together the stories in this book show what painting means to artisans: Painting is a way of life.

PAINTING STORIES AS WRITING

Like "painting," "writing" is both a noun and a verb. Writing is a process that at some point may materialize into a text. The kind of text depends on the genre, audience, and voice. *Painting Stories* crosses genres to reach, I hope, beyond academia. While faithful to reality – and thus ethnography as genre – I have used literary devices to move readers toward an understanding of life among the painters. I have offered my interpretation and show one possible meaning, but I avoid explicit explanation to keep interpretive possibilities open.

Anthropologists occasionally obsess over the ways in which language impacts their research. It is less common, however, to discuss how the dominance of the English language in academia affects anthropologists who are not native English speakers. Arguably, this is less of an issue in conventional academic texts, but, as I have found, it is comparatively debilitating when crossing into other genres of writing. The only advantage, as far as I can see, is that I have been forced to write simple and easily comprehensible prose. It is just my luck that this echoes villagers' unassuming way of speaking.

Anthropologists are free to write stories as analytic practice as long as their texts have basis in fieldwork and an origin in the discipline of anthropology.[29] It is common to employ narrative as a textual strategy in anthropological texts.[30] But when it comes to storytelling, conventional anthropology often comes up short.[31] Academia, after all, is a conceptual métier. Arguments are pursued and texts are sculpted around concepts that offer a tentative explanation of people's activities. This is done in close dialogue with existing research to give back to the academic community and, as such, it has value. However, the conceptual quest comes at a price as the pressure on academics to publish articles increases. Sapless papers are written and circulated among academics, texts are published that quote interviewees but contain no dialogue, and entire books are written that glaze over description and sensory details, leaving readers without any bearing to relate to the places discussed.

Pausing the search for broader meaning that is common in academic texts and instead focusing on small-scale meaning-making has allowed me to think through writing. This may not lend itself easily to abstract knowledge production, but as I hope to have shown it can lead

to analytical concepts that are closely anchored in a world. The concepts that arise from the texts are no substitutes for the stories. Indeed, they cannot stand alone,[32] but they offer themselves to anyone who wishes to explore them further in a classic anthropological analysis. The stories, however, offer a glimpse of what ethnographic writing can also be – namely, a painting of stories for the world.

One reason I never previously wrote about the ladies' bicycle, open-air cinema, or the ritual pollution of my motorcycle helmet is that the ethnographic material somehow never fit what I was working on. Ethnographic material – resulting from people's generosity with their time – is all too often left fallow. But it does not have to be so. It is possible to write a different kind of ethnography,[33] one that is written in an accessible language, draws on literary tools to engage the reader, and allows for an assortment of texts that, when cumulated, provide an impression of a lifeworld. The stories in this book are unruly, their distinct characteristics reflecting the varied material on which they build. Some are re-narrations of painters' life stories, others are based on our shared experiences, and still others are my personal reflections triggered by my encounters with painters in Odisha or via social media. The mosaic reflects the numerous ways life can unfold, often in an unexpected cadence.

Painting Stories, I hope, pays tribute to the painters and their creative endeavor, an impressive undertaking in day-to-day life and awe-inspiring during times of disaster. The collaborative reflections on which the stories are based were intimate interactions, but so was the act of writing the stories. Writing about life is to bring forth a person or situation in the mind of the writer and, if successful, in the minds of readers. Like painting, writing can be an expression of *celebrative caring*, a symbolic reaching out across distance.

Acknowledgments

What is a book if not a testament to some of the relations that make up a life? Fieldwork is all about establishing relationships, but as any fieldworker knows, there are qualitative differences that will affect the experience and outcome of fieldwork. The people an anthropologist works with know it too. Some relationships are more important than others. One afternoon in Raghurajpur I was chatting with Mera when she jokingly said that Sula would always be my best friend no matter what the other women in the hamlet did. While talking, she looked me straight in the eye, perhaps giving me a chance to disclaim her statement. I let it pass.

Denmark shut down on March 11, 2020, due to the COVID-19 pandemic, a week after I was diagnosed with a life-threatening illness. Eleven days later, Modi, the Indian prime minister, in a televised address to the nation, announced a "Janata curfew" that was to last not two weeks but fourteen hours – on a Sunday. His initiative, unfortunately, did not stop the spread of COVID-19 across the continent, causing fatalities and economic destruction. Some states were hit harder than others. I watched with apprehension as Tamil Nadu, where my in-laws live, went from orange to red. Odisha was not passed by. How will the painters fare when COVID reaches the village? I wondered. Unlike me, Manju did not sit about speculating, she acted. With COVID getting closer by the day, she prayed to the mother goddess – for my recovery.

A Danish saying, "*Tak er kun et fattigt ord*," is a way of acknowledging that "thanks" is just that – a word – and a poor substitute for the debt

implied. Having grown up in a country obsessed with the importance of always thanking properly, it took me a while in Odisha to stop my repeated "thank yous" and attempts at polite phrases, a practice that caused nothing but amusement among the villagers. Whether friends or not, and friendship has never been a necessity for pursuing anthropology, the villagers let me in. They would laugh if I thanked them formally. "What is the need? Do not tell – show." The stories, I hope, do just that.

One reason my first fieldwork was such a fruitful adventure was my partner in research, Smaranika Samantray, or Seema. Herself a student of anthropology, Seema was committed to our task and socially gifted. Her sense of humor made fieldwork a memorable learning experience. During my second extended fieldwork, I was fortunate to work with Prasanta Mishra. In 1991, it took a brave man to sit behind a female driver in Odisha – it was not done. Ahead of his time, Prasanta took turns with me riding the red Hero Puch when traveling between Puri and the villages. These days, we go by car, neither of us missing the moped.

Writing is largely a solitary practice, but as with all human activities, it is embedded in social relations. I am indebted to many people who have read and commented on drafts of this book. Behnan, my husband, and I are fortunate to be part of a fabulous fiction reading group called Read and Eat. The careful reading, critique, and encouragement of John Gulløv, Eva Gulløv, Max Pedersen, and Lise Tvorup gave me the confidence to proceed, as did other close friends from my student days in Copenhagen and London, namely Renée Iben, Britta Demmer, Merete Kjær Petersen, and Tine Rehling. Isaac Thomas, my brother-in-law, generously offered his critique of my initial attempt to explain my role as a white anthropologist in an Indian community of village-based painters.

Contemplating signing up for a course in creative writing, I reached out to Kirin Narayan, whose support and encouragement have made all the difference. It was Kirin who suggested I send the story to the yearly competition held by the Society for Humanistic Anthropology, an event that, among other things, led to a memorable night in San Jose with Deborah Reed-Danahay and Helena Wulff. During our discussion over a glass of wine, Deborah suggested the title *Painting Stories*.

I am fortunate also to have amazing colleagues, Cecilie Rubow, Hanne Mogensen, Charlotte Baarts, and Tine Gammeltoft, writers

whose open, playful, and sharp minds make all the difference in a work environment marked by the contemporary university's obsession with "excellency." Colleagues yes, but also friends who were present all the way through 2020 during difficult times. May our WhatsApp groups, Heksecirklen and Creative Ethnography, have a long life.

I have shared snippets of various drafts with many students, the interaction with curious and committed minds being one of the privileges of working in a university setting. One afternoon, just after I had read aloud in class passages from "A Ladies' Bicycle" and "The Helmet," a student asked, "How is storytelling useful to anthropology?" This book, I hope, answers his question. Two of my thesis students, Mette Steen and James Phelan, read an early version of the manuscript and returned it with excellent questions and critiques. In between supervision sessions, James shared with me some of his own writing. Reading his work, I hoped he would agree to edit my English. He did. Any mistakes, of course, are my doing.

The time I have spent in Odisha has been generously funded by a number of institutions for classic research. I mention them here because this book builds on relations and knowledge developed over many years: the University of London Central Research Fund, the School of Oriental and African Studies, the Danish Research Academy, the Nordic Institute of Asian Studies (NIAS), and the Danish Foreign Ministry. My department trusted me to put to good use my yearly research allocation, providing me the opportunity to return to Odisha at a time when I had reached a crossroads in my career.

While writing, I have been able to return on a yearly basis to Klitgården, a refuge for writers and artisans. A beautiful view, a generous spread served with a smile, and a community of people committed to whatever it is that matters to them – what more can one ask for? Apart from good health, I can think of one thing only. Family. Aliya, Mathai, Behnan, and Maggie, you have been with me all the way. What a journey, what a gift.

Glossary

apā elder sister

bhāng drinkable mixture made from marijuana

Brahmin a Hindu of the highest ritual rank

chapal sandal without heel strap

chinna mastā severed head

chhita random decorative patterns commonly made by women using rice-flour paste

chitā decorative patterns women make using rice-flour paste

chitrakāra maker of pictures

chudā beaten rice

chunni a long scarf draped from the shoulders

dahi a kind of yoghurt

darshan seeing and being seen by a deity

deshi of the country, indigenous

dhana treasure, gift

dhoti a traditional garment wrapped around the waist, worn above the knees or longer by men in South Asia

gāmuchhā traditional loincloth worn by some male villagers in their home

Ganesh elephant-headed Hindu god of beginnings, a remover of obstacles whose vehicle is a rat

ganjapā traditional game of cards that previously was popular in Odisha

guni black magic

guru a highly influential teacher

guru kula āshrama a place that offers live-in apprenticeships

Holi Hindu spring festival commemorating lord *Krishna*'s play with cowgirls (*gopis*). Participants throw color powder and water on each other.

huluhuli to utter a loud rhythmical sound expressing reverence and celebration during an auspicious event

idli steamed savory cake made of fermented rice and black gram

jātri patti pilgrim painting

jhoti decorative pattern on the floor made by women with rice-flour paste

kākarā rice cakes, fried

Kali Hindu goddess of destruction, a form of the Mother goddess

Kārtika Hindu lunar month (October/November in the Gregorian calendar)

Kārtikeswara Hindu god of war who is son of *Shiva* and *Parvati*, brother of *Ganesh*, and has a peacock as vehicle

khiri sweetened rice milk

Krishna the eighth avatar of *Vishnu*, one of the most widely revered Hindu gods. He plays the flute and one of his vehicles is the bird-like Garuda

Krishna lila Krishna's playful activities

kurtā pyjāmā a long tunic and loose trousers worn by men

Lakshmi Hindu goddess of wealth and good fortune, seated on a lotus, and the wife of *Vishnu*

mausā mother's sister's husband

māusi mother's sister

Odia the Indo-Aryan language spoken in Odisha

olatā color applied on women's feet

pakhāla fermented rice

pandit priest

patta chitra cloth painting

prasād food offered to a deity during worship, consecrated through the deity's partaking, and then distributed to worshippers

　　　　ct of worship

　　　　skrit texts recounting the birth and deeds of Hindu

　　　　d the creation, destruction, or re-creation of the universe

Purnimā full moon

rajah an Indian king or prince

Rama the seventh avatar of *Vishnu* and one of the most widely worshipped Hindu deities. The story of *Rama* is told in the great epic tale *Ramayana* and briefly mentioned in the (even greater) epic *Mahabharata*

Ramayana the great epic poem describing the life of lord *Rama*

rupee the currency used in India

sālwar kameez a pair of loose trousers with a long shirt worn by women in South Asia

Saraswati the goddess of learning and eloquence

sari a six-meter long garment worn by women on the South Asian continent

saru kalā fine black lines

shastra any of the sacred writings of Hinduism

sevā a service performed for a temple, priest, or Brahmin in a relationship lasting over generations

sevaka a person performing *sevā*

Shasana Brahmin the highest-ranking Brahmins in Odisha

sloka a couplet of Sanskrit verse

sudra the lowest of four groups or classes of people

thāli round metal plate used to serve food

thiā badhiā painting of the *Jagannath* temple. *Thiā badhiā* literally means "standing excellent." However, whereas standing refers to the vertical presentation, *badhiā* does not mean anything when used in this context

tulsi holy basil, Latin name: *ocimum tenuiflorum*

vasanta utsava spring festival

veena a string instrument

Vishnu the preserver and protector of the universe and one of the principal Hindu deities

Notes

1 The names of deities are italicized to easily distinguish between gods and people.

2 They typically depict the *Jagannath* triad, occasionally in one of their special attires. Paintings of some of these *vesas* are presented in Bijoy Chandra Mohanty, *Patachitras of Orissa: Study of Contemporary Textile Crafts of India* (Ahmedabad, India: Ahmedabad Manufacturing and Calico Printing Co., 1980) and in B. Mohanty, *Pata-paintings of Orissa*, Ministry of Information and Broadcasting, Government of India (New Delhi: Patiala House, 1984).

3 Among others, see Helle Bundgaard, *Indian Art Worlds in Contention: Local, Regional and National Discourses on Orissan Patta Paintings* (Surrey: Curzon, 1999); "Contending Indian Art Worlds," *Journal of Material Culture* 4, no. 3 (November 1, 1999): 321–337.

4 At the time, tussar silk was not commonly used as a substitute for canvas in Raghurajpur. The introduction of tussar was one of the outcomes of the research and development taking place in the B.K. College of Art and Crafts in the 1980s under the supervision of the late Dinanath Pathy and supported by the Department of Culture, Government of Odisha.

5 Helle Bundgaard, "Lærlingen. Den formative erfaring," in *Ind i Verden. En grundbog i antropologisk metode*, ed. Kirsten Hastrup (København: Hans Reitzels Forlag).

6 This story is a revised version of "The Book," first published in *Maker and Meaning: Craft and Society Revisited* (Chennai: The Madras Craft Foundation, 2021). Reprinted with permission from MCF. The ethnographic material has previously been used in support of my argument that the significance of awards changes as they filter through the different layers of an art world. At the upper spheres, they are concerned with superior artisanship and aesthetics; at the receiving end other meanings are attached to an award that have to do with status, economics, and social relations. Helle

Bundgaard, "Handicraft Awards and Their Changing Significance: A Case Study from Orissa, India," *Folk* 38 (1996): 107–124; "The Changing Significance of Awards," in *Indian Art Worlds in Contention: Local, Regional and National Discourses on Orissan Patta Paintings* (Surrey: Curzon).

7 Helle Bundgaard, "Elite Discourses on *Patta Chitras*," in *Indian Art Worlds in Contention: Local, Regional and National Discourses on Orissan Patta Paintings* (Surrey: Curzon).

8 This story was first published in *Anthropology and Humanism* 44, no. 1 (2019): 156–161. Reprinted with permission from the American Anthropological Association. It won the Society for Humanistic Anthropology Ethnographic Fiction and Creative Nonfiction Writing Award, second prize in 2018.

9 For a detailed description of the painting, see Helle Bundgaard, "The Puri Painting of the National Museum in Copenhagen," *Folk* 43 (2001): 123–135.

10 B. Wolff, "Letter" (in Danish) to Thomsen, Curator at the National Museum in Denmark (January 16, 1850).

11 B. Wolff, "Letter" (in Danish) to Thomsen (January 3, 1850).

12 Bundgaard, "The Puri Painting of the National Museum in Copenhagen."

13 See Mildred Archer, *Indian Popular Painting in the India Office Library*, 2. Impr. (London: Her Majesty's Stationery Office, 1979).

14 Personal communication, Odisha, 1991.

15 See Halina Zealey, "Indigenous Arts of Orissa," report sent to the American Friends Service Committee (Philadelphia, PA: 1953), 3.

16 Philip Zealey, "Revival of Artistic Crafts in Orissa," *The Economic Weekly*, July 17, 1954; Halina Zealey (1953: 2).

17 Philip Zealey (1954).

18 Halina Zealey, "List of Objects Offered for Sale," *Ethnographic Document 1664* (September), Museum of Mankind, 1976, 3.

19 Joanna Williams, "Criticizing and Evaluating the Visual Arts in India: A Preliminary Example," *Journal of Asian Studies* 47, no. 1 (1988): 3–28.

20 In the wake of what Clifford and Marcus termed a "crisis of representation"; James Clifford and George E. Marcus, *Writing Culture: The Poetics and Politics of Ethnography* (Berkeley: University of California Press, 1986).

21 Carolyn Fluehr-Lobban, "Collaborative Anthropology as Twenty-First-Century Ethical Anthropology," *Collaborative Anthropologies* 1, no. 1 (2008): 175–182; R. Holmes Douglas and George E. Marcus, "Collaboration Today and the Re-imagination of the Classic Scene of Fieldwork Encounter," *Collaborative Anthropologies* 1, no. 1 (2008): 81–101.

22 See Mysore N. Srinivas, in Kirin Narayan, "How Native Is a 'Native' Anthropologist?" *American Anthropologist* 95, no. 3 (1993): 671–686.

Cohn, "The Command of Language and the Language of ," in *Subaltern Studies IV: Writings on South Asian History and* Ranajit Guha (Oxford: Oxford University Press, 1985),

276–329. See also Sumit Guha, *Beyond Caste: Identity and Power in South Asia, Past and Present,* Brill's Indological Library, vol. 44 (Leiden: Brill, 2013); and Nathaniel Roberts, "Setting Caste Back on Its Feet," *Anthropology of This Century* 13 (2015).

24 For explanations of what visual skills as cultural skills imply, see Michael Baxendal, *Patterns of Intention: On the Historical Explanation of Pictures* (New Haven: Yale University Press, 1985); Clifford Geertz, "Art as a Cultural System," in *Local Knowledge: Further Essays in Interpretive Anthropology* (New York: Basic Books, 1983).

25 Born in Raghurajpur but settled in the capital, Binod Moharana taught at the State Institute of Handicrafts Training in Bhubaneswar for almost thirty years. After retiring, he has kept creatively expressing himself through painting.

26 See Michael Jackson, *Minima Ethnographica: Intersubjectivity and the Anthropological Project* (Chicago: University of Chicago Press, 1989).

27 See Helle Bundgaard, "Analytic Discourse and Lived Practice," in *Indian Art Worlds in Contention: Local, Regional and National Discourses on Orissan Patta Paintings* (Surrey: Curzon Press, 1989).

28 The notion of fulfillment is alluded to in the stories but not unfolded, reflecting the rarity of this particular experience among painters.

29 See Kirin Narayan, "Ethnography and Fiction: Where Is the Border?" *Anthropology and Humanism* 24, no. 2 (1999). See also the list of recommended readings.

30 John Van Maanen, *Tales of the Field: On Writing Ethnography* (Chicago: University of Chicago Press, 1988).

31 See Thomas H. Eriksen, *Engaging Anthropology: The Case for a Public Presence* (Oxford and New York: Berg, 2006); Rodolfo Maggio, "The Anthropology of Storytelling and the Storytelling of Anthropology," *Journal of Comparative Research in Anthropology and Sociology* 5, no. 2 (2014).

32 See Michael Jackson, *At Home in the World* (Durham, NC: Duke University Press, 1995).

33 Denielle Elliott and Dara Culhane, *A Different Kind of Ethnography: Imaginative Practices and Creative Methodologies* (Toronto: University of Toronto Press, 2017).

Recommended Readings

As a child, I loved reading and writing stories that brought me to other worlds. My grandmother listened, mending our socks while sitting in the bright corner of our living room, and encouraged me to go on writing stories. I was also drawn in by the colorful stamps that covered the large envelopes my father received from China and India. If only one day I could travel to see some of the places and people that had inspired the makers of those stamps. Years later, I came across anthropology and was won over immediately by the description of the subject as the study of people, their social relations, and their culture in societies all over the world. In this respect, I am not alone. I recognize the same desires in most first-year students in my department.

I learned many things as a student of anthropology; writing compellingly was not one of them. Like many students, I came with strong writing skills, developed from the days spent with my grandmother, through elementary school and high school, and into my enrollment at university. But by the time I left university, neither my fellow students nor I had improved our skills at writing texts that matter outside a university. Instead, we had mastered academic writing, some better than others. The more prestigious a text, the less likely it would appeal to a broad audience. It was writing devoid of emotion. Writing cluttered with multisyllabic, technical terms marched up like medieval knights guarding the Holy Grail. Writing that speaks to the intellect but does not trust readers to make up

their own minds. Writing as parched and lifeless as a yellowed lawn at the height of summer.

I have always valued clarity and presence in writing, one reason I feel drained when reading academic work dotted with a surplus of interrupting references and jargon but no sense of place. My fatigue is doubled by the dull prose that so often makes reading anthropology an exercise of endurance. For years, I have secretly indulged in fiction, leaving screaming journal articles untouched in their stack on my desk.

Lonely ethnographers have discussed their frustration with standard ethnographic prose before, and some of them have been fortunate to be part of the occasional wave of interest in ethnographic writing. The conversation has lived a quiet existence at the margins of anthropology. If the increasing number of publications on anthropology and writing is anything to go by, a new wave might just be underway. Perhaps dawn is breaking. I, for one, hope so. I have learned, rather late, that to cut the stifling ribbons of convention and write anthropology differently, one must cross disciplinary boundaries.

Anthropology has immense value as an analytic practice that offers translation and explanation of human behavior and, more recently, also contributes as a part of a collaboration with the people anthropologists study. The generation of analytical concepts that can help to increase mutual understanding has arguably never been more important. When I suggest we must set time off to develop our writing, I am not questioning the importance of anthropology's analytic endeavor. I am simply insisting that we can do more. Rather than merely a question of communication, I believe that a different kind of ethnographic writing can stimulate ethnographic analysis. Just as I care for my plot in the hope that something might grow, I want to engage with my ethnographic material in order to know it and make sense of it. This is writing as cultivation.

Since the 1990s, anthropologists have spoken about the role narrative plays in anthropological texts. Anthropology, we insist, is a storytelling business, but the ethnographic texts we write tend to distance us from the shared life on which we build our ethnographic writings. It does not have to be so as we know from a few exemplary ethnographies. We ~~ ourselves that we come close to other people's lifeworlds – closer ~~alists or travelers. Regardless of whether that is true, the ~~ommunicate the knowledge in its writing. For that to hap- ~~pologists will have to look beyond their discipline – not a

new call, but one that bears repeating – to learn from real storytellers who are able to transport their readers to other worlds through their use of language. Writers of fiction can also teach us the art of leaving a text open and inspire us to fight the urge toward closure commonly practiced in the social sciences. If we have learned one thing from anthropology, it is that there is rarely only one right answer. The recent experiments in ethnographic writing are at once promising and foreboding, an indication that what has been living a quiet existence at the margins, literary anthropology, might be working its way toward the hearth. The price, however, appears to be an increase in parochial writing that, although welcomed in academia, is unlikely to move the world.

Painting with words is as difficult as painting with a brush, both skills taking years of practice. Like painters who seek inspiration in the forgotten motifs or a striking pose of another artisan's work, I have turned to fiction to nurture my story writing. Although I am no longer an apprentice when it comes to conventional academic writing, I have a lot to learn from writers I admire, a few of them anthropologists. Life is brief; I wish I had crossed disciplinary boundaries long ago and now encourage students to explore different genres of writing sooner rather than later.

There is a lot to be gained from fiction but also from re-reading one's favorite ethnographies with a view to how the authors have written memorable texts. This can be eye opening for someone trained to focus mainly on argument. Reading differently may increase the joy of writing, strengthen one's own writing, and thus offer substantial support for an argument, and not least help in finding one's voice.

Apart from fiction, creative nonfiction, the occasional ethnography, and ethnographic stories, I recommend reading texts in which authors share how they and other writers read and write. A few of the texts that have inspired me are listed below and present one possible place to begin. Those marked with a star contain excellent suggestions for further reading, including some ethnographies.

On Writing Ethnography

Behar, Ruth. "Ethnography in a Time of Blurred Genres." *Anthropology and Humanism* 32, no. 2 (2007): 145–155.*

Elliott, Denielle. "Writing." In *A Different Kind of Ethnography: Imaginative Practices and Creative Methodologies*, 23–44. Toronto: University of Toronto Press, 2017.*

McGranahan, Carole. "Introduction. On Writing and Writing Well: Ethics, Practice, Story." In *Writing Anthropology*. Durham, NC: Duke University Press, 2020.*

Narayan, Kirin. *Alive in the Writing: Crafting Ethnography in the Company of Chekhov*. Chicago: University of Chicago Press, 2012.*

Narayan, Kirin. "Ethnography and Fiction: Where Is the Border?" *Anthropology and Humanism* 24, no. 2 (2007): 134–147.

Narayan, Kirin. "Tools to Shape Texts: What Creative Nonfiction Can Offer Ethnography." *Anthropology and Humanism* 32, no. 2 (2007): 130–144.

Pandian, Anand, and Stuart McLean. *Crumpled Paper Boat: Experiments in Ethnographic Writing*. Durham, NC: Duke University Press, 2017.

Rapport, Nigel. "Representing Anthropology, Blurring Genres: Zigzagging towards a Literary Anthropology." In *Mediterranean Ethnological Summer School*, Vol. III, 29–48. Ljubljana: Institut za multikulturne raziskave, 1999.

Rosaldo, Renato. "How I Write – Renato Rosaldo Transcript." https://web.stanford.edu/group/howiwrite/Transcripts/Rosaldo_transcript.html.

Stoller, Paul. "Ethnographies as Texts/Ethnographers as Griots." *American Ethnologist* 21, no. 2 (1994): 353–366.

Stoller, Paul. "Ethnography/Memoir/Imagination/Story." *Anthropology and Humanism* 32, no. 2 (December 1, 2007): 178–191.

Stoller, Paul, "What Is Literary Anthropology?" *Current Anthropology* 56, no. 1 (2015): 144–145.

Stoller, Paul. "Writing for the Future." In *The Anthropologist as Writer: Genres and Contexts in the Twenty-First Century*, edited by Helena Wulff. New York, Oxford: Berghahn, 2016.

Wolf, Margery. *A Thrice-Told Tale: Feminism, Postmodernism, and Ethnographic Responsibility*. Stanford, CA: Stanford University Press, 1992.

On Reading

Lesser, Wendy. *Why I Read: The Serious Pleasure of Books*. New York: Farrar, Straus and Giroux, 2014.

Prose, Francine. *Reading Like a Writer: A Guide for People Who Love Books and for Those Who Want to Write Them*. London: Aurum Press, 2012.

Prose, Francine. *What to Read and Why*. New York: Harper Perennial.

On Writers and Writing

Atwood, Margaret. *On Writers and Writing*. London: Virago Press, 2003.

⌐⌐ertz, Clifford. *Works and Lives: The Anthropologist as Author*. Cambridge: �macroᴘress, 1999.

⌐. *The Other Shore: Essays on Writers and Writing*. Berkeley: California Press, 2013.

On Writing Well

Cheney, Theodore. A. Rees. *Writing Creative Nonfiction: Fiction Techniques for Crafting Great Nonfiction.* Berkeley: Ten Speed Press, 2001.

Lamott, Anne. *Bird by Bird: Some Instructions on Writing and Life,* 2nd ed. New York: Anchor Books, 1994.

Le Guin, Ursula K. *Steering the Craft: A 21st-Century Guide to Sailing the Sea of Story.* New York: Mariner Books, 2015.

Zinsser, William K. *On Writing Well: The Classic Guide to Writing Nonfiction.* New York: Harper Perennial, 2016.

Ethnographic Stories

Friedl, Erika. *Women of Deh Koh: Lives in an Iranian Village.* Washington, DC: Smithsonian Institution Press, 1989.

Gardner, Katy. *Songs at the River's Edge: Stories from a Bangladeshi Village.* London, Chicago: Pluto Press, 1997.

Lindisfarne, Nancy. *Dancing in Damascus: Stories.* Albany: SUNY Press, 2000.

Stewart, John O. *Drinkers, Drummers and Decent Folk: Ethnographic Narratives of Village Trinidad.* Albany: SUNY Press, 1989.